VINCENT VERSACE

FROM OZ TO KANSAS

ALMOST EVERY BLACK AND WHITE

CONVERSION TECHNIQUE KNOWN TO MAN

EDITED BY EDNA ELFONT, PH.D.

D1262534

FROM OZ TO KANSAS
ALMOST EVERY BLACK AND WHITE CONVERSION TECHNIQUE KNOWN TO MAN
Vincent Versace

New Riders
1249 Eighth Street
Berkeley, CA 94710
510/524-2178
510/524-2221 (fax)
Find us on the Web at: www.newriders.com

To report errors, please send a note to errata@peachpit.com

New Riders is an imprint of Peachpit, a division of Pearson Education

Acquisitions Editor: Ted Waitt
Developmental Editor: Edna Elfont, Ph.D.
Production Editor: Lisa Brazieal

Compositor: Sean Dyroff
Indexer: James Minkin
Cover Design: Charlene Charles-Will
Cover Photography: Vincent Versace

ISBN 13: 978-0-321-79402-4
ISBN 10: 0-321-79402-8

9 8 7 6 5 4 3 2 1

Printed and bound in the United States of America

To all the Bunnies in the world.

And

To Walter Kahn,

who never stopped asking why.

Acknowledgements

I myself have always stood in awe of the camera. I recognize it for the instrument it is, part Stradivarius, part scalpel.

— Irving Penn

Now that this book is finally done, I have to say that underestimating the difficulty of writing this book was the greatest "What the hell was I thinking?!" moment of my life. This truly was the most difficult thing I have ever done. I would first like to thank Richard Zaika for taking the time to read the chapters of this book as they were evolving, as well as writing the foreword. I wish you were here to read the finished version.

This book simply would not be this book if it were not for the draconian editorial diligence of Edna A. Elfont, Ph. D., and the scientific diligence of Lawrence B. Coleman, Ph. D., Professor of Physics at the University of California at Davis and George Kronizer, Ph. D, Senior Dupont Color Scientist. When you read this book and you find that the thoughts are clear, concise, easy to understand, and make sense, trust me: that's all Edna.

If it were not for Professor Coleman's and Dr. Konizer's kind and gentle criticisms, their incredible insights and explanations that made me see the light when I was scientifically out of my mind, this book would be far less of a book. This book's scientific strength is powered by two very beautiful minds. Thank you, I know you both had better things to do in your free time. Your gift to me is not lost.

I am the photographer I am today because of CJ Elfont. Also, the technical photographic accuracy of this book would not be what it is if it were not for CJ's intervention. Without CJ (and Edna, too), I would not be an artist, I would not be a photographer; I would be someone else—certainly not the person who could ever have written this book.

To Nils Kokemohr (the N, I, and K of Nik Software): You are the smartest human I know. Your software makes my life and me more creative than I could have ever imagined.

To Sean Dyroff: Once again, you have proven that you are a Super Hero with "spidey" powers. You laid out this book, tech-edited it, fixed every one of my actions, and answered every one of my Photoshop questions, all while finishing graduate school and finally getting your Master's degree. Bravo!

To Eric Walowit: Thank you for taking the time many years ago and coming out of retirement to take me on as "a project" and teaching me the importance of color theory and color management.

To Eric Magnusson: Thank you for always taking the time to explain what Eric Walowit meant when he taught me color theory and color management.

To Gordon P. Brown: Thank you for all of the help you have not only given to me on this book project but over all the years you have been my Shell answer man of all things photographic.

To Jed Best: Thank you for being the beta tester of this book, for making sure I explained everything. Thank you for also being such a good friend.

To Mark Jaress: Thank you for being the person who taught me Photoshop. Thank you, thank you, thank you...

To Chef John Fraser of Dovetail Restaurant in New York City: First, thank you for taking the time to write the Afterword of this book and second, thank you again for the week I spent in your kitchen.

To this day, studying with you reminded me of the importance of being attentive to detail in my work. Everything matters when you create; everything dovetails into everything else. A day has not gone by that I have not reflected on what I learned in your kitchen. Thanks also to your entire staff for so generously sharing their knowledge.

To Fatima Nejame: Thank you for talking me into teaching, thank you for all of the wonderful places you have asked me to go and teach, and thank you for being my friend. I really like seeing the world through a camera with you.

To Ted Waitt, my editor at Peachpit Press: This book is finally done. Thank you for fighting the good fight for me, and thank you for keeping me safe.

To everyone at Peachpit Press: Thank you for your hard work and efforts to make this book happen.

To Ed Sanchez and Mike Slater of Nik Software: Thank you for keeping the company so alive and on the edge of technology. Thank you for providing five of the "crown jewels" for this book. Your friendship outside of work is cherished.

To Josh "the boy wonder" Haftel of Nik Software: You never sleep, and that's a good thing for all of us who use the products you manage.

To Joe Sliger of Wacom: Once again if it were not for you, the tablet presets that are part of this book would not have happened.

To Dr. Adrian Cohen: You are the standard I try to live up to in all my deeds.

To Jeff Chien, Brian O'Neil Hughes, Chris Cox, and John Nack of Adobe: you four have the patience of Job. Thank you for answering all of my questions, my follow-up questions, and my follow-up follow-up questions....

To Challen Cates, Lilan Bowden, Stephen Kearin, and Lizzet Lopez: Thank you for all the time you spent sitting in front of my camera waiting for me to get it right.

To Dan Steinhardt of Epson: Thank you yet again for providing me with your unfailing support even when I was/am/still a complete pain in the ass. Because of you, once again, another pocket of time was created in which I could create this book.

To Nancy Carr of Kodak; Vincent Park and Anthony Ruotolo of American Photo magazine; Peter Poremba of Dyna-Lite; Fabia Barsic of Epson; Tadashi Nakayama, Makoto "Mike" Kimura, Naoki "Santa Claus" Tomino, Jeff Mitchell, and Mike Corrado of Nikon; Liz Quinlisk and Thomas Kunz of X-Rite, Jeff Cable of Lexar, and Richard Rabinowitz: Without all of your faith and support over the years, I would never have had the career that I do.

To Toby, Sally, Adam, and Jamie Rosenblatt: Were it not for you, I would have stopped being a photographer.

To my sister Eve and my mother, I really did win the relative lottery.

To my wife, Sylvia, who had to suffer through the writing, rewriting and re-re-writing of this book. You have kept me calm when I was anything but. I am so lucky....

And lastly, Prrrl j. Cat, the fur person. I am appreciative that I am part of your "staff." Thank you for sitting on my keyboard and reminding me when it was time to rest.

Contents

Foreword **viii**

Preface **x**

First Words **xiii**

Chapter 1: The Black and White on All of the Gray Areas of Black and White 2

Coming to Terms. .5

Desaturation: Why You Should Not.11

Desaturation: When You Should12

Believing Is Seeing: The Way the Eye "Sees" What it Saw.26

Chapter 2: Variations on a Theme 32

Film and Filter: Three Approaches.34

Approach One: The Classic Film and Filter. .35

Approach Two: Neo-Classic Film and Filter. .38

Approach Three: Neo-Neo-Classic Film and Filter41

Why Knowing This Matters54

Chapter 3: Defying Logic 58

The Camera & the RAW File60

In Camera Conversion 61

In RAW Processor Conversions 65

To Begin the Beguine. 66

Conclusion. 82

Chapter 4: Defying Reason 84

The Black and White on Convert to Grayscale . 86

The Black and White on Split Channel Conversions 88

The Black and White on Lab Color Space Conversions 90

The Black and White on Equalizing Lab 98

The Bottom Line.102

Chapter 5: Somewhere Over the Grayscale 104

The Black & White Adjustment Layer Basics .112

The Black and White on Using the Black & White Adjustment for Color129

Conclusion. .133

Chapter 6: The Black and White on the Zone System 134

Zoning in on the Zone System.136

What You See Is What Will Take You .147

Chapter 7: The Black and White on the Channel Mixer Adjustment Layer 148

The Soul of the Art of Black-and-White Photography. .150

How to Dance with Multiple Partners on the Channel Mixer Dance Floor157

Image 1: Using a Multiple Channel Mixer Conversion Approach on a Portrait . .158

Image 2: Using a Multiple Channel Mixer Conversion Approach on a Landscape . 184

Conclusion. .198

Chapter 8: The Black and White on Silver Efex Pro 2 200

The Black and White on the Silver Efex Pro 2 User Interface203

Image 1: Using a Single Silver Efex Pro 2 Smart Filter Layer.209

Image 2: The Harmonics of Chording— The ABCs of Playing the RGBs223

Variations on a Theme: When Conversion Techniques Collide239

Conclusion. .242

Last Words 244

Afterword 247

Index 248

Foreword

In times of change, learners inherit the earth…they find themselves beautifully equipped to deal with a world that no longer exists.

—Eric Hoffer

In the 1950s, Eric Hoffer, who worked as a longshoreman in California, began writing books that dealt with social issues. His most recognized and popular book is *The True Believer*, written in 1951. He also authored many other books and was often referred to as the "longshoreman philosopher." He felt strongly that any book from which you derive one good idea is worth reading. I began thinking about this as I was reading *From Oz to Kansas: Almost Every Black and White Conversion Technique Known to Man*. It is a rich resource loaded with many valuable ideas that every photographer can benefit from. It is not just a book of photographic technique, digital procedures, and theory; it is much more than that. It is an inspirational book that emphasizes the importance of creativity and openness to new possibilities. The author writes with a passion from his own experiences as a photographer, teacher, and learner. His writing is engaging and peppered with a number of quotations by earlier photographers. This not only provides a connection to those who have preceded us, but also provides us with some sage sayings—quotes by such luminaries as Edward Weston, Man Ray, Eugene Smith, and Alfred Stieglitz. There are also quotes by painters such as van Gogh, scientists like Albert Einstein, and athletes like Babe Ruth. These quotes cast a wide net for the photographer, encouraging a look at photography beyond the immediate. An early Chinese proverb says it well: "By reviewing the old, we learn the new."

The author's writing style is informal, interesting and, at times, very amusing. This entertains and helps keep the reader's attention. Along the way he provides some sage advice, such as, "Shape is the enemy of color." In other words, shape competes with color. This is the reason that Josef Albers, in his series "Homage to a Square," used simple square shapes. Another gem is to "Consider light as a tangible thing." This is a reminder to attend to the quality of the light falling on the subject and not just to the subject.

Vincent writes with the reader in mind and anticipates questions that might arise, based on a collection of questions that photographers have asked at his many workshops. Each chapter/lesson is designed to connect with and reinforce the previous one. Several ways for converting color to black-and-white are offered in a step-by-step procedure that is well thought out, highly visual, and easy to follow. Although most of the book deals with the ways to convert color to black-and-white, there are two chapters that also speaks to the importance of being creative and guide you toward finding and expressing your own voice.

In earlier digital days, converting a color image to black-and-white was a real problem and the results were discouraging, leaving much to be desired. Compared to the silver prints, they looked puny. Now, with the new software, printers, and inks, digital prints are on a par with silver prints and in some cases even better, with richer blacks. The author

offers the reader several different step-by-step ways do these conversions.

Eric Hoffer wrote this about his writing: "...my writing grows out of my life just as a branch from a tree." So too, one can say that Vincent Versace's writing grows out of his many life experiences as a photographer, speaker, teacher, researcher, and writer. His book and stunning photographs testify to his intellectual curiosity and desire to understand what he is doing. He is not afraid to take on new ventures, even one in which he spent a few days in a kitchen (of a friend who is a master chef) to learn what goes into being an artistically motivated chef. One of the things he learned was that being creative in your work is as important for a successful chef as it is for a photographer.

All artists want to communicate with others, and photography is communication. Great photographers are great because they speak eloquently. They use their medium as a composer uses his instruments or a writer clothes his thought in words and phrases. They are masters not only of the technique of photography, but, for at least one brief moment, they are masters of the eyes and mind of another human being.

—Richard D. Zakia
Professor Emeritus
Rochester Institute of Technology

Author's Note: Dr. Zakia wrote this foreword from his hospital bed and passed away shortly thereafter. I am honored that he took the time to both read this book and write the foreword. Dr. Zakia has had a great influence on me as a black-and-white photographer and he will be sorely missed.

Preface: About Beginnings & the Scope of This Book

Ninety percent of my photographic process is, in fact, not photographic.

—Taryn Simon

The magic in watching a silver-based, black-and-white image appear in the developer tray, along with the smell of stop bath and fixer, is what sparked my desire to be a photographer. My formal education in photography was in large-format, Zone System, black-and-white, nature photography. Before 1998, the year that I went totally digital, I was shooting approximately 6,000 rolls of film per year of which 90% were black-and-white. At the time, I made my living doing head shots for Hollywood actors, and those were always shot and printed in black-and-white.

When I started beta-testing some digital photography equipment in 1992, I was told that I had to start shooting color if I wanted to be a beta site for any future devices. So I entered the digital world, allowing black-and-white prints to take a backseat to the new art of digitally capturing color images and to the concerns of how to best produce a print that remained true to my vision. One of the basic tenets of my training as a photographer was derived from an Ansel Adams quote: "The negative is everything, the print is all. The negative is the sheet music and the print is the symphony." That is, the print is the culmination of the effort, the thing that represents you as an artist.

It was not until the advent of printers with multiple levels of black pigment-based ink sets, and printer drivers designed to exploit those inks, along with papers formulated to replicate the look and feel of silver gelatin papers, that I felt that I could refocus on black-and-white photography instead of waxing poetic about a lost love.

Because I am, by proclivity and passion, a black-and-white photographer, I believe that my best work is in black-and-white. I think that by removing the distraction of color in journeying into the abstraction of the grayscale that the most compelling images are created. A black-and-white image is not one that you should decide to create casually, and you should certainly not do it if you think that the image with which you will begin is not a successful color image. Uninspiring color images are even less interesting in shades of gray.

There are three questions that I am frequently asked when people look at my black-and-white work. First, "Did you see the photograph in black-and-white?" The next is, "How do I see in black-and-white?" and, finally, "How come my black-and-white images do not look like yours?" The goal of this book is to answer those three questions.

In the pursuit of writing a book that answers those questions, I came to realize that the best way to accomplish this task was to teach the creating of a black-and-white photograph in a way that not only focuses on the mechanics of conversion but also on how to be most true to your individual voice and vision, as well. It is also important to recognize that just like any discussion of film-based, black-and-white photography was also a major discussion about darkroom technique and printing, so too is any discussion of digital black-and-white photography a discussion about the manipulation and conversion process in Photoshop and other post-processing software.

In this book, every lesson builds on every other lesson. This means that you need to do all of the lessons in this book and do them in the order that they are presented (ideally, doing even those lessons that involve technology you do not think that you will use) so as to get their full benefit.

My goal for you is that when you are finished with this book, the echo of the knowledge that you will gain will remain within you, and later, when you look at a scene or an image, you will know what to do. Most importantly, you will not only know what to do, but why to do it.

In my large-format, Zone System, black-and-white, film-based photographer past, of all the things that I did, I was perhaps best at printing. I was taught that the best photographers in the world were also the best printers, but the best printers were not necessarily the best photographers. What this means is that the best photographers were the ones that understood and experimented with all that was possible in the darkroom while being aware of certain limitations. The eye always trumps technique, but an eye without technique produces little of the artist's voice.

I was taught that all decisions are best made at the point of capture and that all decisions are informed by your understanding of how it all works. In other words, the more you understand about the middle (Photoshop), the more informed your decision can be at the beginning (the point of capture), because everything you do is in service of the final goal (the print) which is your voice.

What This Book Is Not

This book is not a manual. A manual tells you what to do and not why to do it; it does not give you insight into all that is possible and then encourage you to use this knowledge to sort out what might be best in a particular situation.

This book is not a repair manual. I will not teach you how to take a mediocre image and transform it into something wonderful, mainly because I do not believe that is possible. One of my mantras is that Photoshop is not a verb, it is a noun. On the other hand, however, if you believe that post-processing software is not involved or has no significant place in digital photography, I recommend that you not purchase this book.

This book does not focus on the "button-ology" of cameras and how to compose better photographs. It is not a book about tips and tricks and, if you want a book in which you can randomly pick and choose the sections to read, this one is not for you. This book's purpose is to give you a solid foundation of information and help you to use that information to make magic.

What This Book Is

Do I think you can become a better photographer by reading this book? I do! As I look back at my 45 years as a photographer, and at how well I feel that my images express my voice, I can tell you that it is my understanding of all the things that can be done to an image that guides my hand when I am shooting. With regard to black-and-white digital photography, I feel certain that the more you understand about the middle part—the post-processing part—of your photographic journey, the more successful you will be at making decisions at the point of capture, where all of your decisions about a photograph's ultimate fate should be made. Every choice you make along the way is in service of the print, and the print is always in service of your artistic voice. It is your artistic voice that compels you to take photographs, is it not?

Though this book is based on CS6, its approach and the techniques that I will discuss are not revision specific. Because this book's focus is on converting a color image into a black-and-white one, I will leave a discussion of all the new and wonderful things that you will find in CS6 to another author.

This book takes you, as close as possible, on the journey that I have travelled to develop the techniques that I use to produce my black-and-white images. It is specifically focused on the considerations of how to best convert an image from full-color to grayscale. There is little to no discussion of sepia toning, cyanotype, warm tones versus cold tones, how to faux-solarize, duo-toning, split-toning, how to make a digital negative, etc. These are all aesthetic choices that you make after the conversion process is finished and this book's focus is about the conversion process itself. I believe that, by giving you an understanding of the conversion process, I will provide you with the way to answer your questions about how and why (from the moment of capture to the final print) a black-and-white photograph is created.

In this book, I have made some basic assumptions about you, the reader, and you, the photographer. I assume that you already know how to take a photograph, that you have an understanding of composition, and that you know how to properly expose an image. I also operate under the premise that you have some understanding of Photoshop and how its tools operate, as well as what the buttons on your camera do.

Because I believe that a black-and-white photograph should never be an afterthought, I assume you are here by choice. All I ask is that you approach this book and its lessons with an open mind and spirit. This book is about expanding your knowledge base, so that even if you think a lesson might not be pertinent to what you normally do, I encourage you to try everything so that you can find a new normal. Try to keep yourself in the state of a beginner's mind, one who believes that, even if you are doing something for the first time, you will succeed. If you approach this book in that way, you will create successful images.

First Words: The Pleasure of Creativity

Why Create?

If you hear a voice within you say, "you cannot paint," then by all means paint, and that voice will be silenced.

—Vincent van Gogh

Most of us can look at the artistic work of others and decide whether or not we like a particular piece. Why then, when we view an image of our own, are we frequently fraught with ambivalent feelings? I do not understand why we tend to be our own worst critics. Certainly there are enough people in the world who will find fault with anything that we do. We must learn not to assist them.

But why pursue anything creative if we are doomed to torture ourselves about what we did and approach being creative as if there is some cosmic scorekeeper that decides if we are ahead or behind? The truth is that nobody but you is keeping score. We spend too much time concerning ourselves with the notion that for our creative work to be valid, that others have to like it.

All artists hear a call to express themselves creatively, but too often, that voice fades with time and is replaced by one that says, "You can't do that" or "If it was such a brilliant idea, someone else would have thought of it first." The quickest way to silence that voice is to do exactly the thing that you think you cannot.

Hardening of the Categories

Hardening of the categories causes art disease.

—W. Eugene Smith

If you want to take more interesting pictures, stand in front of more interesting stuff.

—Joe McNally

The way you live your life is not determined by what happens to you, but by how you react to what happens. You are not defined by what life brings to you, but rather by the attitude you bring to life. If you have a positive attitude, you trigger a chain reaction of positive events and positive outcomes that will be seen in your images, for they are a reflection of how you live your life.

Every image you create is an expression of the artistic inspiration that moves you. You express your creative voice by developing the ability to show this without screaming for the attention of others. It means getting out of your own way and, in the moments when your creative spirit is moved, trusting that what comes from those moments will be good. Your goal should be to trust what you feel and constantly strive toward personal excellence and elegant performance. When your effectiveness becomes effortless, your images will move the viewer solely by the power that caused you to be moved.

Because you are reading this book, I assume that most of you have chosen photography to express how you feel to the outside world. However, regardless of the path you have chosen, it is you who drives the art form bus, not the other way around. Techniques exist to help you express yourself. If there is a battle between voice and technique, voice should always win. Emotionally full and technically imperfect trumps technically perfect and emotionally vacant every time.

I believe that there is no drug as addictive or as alluring as being successful creatively. To make a living from the fruits of one's imagination is truly a blessed way to live. But herein lies the rub. With practice, and perhaps success, we find our groove. But grooves frequently become ruts, and ruts can become trenches, and trenches can become graves in which our creativity becomes buried.

So how do you become more creative and create diverse, emotionally moving images? If you want to have more creative work, find creative moments in your everyday life. If you want to have more emotionally captivating work, let your everyday life captivate you emotionally. If you want your work to be more diverse and interesting, lead a more diverse and interesting life. In simpler terms, your work is only as good as the inspiration that you find in the life you lead.

If You Have a Minute, Tell Me Everything You Know

I would say to any artist: "Don't be repressed in your work, dare to experiment, consider any urge, if in a new direction all the better."

—Edward Weston

A discussion about photography should be about why we are moved to create the images we do, and how to best practice the things that will help our voices be heard in the clearest, truest way. A discussion about technique that excludes one about why particular techniques are chosen is like trying to have an aesthetic conversation about a repair manual. All creativity comes from a wellspring within us, and the more frequently and diversely we exercise our creative muscles, the stronger and clearer our emotional voice becomes. Feeling that you will never do something well is no reason not do it. Let that something become your new best friend, because it is from doing, that things never before seen are born.

For me, great photographic lessons were learned from shooting both portraits and landscapes. What I learned is to shoot my landscapes like portraits and my portraits like landscapes. When I photograph a flower, am I not taking the flower's portrait? When I photograph a person, is it not the objective, with one frame, to lay bare the essence of that person in that instant? My most successful portraits and landscapes are the ones in which those things happen.

What makes images even more successful is bringing life experiences and a knowledge base of techniques to the table. This allows you to create an image that reflects what you felt when you were taken by the moment.

I would like to tell you a story. I love to cook and, even though I know it is unlikely that I will ever be as great a cook as one of the great chefs that I know,

I keep trying to learn more about cooking creatively. I had the honor of spending a week in the kitchen of John Fraser, the chef at Restaurant Dovetail in New York City. By mid-week, I had finally graduated to "preparing ingredient," specifically the task of chopping carrots into the equivalent of pixel-sized cubes. About halfway through my second bunch of carrots, Chef Fraser walked by and told me that my efforts were not acceptable. My first thought was, "But they are just carrots." Apparently, my face belied that thought, and Chef Fraser said, "I see you don't understand." Again, I must admit that I was still thinking, "But they are just carrots." What I said was, "No, I do not."

"Okay," he said, "let's talk about something I know you understand. These carrots are not visually acceptable. You need to be cutting cubes and you have cut rectangles and diamonds. The visual composition I want to create is squares in a circle. So compositionally what you have done does not work." I did get that! "But the bigger issue is that because they are irregularly shaped and different sizes, they will cook differently. Some parts of the carrot will be over-cooked and some will be under-cooked. My goal is to create a dish that is so visually appealing that you almost don't want to eat it because of how pretty it looks, and when you do, you will find that it tastes even better than it looks. By not cutting the carrots uniformly, you have disrupted the pleasure of the person eating this dish. Everything matters. Everything dovetails into everything else. It's why the restaurant is named Dovetail." That was one of the most important lessons I have ever learned. Everything matters, and everything dovetails into everything else.

From Imperfection Perfection Grows

A picture is the expression of an impression. If the beautiful were not in us, how would we ever recognize it?

—Ernst Haas

Photography should not be about taking photographs; it should be about being taken by them. It should be about allowing yourself to be consumed so completely that the decisive moment pulls you through the lens and the image is captured along the way. When creating an image, you must be totally engaged, all creative cylinders firing at once and as one. This is often referred to, in Japanese Zen Buddhism, as being in a state of Shibumi: the act of thoughtful thoughtless thought, or doing the right thing in the moment without consciously thinking about doing the right thing. It is a state of grace. It is in this state of grace that photography becomes not merely about looking, but about seeing, because to just look is simply a visual experience. Seeing is a creative process.

So how does one make the leap from looking to seeing and from taking, to being taken by one's pictures? You must take satisfaction from practicing at mastering every aspect of an image's creation, because being taken by an image occurs in a wonderful but fleeting moment. In order to find the path to being taken emotionally (and thus take the viewer of your image to the same place), care and attention must be paid to every step in the process. Nothing about the journey is insignificant. Everything matters, and everything dovetails into everything else.

Traveling at the Speed of Life

One does not plan and try to make circumstances fit those plans. One tries to make plans fit the circumstances.

—Gen. George S. Patton

Life does not move at 1/125 of a second. It moves with great deliberation and within the blink of an eye, and it does both at the same time. It moves at the speed of life. And when we put camera to eye to capture some moment, we strive to capture an image of a moment that matters. The digital revolution has made it simple to take pictures, but creating meaningful photographs is still a difficult, creative process.

It is a shame that many of us are being taught how to take photographs to Photoshop them. Photoshop is not a verb. It is a noun. Photoshop is not the end, it is the means to the end, and that end is a great image. Making a great image, one that expresses even a glimmer of what you felt in the moment of capture, requires great care and patience. All decisions about what the image should be are best made at the moment of capture, but creating a great photograph is a slow dance.

Become a better photographer, not merely a better Photoshop jockey. Better yet, become an extraordinarily creative photographer! Photoshop is a tool for you to use, nothing more. If there is nothing of you in an image, then the image is nothing but pixels on a screen; ink on paper. All you will create are forgettable photographs.

Memorizing a Dictionary Does Not Mean You Have Something To Say

If I think, everything is lost.

—Paul Cézanne

By the end of this book, I will have shown you multiple post-processing techniques, and technique is important—very important. But nurturing and expressing your voice, even if your technique is not the best, is even more important.

Most creative artists become good technicians; however, not all good technicians become creative artists. If all you do is follow the steps I give you, there is no certainty that you will end up with a perfect black-and-white image. As you work on an image, if you do not feel the same emotion that you felt when the image took you and do not let that guide your hand, it will never be perfect. Let the passion that you felt at the moment of capture be held like an expectant breath within your images, and they will move your viewer in the same way that you were moved.

Home Run Hitting 101

Don't let the fear of striking out ever get in your way.

—Babe Ruth

Be careful of the artist who boasts of 35 years of experience. Such a person may have one year of creativity experienced 35 times. To me, a true artist practices by acting, by putting truth into his or her creations so that they have an elegant simplicity. Great art is created when the artist discovers that being an artist is about understanding themselves and expressing that. Knowing more about techniques helps that expression happen.

So why should you know every black-and-white conversion technique known to man and how to use all of them? Because the more you know about how to bring forth your vision, the clearer your voice will be heard. So what if you swing and miss? If you do not swing at all, you will never have the chance to knock it out of the ballpark.

The underlying goal is a simple one: to make a print of a picture that moves you, just like it moved you the first time you saw it. The joy of creation is in knowing that your photograph moves others.

The bigger and fuller you experience life, the bigger and fuller your creative expressions of life will be. It is on that note that you should begin all your creative symphonies. It is on that note that you should begin every breath you take.

The Black and White on All of the Gray Areas of Black and White

Color is my day-long obsession, joy, and torment.

—Claude Monet

IMPORTANT: Before going any further in this book be sure to install the Color Efex 4 Promo 5 from Nik Software that comes free with this book. Also, every black-and-white conversion that is discussed in this book has been made into an action and a configurator, as have the additional things that are done to an image, all of which can be found in the Oz Power tools action set. Be sure to download them and install them. If you are using a Wacom Intuos or Cintiq tablet, be sure to install the tablet presets that also come with this book. (These presets are for both right- and left-handed users, as well as for Windows and Mac.) A description of the layout of my presets, as well as a PDF discussing an overview of my image editing workflow, is also part of this book. The link for the Nik Software plug-ins that come with this book and the tablet presets can be found on the download page for this book. Be sure to have this installed before you move on any further in this book.

HTTP://WWW.OZ2KANSAS.COM

Coming to Terms

Of two equivalent theories or explanations, all other things being equal, the simpler one is to be preferred.

—William of Ockham

In the world of traditional analog photography, a black-and-white photograph is defined as an image whose colors range, in tones of gray, from black to white. Such an image usually will contain an area of pure black and move through the grayscale to an area of pure white. In the pre-press world, the world of offset printing, a black-and-white image is made up of blacks (ink) and whites (paper tone). In the world of digital photography, such an image will contain an area of pure black in which the RGB values will be 0, 0, 0 and move through the grayscale to an area of pure white in which the RGB values will be 255, 255, 255. The more accurate description for a traditional, silver, black-and-white photograph is to call it a grayscale image, and the more accurate definition of a digital black-and-white image is to refer to it as a *chromatic grayscale* image (see the sidebar: *Terms of Engagement*). I chose the term chromatic grayscale image for digital black-and-white images, not simply as an exercise in semantics, but because such accuracy in terminology is extremely important for conceptualizing the conversion of an image from a full color palette to a chromatic grayscale one without ever leaving the RGB color space. What you will see throughout the course of this book is how you address all the colors of an image will directly affect the chromatic grayscale image (**Figures 1.1** and **1.2**).

Consider what constitutes a black-and-white capture on film, and which of its characteristics you might want to replicate. Panchromatic black-and-white film (*pan* means "all" and *chromatic* means

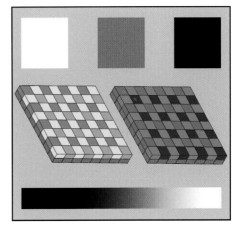

FIGURE 1.1 *Color target captured in color*

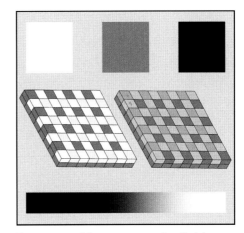

FIGURE 1.2 *Color target captured on Kodak TMAX 400 film*

Throughout the course of this book, I will frequently use the following terms and have defined them as follows:

Bit Depth—is a measure of the amount of color information in each pixel. In a digital system, information is represented by bits that can have a value of 0 or 1. The more bits that are used to represent information, the greater the number of discrete values that information can have. In a bitmapped image (such as a TIFF, PSD, or JPEG), the number of bits used to represent the red, green, and blue pixels determines the number of colors that can be created. With a bit depth of 8, each pixel can have 256 possible values per color channel, so that the number of possible colors is 256 x 256 x 256 or over 16 million. An RGB image with a bit depth of 8 bits per color channel is considered a 24-bit image (8 bits per color channel times 3 channels). An RGB image with a bit depth of 16 bits per color channel is considered a 48-bit image. In a grayscale image, an 8-bit image is one with a maximum of 256 shades of gray.

Black-and-White—In pre-press printing terms, a black-and-white image is one that is made up of blacks (ink) and whites (paper tone). Photographers refer to their images as *black-and-white,* but they are better defined as *chromatic grayscale* images.

Brightness—is the perception of the intensity of light emitted or transmitted by an object or group of objects.

Chromatic Grayscale—(as defined for the discussions in this book) is an image containing black, white, and a range of gray shades made up of colors that have equal values of R, G, and B. The best conversions of full color to monochromatic gray images are best done in the RGB color spaces. Even though the gamut of color in a monochromatic grayscale image can be easily reproduced in as small a color space as sRGB, the file from which the grayscale image is being created is a full color one. Thus, it is important to preserve the full color integrity of the source image. Also, the best continuous tone, monochromatic, grayscale, digital photographic prints are made when all of the color heads of an inkjet printer are used and when the image has never left the RGB world.

Color Space—is a theoretical model that is useful to explain how colors are detected, managed, and displayed by a particular device or system. Color spaces have distinctive capabilities that define what intensity of saturation colors will appear and how well they will retain shadow and highlight detail. They contain digitized, numerical representations of color and differ from one another in the quality and quantity of colors that they can handle and display. I like to think of a color space as a painter's panel in three dimensions that not only (digitally/numerically) defines colors and color combinations, but their hues, saturation, and brightness as well.

Contrast—(as defined for the discussions in this book) is the difference in visual properties that makes an object (or its representation in an image) distinguishable from other objects and the background. It is a measure of the ratio of the luminance of the brightest color (white or near white) to that of the darkest color (black or near black). If the difference between the luminance of the brightest and darkest colors is large (e.g., the brightest area is 500 times brighter than the darkest area that is black), the image will appear to have high contrast. If the difference between the luminance of the

brightest and darkest colors is small (e.g., the brightest area is five times brighter than the darkest one), then the contrast will appear low. Low contrast images are typically described as "washed out."

NOTE: For an in-depth discussion of contrast, see Professor Alan Gilchrist's book, *Seeing Black and White,* New York, NY: Oxford University Press, Inc., 2006.

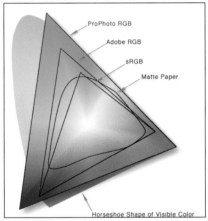

Diagrammatic relationship of many color spaces to all of human vision

Curves—result when a smooth line is drawn to connect the intersecting points of two related variables (one plotted on the X axis of a graph and the other on the Y axis).

Grayscale Image—is an image in which the value of each pixel is a single sample, that is, it carries only intensity information. These are images composed exclusively of shades of gray, varying from black at the weakest intensity to white at the strongest.

Lightness—the brightness of an area judged relative to the brightness of a similarly illuminated area that is white or highly transmitting.

Luminance—is the measured amount of light emitted from a source or reflected from a surface. While the luminance is an exact photometrically measured value, human perception of luminance depends on many factors, such as how dark or light adapted you are.

Tone Reproduction—Tone, as it applies to photography, is a description of the quality of an object or scene's luminance. Tonal

reproduction is the process by which photographers try to take the range of light that they see (which is vast) and compress it to meet the limited capabilities of output media (e.g., silver-based photographic paper, the color gamut of ink jet prints, or a screen display device), while retaining much of the tonal appeal of the actual object or scene.

Tonal Reproduction Curves—are derived by plotting the original scene luminance against the resulting print or display luminance. When a line connects the points at which they intersect, a curve results rather than a straight line, because the relationship is non-linear. These curves can be applied to the image information so that the computer can either compress or expand the tonal elements in a photograph in order to make it look more like the original scene. This may be done in the software that is built into some cameras, or in post-processing, by the photographer using software with this capability.

"colors") is the film type that is most often used to take black-and-white photographs because it records light in the range visible to the human eye. Visible light, which is measured in nanometers (nm), is in the 400–700 nm range. A general approximation is that blue ranges from 400 to 500 nm, green from 500 to 600 nm, and red from 600 to 700 nm. The human eye is most sensitive at 555 nm, right in the middle of the green spectrum.

When mixes of colors (or relationships among the colors of light) change, film can record that change. In the digital world, digital cameras record the relationships among red, green, and blue light within the image. Red, green, and blue are words used to describe three independent wavelengths of light. Any color that you capture with a digital camera can be defined by its mixture of red (R), green (G), and blue (B) light, and by its profile.

Without explicit reference to an RGB profile (e.g., Adobe RGB-1998), RGB is meaningless; you simply have no idea what the colors really are. Without a reference RGB profile, all you know is that the red is some shade of red and the green is some shade of green. With a reference RGB profile, you know what those particular shades truly are.

Film works with density and digital cameras work with luminance, so they have different RGB responses and tone reproduction curves. Images captured with digital cameras produce digital values relative to the scene luminance as automatically calculated by the camera's tonal reproduction curve. This means that equal changes in scene brightness will produce equal changes in digital values. This is why it is critical to maintain the relationships among R, G, and B when converting a digitally captured image from color to chromatic grayscale if you want to replicate the look and feel of traditional black-and-white film photography.

RGB Is Not a Color; It Is a Formula to Mix Color

Film and digital cameras record colors differently. There are many reasons for this, but two of the more significant ones are that spectral sensitivities and tonal reproduction curves are unique to each medium. Every film type has unique RGB characteristics because of the chemistry of its photographic emulsion. Each digital camera type has unique RGB responses and tonal reproduction characteristics because of its RGB sensors and filters, as well as its signal (image) processing characteristics.

Neither film nor digital cameras reproduce color the way the human eye sees it. The eye has unique color and tone responses. Film and digital cameras attempt to approximate the way people see color, but there are design trade-offs that compromise this goal.

If you simply remove all of the color from a color image by desaturating it, which is the way many of us created our first digital black-and-white image, all you will see is an image in which different colors of equal luminance will all be the same gray. If you look at the Info panel, where the colors once had an RGB value of R=255, G=255, and B=255 (**Figures 1.3** and **1.4**), they now have an RGB value of R=127, G=127, and B=127; almost middle gray (**Figures 1.5** and **1.6**). You lost 100% of the colors (other than gray) and 1% of image density, but the 1% that you lost contained the aesthetic qualities of the silver, black-and-white image that you were aiming to replicate. You also lost two-thirds of the file's data.

NOTE: Photoshop keeps all the color/luminance information in Lab and then translates it as necessary to ProPhoto RGB, CMYK, sRGB, Grayscale, etc. To see this, convert an RGB image to Lab and watch what happens in the Info panel. Applying the desaturate command discards the A (green-

magenta) and B (blue-yellow) color channels, retaining only the Luminance (L) channel information. Two of three channels are lost, therefore, you have lost two-thirds of the original file's information, and the file size shrinks accordingly. Translating the file back to RGB, returns it to the original file size, but what remains in the R, G, and B channels, is only the L channel information. The same thing happens if you convert RGB to Grayscale; the file size is reduced by two-thirds.

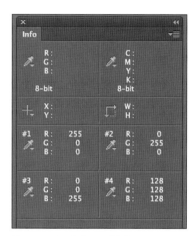

FIGURE 1.3 *Info panel before desaturation*

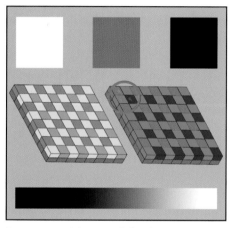

FIGURE 1.4 *Color target before desaturation*

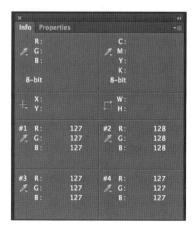

FIGURE 1.5 *Info panel after desaturation*

FIGURE 1.6 *Color target after desaturation*

Desaturation: Why You Should Not

To compare the results of desaturation with the results from black-and-white film, look at the three RGB channels of this image of Challen Cates (**Figures 1.7, 1.8, 1.9, and 1.10**). You see that each has a different grayscale value. By my working definition, each channel is a black-and-white image. This is what the image would look like if I shot it using Ilford HP5 Plus (a 400 ISO film) and processed it at 200 ISO (**Figure 1.11**). This is what the image would look like if I desaturated the digital image (**Figure 1.12**), and this is what the individual RGB channels would look like after desaturation (**Figures 1.13, 1.14, and 1.15**). Note that the film

and the desaturated image are both grayscale images and that they are different from each other. Note also that all three channels of the desaturated image are grayscale images and look alike. According to my definition, all five of these images are black-and-white ones.

What was lost, however, when the image was desaturated, was all the color information. What was left was simply the luminance, or light-to-dark aspect of the image. What is not present, as would be the case with a film image, is the relationship between red, green and blue translated to the grayscale. So would you ever use such a conversion technique? The answer may surprise you.

FIGURE 1.7 *The color image* FIGURE 1.8 *The Red channel* FIGURE 1.9 *The Green channel* FIGURE 1.10 *The Blue channel* FIGURE 1.11 *Ilford HP5 Plus film*

FIGURE 1.12 *The image desaturated* FIGURE 1.13 *The Red channel desaturated* FIGURE 1.14 *The Green channel desaturated* FIGURE 1.15 *The Blue channel desaturated*

Desaturation: When You Should

Everything should be made as simple as possible, but not simpler.

—Albert Einstein

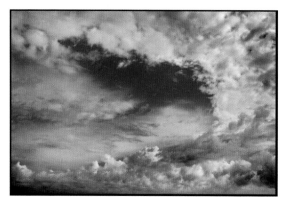

FIGURE 1.16 *An image of clouds from the Valley of 4000 Temples in Bagan, Burma*

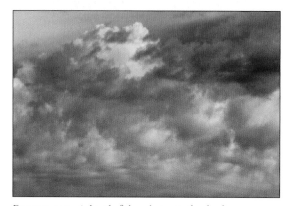

FIGURE 1.17 *A detail of the coloring in the clouds*

The simplest way to do something is usually the best way, it is important to make things as simple as possible and no simpler. For the image of Challen, what appeared to be the simplest way was not the best way. Using desaturation to make things simpler than possible proved damaging to the integrity of the image.

An example of an image in which desaturation might be a good idea is an image of clouds. Most often (except at sunrise and sunset) you perceive clouds to be black-and-white, not color. They are either light or dark and their luminance varies. How they appear in a photograph, however, is frequently different from how you perceive them.

I would argue that the image of clouds from the Valley of 4000 Temples in Bagan, Burma (**Figure 1.16**) is mostly a chromatic grayscale one, even though there is some blue in it. But if you zoom into the bottom area of the image, you will notice that there is a lot of color in these clouds (**Figure 1.17**). Frequently, clouds look blue-gray in a photograph versus the white or gray that we think we see, because they often take on the color of the light that is reflected from the surrounding blueness of the sky or up from the ground beneath them. In this instance, the color is a yellow-brown, because the grass of the valley is mostly yellowish-brown during the time of year in which this image was captured.

Would you use a Multi-Channel Mixer adjustment layer, multiple plug-in chromatic grayscale conversion approach or simply use desaturation to get the color contamination out of something that is (for the most part) already in grayscale? If you agree with Albert Einstein, as quoted previously, you would try desaturation.

For Every Repetitive Action You Take, React by Making an Action

For every action, there is an equal and opposite reaction.

—Sir Isaac Newton

Even though Newton was discussing forces and not programming actions, from this point forward, everything that you will do in this book that can be made into an action or a configurator, has been, and you can download them from the download page for this book. (See the sidebar: *For Every Action That You Take, Make an Action* in this chapter.) The actions are for all versions of Photoshop and the configurator is for CS6. You can save time on repetitive actions in Photoshop by creating an action or a configurator to do most of the heavy lifting. Also on the download page, is a QuickTime movie that shows you how to load the actions and configurators. Actions and configurators will be updated when the need arises.

I would highly recommend, unless otherwise directed, that you do the lessons manually first. After that, try the action with the same image. I feel that it is important to know what is going on under the hood. By doing every step in this book before simply running the actions, you will reinforce your understanding of how to control the way your viewer reacts to the image that you create. Also, by doing each step, you will gain a better understanding of how to, why to, when to, and why not to use a given approach. As Vince Lombardi said, "Practice does not make perfect. Perfect practice makes perfect," and what you need to do is practice at practicing.

Removing Color Contamination Using Selective Desaturation

The more things change, the more they remain the same.

—Alphonse Karr

1. Open the CLOUDS1.tif file located in the Chapter 1 section of the download page for this book.

2. Go to the Adjustment panel (CS4 and above) or the Create New Fill or Adjustment Layer icon (Photoshop version 3 and above) located at the bottom of the Layers panel, and create a Hue/Saturation Adjustment Layer (**Figure 1.18**).

3. In the Hue/Saturation Adjustment Layer dialog box, move the Saturation slider to –100 and the Lightness slider to –1 (**Figure 1.19**).

NOTE: The Lightness slider adjusts the lightness of the pixels. You are adjusting it to –1 to add darkness, or density, that was lost by removing all of the color.

FIGURE 1.18 *Adding a Hue/Saturation adjustment layer*

FIGURE 1.19 *The Hue/Saturation adjustment*

Actions

An action is a stored Photoshop record of the steps that you perform on an image. You decide what and when Photoshop will start and stop recording. Once an action is recorded, you can run it any time, on any image. The action does everything you record just as if you were executing the commands yourself, but does them much faster than you can. Actions work in all versions of Photoshop.

Actions are misunderstood, because they may appear difficult to create. That is not the case. They can, however, be tedious to make and are unforgiving, because they record everything you do, and I do mean everything. So, once you press record, do only the steps that you want *recorded*. When creating actions, especially long ones, I have found that it is best to record small groups of steps and make duplicates along the way. This approach compartmentalizes the work, and you do not have to start at the beginning should something go wrong.

Configurators

Adobe Configurator is a utility that enables the easy creation of panels for use in Adobe Photoshop CS4, CS5, and CS6. Configurator is designed to make it easy to drag and drop tools, menu items, scripts, actions, and other objects into a panel design, and then export the results for use in Photoshop. It helps you gain back screen acreage that was lost with the user interface changes that occurred in CS4. Configurator

allows you to customize Photoshop CS4 (and above) to your workflow, but the configurators made for CS4 do not work in CS5 or CS6 and vice versa.

How to Load an Action

1. Go to Menu > Window > Actions to bring up the Actions panel (**Figures 1.20** and **1.21**).

2. Click on the Actions Menu icon located in the upper right corner of the Actions panel, and select Load Actions (**Figure 1.22**).

3. Locate the action that you want to load onto your computer. In this case, it is the OZ_2_KANSAS_12 action. Select "OZ_2_KAN-SAS_12.atn" from the Load Actions dialog box and click OK (**Figure 1.23**).

NOTE: Whenever I load an action, I simplify my workflow by placing it on the Desktop so that it is easy to locate.

Now you have loaded all of the actions for this book and you should see the actions loaded into the Actions panel when you open the OZ_2_KANSAS_12 actions folder.

FIGURE 1.20 *Window Menu*

FIGURE 1.22 *The Actions panel menu*

FIGURE 1.21 *The Actions panel*

FIGURE 1.23 *Selecting the action set from the hard drive*

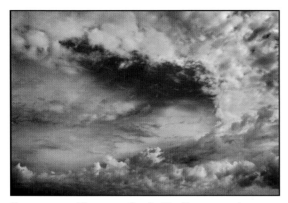

FIGURE 1.24 *The image after the Hue/Saturation adjustment without the layer mask*

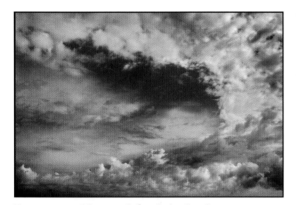

FIGURE 1.25 *The image before the brushwork*

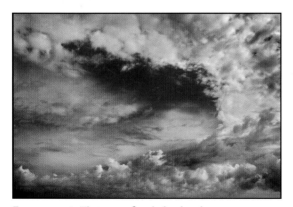

FIGURE 1.26 *The image after the brushwork*

4. Set the foreground color to white and the background color to black (the D key sets the foreground and background to the default colors of white and black, and the X key toggles the foreground and background colors) and fill the layer mask with black (Command + delete / Control + backspace).

5. Select the Brush tool (keyboard command B) and set the Brush opacity to 100% (keyboard command 0 [the number zero]), and the brush width to 500 pixels.

NOTE: I determined the brush size by making the brush slightly smaller than the area on which I wanted to do brushwork. Unless otherwise specified, whenever you select the Brush tool, it will be a soft brush with a hardness of 0. (This gives you a feathered brush.)

6. Brush the entire lower area of the clouds that are contaminated with the unwanted color. (**Figures 1.24, 1.25, 1.26, 1.27, 1.28,** and **1.29**).

7. Bring up the Fade Effect dialog box (Command + Shift + F / Control + Shift + F) and dial back some of the color (go from 100% to 68%) (**Figures 1.30** and **1.31**). Save the file (Command + S / Control + S).

Examine the final result in **Figure 1.32**.

FIGURE 1.27 *The layer mask of the brushwork*

FIGURE 1.30 *Adjusting the Fade Effect dialog box*

FIGURE 1.28 *Detail of the clouds before the brushwork*

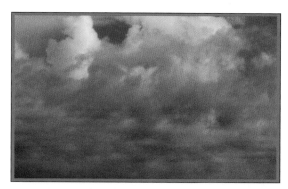

FIGURE 1.31 *Detail of the clouds after adjustment*

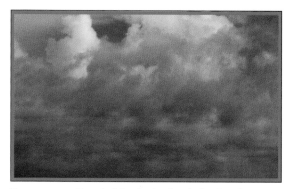

FIGURE 1.29 *Detail of the clouds after the brushwork*

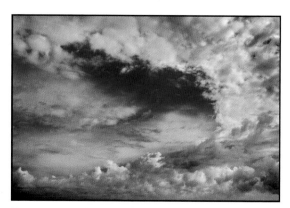

FIGURE 1.32 *The image after the adjustments*

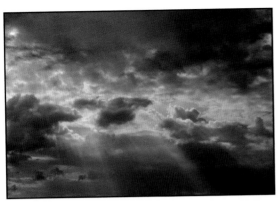

FIGURE 1.33 *An image of clouds also at the Valley of 4000 Temples in Burma*

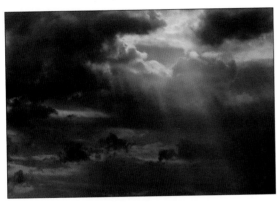

FIGURE 1.34 *A detail of the color in the clouds*

Desaturating to Remove Color Contamination, Adding Drama with Curves Adjustment Layers, Blend Modes, and the Nik Software Contrast Only Plug-In

In this lesson, you are going to completely desaturate the image, and then you are going to play with contrast and blend modes to add drama. Also in this lesson, you are going to get your feet wet and do part of it using actions.

This image of clouds (**Figure 1.33**) was also shot in the Valley of 4000 Temples, taken moments after the first set of clouds on which you just worked. I simply turned 90 degrees to my right. Whenever I am out shooting, I approach my time with the attitude that the journey is the destination. I try to capture as many different expressions of the moments that take me as time, battery, and flash card will allow. I take my time; as much as I can. I do not indulge in "drive by" shooting. The only thing that makes me move quickly is the speed with which the light changes. If the considerations of light matter anywhere, they matter most when it comes to creating a chromatic grayscale (black-and-white) image. Black-and-white photography is all about the dance of light, dark, and contrast, and it is how you choose to play with these variables that result in images that reflect your vision.

Because the entire process of photography has been accelerated by the digital camera and accompanying software, some of us expect to create masterpieces with every click of the shutter. And some believe that if they miss *it*, they can fix *it* in post-processing. Such people have lost their organic connection to the joy of creating an image. You would never think to rush in the analog black-and-white darkroom. There, time and care is reflected in the quality of the final image.

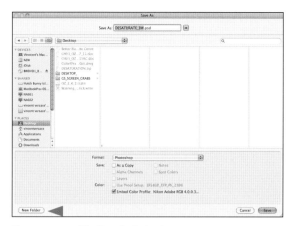

FIGURE 1.35 *The Save As dialog box*

FIGURE 1.36 *Creating a new folder called CLOUDS2*

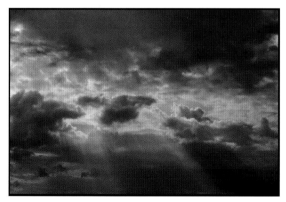

FIGURE 1.37 *The image desaturated*

What holds true there must also hold true in the digital darkroom. Take your time. Take as much time as the image deserves.

In **Figure 1.34**, there is color (primarily blues and yellows) throughout the clouds that you may not want. You may also want to make the clouds appear more dramatic.

Getting the Other Colors Out

If you can see it with your eyes, it's a color.

—Matisse

8. Open the file CLOUDS2.tif (located in the Chapter 1 section of the download page for this book).

9. From the Actions panel in the OZ_2_KANSAS_12 actions folder, click on the DESATURATE action and then on the Run button located at the bottom of the Actions panel.

NOTE: The moment that you click the Run button, the action will start. (Even when it pauses to have you do something, it is still running.) The action will not stop until all of the steps of the action are complete.

10. Photoshop will open the Save As dialog box (**Figure 1.35**). When it comes up, click on the New Folder button located in the lower left corner of the Save As dialog box. When the New Folder dialog box comes up, name the folder CLOUDS2 (**Figure 1.36**).

11. Type CLOUDS2_ after the DESATURATE_BW in the naming box located in the top middle of the Save As dialog. Click Save. The action will then restart and desaturate the image (**Figure 1.37**).

NOTE: To add words to a file name in the Naming dialog box, place the cursor either before the first letter or after the last letter where you want to add text. In this case, it is before, because you are adding a name to the description. If you were adding something like the size of the image (e.g., _13x19 or _20x34), you would put the cursor to the right of the last letter of the filename.

NOTE: You can double-click on an action to load it, but occasionally, it will not appear when you next open Photoshop. Loading actions, as previously described, guarantees that the action will be loaded when you reopen Photoshop.

Getting Drama Using Contrast

There are two ways that you can go about getting contrast. You can use either Curves or Nik Software's Contrast Only filter (one of the five, free filters that you get with this book). You are going to learn how to use both, because both are extraordinarily useful.

Adding Contrast with Curves Adjustment Layers

NOTE: The following steps have also been made into an action called "PS_CONTRASTS_LIGHTEN_BM" located in the "OZ_POWER_TOOLS" action set located on the download page for this book.

12. Create a Curves adjustment layer. Name this layer CONTRAST_NORM (for Contrast Normal Blend mode) either from the Adjustment Layer panel or the Adjustment Layer icon located at the bottom of the Layers panel (**Figures 1.38** and **1.39**).

NOTE: From this point on, I will show only screen captures of dialog boxes that have not previously been used. If I have described a technique or how to do something at length, I will not repeat all of the steps.

13. Once you are in the Curves dialog box, there are several choices located in the Presets pull-down menu. For this image, only two are of interest: Medium contrast and Strong contrast and, because you may want a lot of drama, Strong contrast is the best choice (**Figures 1.40, 1.41, 1.42,** and **1.43**).

14. Duplicate the CONTRAST_NORM Curves adjustment layer and rename it CONTRAST_LIGHTEN. Select the Lighten blend mode from the Blend Mode pull-down menu located in the upper left corner of the Layers panel. Holding down the Shift key, click on both CONTRAST_NORM and the CONTRAST_LIGHTEN Curves adjustment layers. Drag them to the Make New Layer Group icon located at the bottom of the Layers panel and name the new layer group CURVES_CONTRAST. You will see the lighter clouds get brighter with increased contrast while the darker clouds stay dark (**Figures 1.44, 1.45,** and **1.46**).

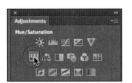

FIGURE 1.38 *The Curves option in the Adjustments panel*

FIGURE 1.39 *The Adjustment layer button in the Layers panel*

FIGURE 1.41 *Selecting the Strong Contrast (RGB) preset*

FIGURE 1.44 *The Blending mode drop down menu (arrow) and the New Layer Group icon (circle)*

FIGURE 1.40 *A Curves adjustment*

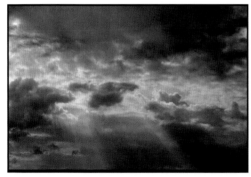

FIGURE 1.42 *The image before the Curves adjustment*

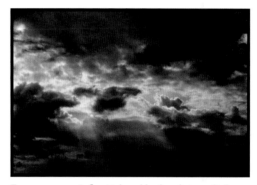

FIGURE 1.45 *Before Lighten blend mode is applied*

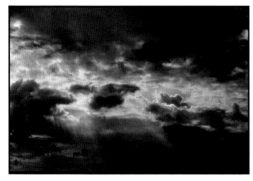

FIGURE 1.43 *The image after the Curves adjustment*

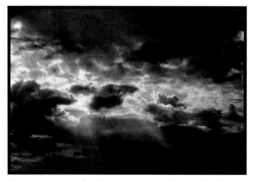

FIGURE 1.46 *After Lighten blend mode is applied*

NOTE: If you are using a Wacom tablet or a Wacom Cintiq I have programmed the Express keys and Radial dial. To see how they work, refer to the **Why to of My How** PDF on the download page for this book. This approach to contrast creation has also been made into an action.

Brewing Up the Perfect Blend

In the simplest of terms, a Photoshop blend mode affects how the pixels of one layer will interact with the pixels of the layer or layers beneath it it. Photoshop has 27 layer blend modes that you can apply to any layer.

NOTE: Blending modes are algorithms assigned to layers (or tools) which affect how they interact with other layers. The blending mode assigned to a layer (the "blend" color layer) determines how the colors of the pixels on that layer interact with the colors of the pixels on the base color layer or layers below. The result of that interaction is know as the "result color." When working with tools, the blending mode of the tool affects how that tool will alter the pixels on every layer below.

There are two ways to lighten an image using blend modes: *Lighten* and *Screen*. You will be using the Screen blend mode later in this book, so I will define them both now because what to best do with your image involves understanding how each of these blend modes function.

The Lighten blend mode looks at the color information in each channel and selects the base or blend color— whichever is lighter—as the result color. Photoshop lightens any pixels that are darker than the blend color, while leaving those that are lighter unchanged.

The Screen blend mode looks at each channel's color information and multiplies the inverse of the blend and base colors. The result color is always lighter. (The effect is similar to projecting multiple photographic slides on top of each other. The resultant image will be 50% lighter.)

Because you want to brighten the lighter clouds and maintain the contrast boost without adding lightness to the darker clouds, using the Lighten blend mode is the better choice. Also, because you are using an adjustment layer to do this, a layer mask is automatically attached to it when you create one. So, if an area is too hot or blown out (i.e., brighter than you desire), simply brush it back. You can also adjust the layer's opacity to diminish the affect of contrast lightening. Again, make things a simple as possible, but no simpler.

NOTE: To streamline and simplify the learning process, rather than give you a description of all 27 blend modes at once, I will describe them as they are pertinent.

FIGURE 1.47 *Converting a layer for Smart Filters*

FIGURE 1.48 *Launching Color Efex Pro 4 Promo 5*

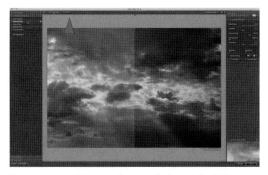

FIGURE 1.49 *Selecting Contrast Only and the Split Screen mode*

Adding Contrast with the Nik Software Contrast Only Plug-In

Go to an extreme and retreat to a usable position.

—Brian Eno

15. Turn off the CURVES_CONTRAST layer group.

16. Duplicate the background layer (Command + J / Control + J).

17. Make the layer that you just created into a Smart Filter (Filter > Convert to Smart Filter). Name this layer CONTRAST_ONLY (**Figure 1.47**).

18. Go to Filter > Nik Software > Color Efex Pro 4 Promo 5 (**Figure 1.48**).

19. When the Color Efex Pro 4 Promo 5 dialog box comes up, select Contrast Only and Split Screen mode (**Figure 1.49**).

20. Increase the brightness to 13 and increase the contrast to 54 (**Figure 1.50**).

NOTE: For the actions to run correctly, even if you have Color Efex 4.0 installed, you will need to install the Color Efex 4.0 Promo 5 version that comes with this book.

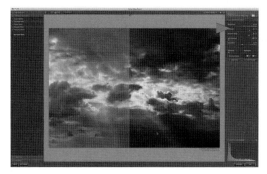

FIGURE 1.50 *Adjusting the Brightness and Contrast sliders*

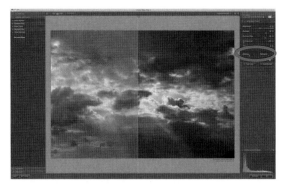

FIGURE 1.51 *Protecting the shadows and highlights*

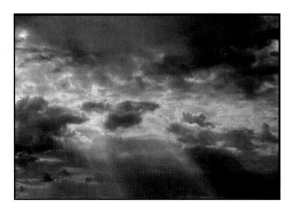

FIGURE 1.52 *Before the Contrast Only filter*

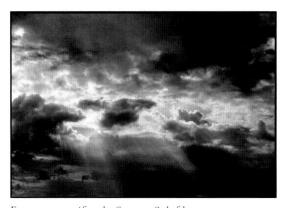

FIGURE 1.53 *After the Contrast Only filter*

21. Click on the disclosure triangle for the Loupe and Histogram located in the bottom right corner of the dialog box to reveal the Loupe and Histogram, and click on the Histogram section. This will change the view from the Loupe to the Histogram. Move the Protect Shadows to 50% and the Protect Highlights to 65%. (See the sidebar: *How Protect Shadows and Highlights Works* later in this Chapter.) If you look closely at the histogram, you can see where you are working, what you are doing, and how you are protecting the shadows and highlights (**Figure 1.51**).

22. Save the file.

Figures 1.52 and **1.53** show the image before and after using the Contrast Only filter.

NOTE: I arrived at these numbers by trial and error and by having the ability to "re-bake the cake" and undo what I had done, because the Contrast Only layer is a Smart Filter. This allows me to go to an extreme correction and, if need be, retreat until I have a usable value. This is the case with both contrast approaches. You have the ability to selectively brush contrast out or in by using a layer mask and you can further dial in the effect you want by using layer opacity.

The Protect Shadows and Protect Highlights sliders help you protect image details at both ends of the tonal range (from pure white with no texture to pure black with no detail) (**Figure 1.54**). The controls take advantage of the TrueLight function in Color Efex Pro 4. The Protect Shadows and Highlights section displays one slider for protecting shadows and one for protecting highlights. As you click and drag either slider to the right or left to increase or decrease protection, notice the change in the image's details. A histogram representing the full tonal range of the active image after the current enhancement has been applied can be found in the Loupe and Histogram section of the dialog box. The histogram changes in real time as you adjust the filter controls and Protect Shadows/ Protect Highlights sliders. The top and bottom 2.5% of tonal values represent Shadows without Detail on the left and Highlights without Detail on the right. The next 2.5% of the shadows and highlights (indicating Shadows with Detail on the left and Highlights with Detail on the right) appear in green. Connected to each of the four colored areas (Shadows without Detail, Shadows with Detail, Highlights without Detail, and Highlights with Detail) are numerical call-outs displaying the percentage of pixels from the active image that exist in each of those four areas after the enhancement has been applied.

Use the Protect Shadows and Protect Highlights sliders to keep the greater part of the image between the green areas (Shadows with Detail and Highlights with Detail) of the histogram. Portions of the image in Shadows without Detail will likely print pure black; those in Highlights without Detail will likely print as paper white. Click and drag the Protect Shadows slider to the right to adjust the filter's effect and prevent details from being moved into the Shadows without Detail area. Click and drag the Protect Highlights slider to the right to adjust the filter's effect and prevent details from being blown out or being moved into the Highlights without Detail area.

NOTE: In general, it is best to maintain the histogram in the region between the Shadows with Details and the Highlights with Details sections. Nevertheless, many good images have spectral values in those areas of the histogram (e.g., highlights on a chrome bumper).

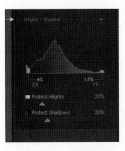

FIGURE 1.54 *The Protect Shadows and Highlights tool*

Believing Is Seeing: The Way the Eye "Sees" What it Saw

Wherever there is light, one can photograph.

—Alfred Stieglitz

As I discussed at some length throughout the book *Welcome to Oz 2.0*, the human eye sees in a predictable manner. The photographer must decide what journey the viewer's eye will take through his/her image because controlling that journey can strongly influence the viewer's perception. I have come to believe that there are two types of eyes at play: the unconscious one that sees the image, and the conscious one that interprets the story that the unconscious eye sees.

Seeing: The Unconscious Eye

The tricks of today are the truths of tomorrow!

—Man Ray

To best understand how to control the journey of the unconscious human eye through an image, you first have to understand some of the biomechanics of how the eye sees. The human eye is always in a seek mode; it tends to wander rather than to look at any one thing for very long. One of your goals should be to create an image at which the human eye is compelled to linger in order to short circuit its wandering tendencies. The longer the eye looks at your image, the more likely you are to convey to the viewer the emotion that you felt when you captured it, and, therefore, the more likely it will be that the viewer will consider purchasing your image if it is for sale. The purchaser then displays your work to others because it stirred an emotional response in him/her, regardless of whether or not it is the identical response that you had.

Oscar Wilde said, "Amateurs speak in terms of art. Artists speak in terms of money." The primary reason that I create an image, from the moment of capture to the final print, is for my own edification and pleasure, but I also hope to sell what I create. I believe that if your image pleases you, it will please others who share your sense of the aesthetic and, the more visually compelling it is, the more likely it will be that your viewer will be compelled to transplant a cemetery of dead patriots from their wallet into yours.

If your goal is artistic and monetary, how do you get the viewer's unconscious eye to stay locked onto your photograph so that their conscious eye can see into it? The answer lies in understanding how the biological mechanism that is the unconscious eye sees; what attracts it and how you can cause it to move through your photograph.

Briefly, this is how the human eye "sees." The eye moves from patterns that it recognizes first: from light to dark, high contrast to low contrast (for a full description of contrast, see the sidebar: *Terms of Engagement* at the beginning of this chapter), high sharpness (see note below) to low sharpness, in focus to blur (which is different than high to low sharpness), and from high saturation of color to low saturation of color. The eye tends to see warm colors as bright and moving forward in an image and cool colors as less bright and receding. If you think about each of these statements, they describe the propensity of the eye to track subjects based on contrast.

NOTE: Sharpening (performed with a technique called unsharp mask in Photoshop and most image editing programs) refers to the increase of apparent edge contrast by increasing contrast on either side of the pixels' edges. In this way, contrast and sharpness are related. It is worth noting, however, that contrast is normally spoken of on a global scale, and sharpness is highly localized. When an image is sharpened using Unsharp Mask, nothing is actually sharpened. What is created is a visually appealing artifact that gives an illusion of sharpness.

The technique of Unsharp Mask is an old darkroom printing technique developed in the 1930s. Its actual name is the Craik-O'Brien-Cornsweet Edge illusion, or the Cornsweet edge for short. According to the Journal of Neuroscience, a Cornsweet edge is created "by increasing the apparent edge contrast of an image by adjusting through a blurred copy of the image."

The human eye is frequently compared to a camera, but it is so much more. The human eye is an optical biological device that has the ability to record time and motion. A still camera can record only fractions of time and, therefore, stops motion with stillness.

FIGURE 1.55 *Diagram of the human eye*

The human eye is roughly a sphere. (It is actually a fused, two-piece unit.) It is completely light-tight except for one opening at the front of the eye; the pupil. The amount of light that is allowed in is controlled by the iris, which opens in low light and closes in bright light. You are able to focus on what you see because the ciliary muscle (which completely surrounds the lens) is capable of changing the shape of the lens so quickly that (in a completely normal eye) everything that you look at appears to be in focus from near to far. Images are projected onto the retina (a light sensitive tissue lining the inner surface of the back of the eye), upside down and backwards. This reversed image is then translated into electric impulses that are sent to the brain to be interpreted (**Figure 1.55**).

The human eye has a dynamic range that is equivalent to approximately 30 f/stops; considerably more than film or digital cameras can achieve. This extraordinary dynamic range is achieved through a combination of the physical properties of the human eye. First, there is the iris, which can expand from 8 mm (when wide open) to 2 mm when closed. This alone is the equivalent of four f/stops.

NOTE: Dynamic range in photography describes the ratio between the maximum (lightest) and minimum (darkest) measurable light intensities.

The answer to how the human eye makes up for the remaining 26 f/stops is found in the two photoreceptor cells (the rods and cones) that are present in the retina. Rods respond to low light and cones respond to bright light accounting for a range of about six f/stops. The remaining range of 20 f/stops is achieved because the sensitivity of both the rods and cones is increased or decreased by the production or degradation of pigments inside those cells. Thus, you arrive at a dynamic range for the human eye that is equivalent to approximately 30 f/stops.

Because all rods are highly specialized for low-light sensitivity, they are used mainly for night vision. While there is only one type of rod, there are three types of cones. Each of these produces a different kind of pigment sensitized to different wavelengths of light. When there is adequate light intensity, humans have color vision, not unlike the way that red, green, and blue color receptors on a DSLR sensor create a color image.

Believing: The Conscious Eye

Photography, as we all know, is not real at all. It is an illusion of reality with which we create our own private world.

—Arnold Newman

Even after you have some small understanding of how the eye sees what it saw, how does that translate into identifying, classifying, and analyzing what you see and believing it is the truth? If you allow me a severe over-simplification, the human eye is not unlike a camera, and the brain is not unlike a high speed, image-processing computer. Together they make up the hardware of the human visual system. The eye merely transforms the light that impinges on its retina into an upside-down, backward image converted into electric impulses in the rods and cones. It is not until those impulses travel down the optic nerve and into the visual cortex, that the first part of the interpreting process occurs. In this part of the brain, determinations about edge definition and what is light and dark are formed. Then those determinations are translated into simple shapes.

After this, the data moves to the parietal lobe and cerebral cortex of the brain where it is compared to previously stored information so that faces and objects can be separated from the background and recognized. Then, the resulting information is moved to the temporal lobe, where a meaning is assigned to what we have seen and names can be given to faces and objects. From there, all of this is moved to the frontal lobe, where feelings are added and, finally, to the prefrontal lobe, where decisions are made about doing or saying something based on what our eyes have just seen.

This means that what we believe we see is not based simply on what the eye saw; it is the raw data of the eye interpreted by the brain. So, in a sense, seeing is not believing; rather believing happens after we see.

This, in turn, brings up many questions, one of which is, "What seems most rational; creating images based solely on the rules of composition or based on the mechanics of how the eye sees and our brain interprets that information?" One could argue that rules of composition are an attempt to describe the reasons why certain images are more successful than others. Over the years, however, these rules have become the dogma that we use to tell ourselves what we should and should not do when we create. But I do not pause before I click the shutter and say to myself, "Self, I think I will use Grecian Mean composition, the rule of thirds, and not fill the center of the frame." I just capture an image that moves me. But I already have an understanding of how the eye tracks and how the mind creates understanding from what the eye sees, and I believe that this knowledge makes my image captures more successful than they would be if I did not have that understanding. And that is what I wish for you.

Every choice that has gone into making the images in this book to this point, and every choice that will be made hereafter, is made from this perspective. If you have an image that you feel is worthy of all the effort needed to convert it into a chromatic grayscale, it is control of how the viewer's eye will move through the image that needs to move your hand as you craft that image.

The Black and White About Light and Dark

The science fiction author Sir Terry Pratchett said, "However fast light travels, the darkness always gets there first and is waiting for it." The photographer W. Eugene Smith said, "In music I still prefer the minor key, and in printing I like the light coming from the dark. I like pictures that surmount the darkness, and many of my photographs are that way." Those are two different ways of saying that dark is as important to an image as light. It is the understanding and controlling of the relationship between dark and light that results in more successful images.

As we seek to understand and control the relationship of dark to light, we encounter a problem because how we determine the lightness (or brightness) of a surface when we look at it, is still a mystery. When light is reflected off a surface, although the rods and cones on the surface of the retina are sensitive to changes in brightness, the signal that they eventually transmit to the brain does not contain information that would allow us to determine what shade of gray that surface would appear if its color were extracted.

Apparently, much of what we see is an illusion. Although the mountain of knowledge that describes how our visual system works is dwarfed by the one representing what science does not know about it, it is important to understand what little is known and exploit that knowledge to create memorable images and prints that move others.

White's Illusion

I want to show you an example of an illusion called "White's Illusion" that, once understood, can be used to control the viewer's eye.

NOTE: White's Illusion came out of Dr. Michael White's Ph.D. thesis on visual perception.

White's Illusion describes changes in the apparent lightness of mid-grays surrounded by black and white. (This effect also occurs when the grays are replaced by colors.) Dr. White explains that the illusion occurs because, "the mid-gray elements assimilate to the color of the uninterrupted bars at their sides, such that the gray elements in the gray–black test region become darker, while the gray elements in the gray–white test region become lighter." Start by looking at two gray rectangles that have an equal value of red, green, and blue that is 128 or middle gray (**Figures 1.56** and **1.57**).

Both are the same gray and both appear to be the same brightness. This will hold true even when parts of the left rectangle are removed (**Figures 1.58** and **1.59**).

But when horizontal black bars are added to the image, things change (**Figures 1.60** and **1.61**).

The gray rectangles on the left appear to be lighter than before while the gray rectangles on the right appear darker, even though they are the same value of gray. Also, the gray bars to the left appear to be in the foreground and wider than the gray bars on the right that appear to be narrower and in the background. Let me reiterate. Things are not always what they appear to be, but if you learn to manipulate them, you will successfully create illusions that tell the truth of what you feel.

What White's Illusion shows is that by manipulating the darks, lights, and grays in an image, you can change the viewer's perception of it. You can create the illusion of depth, hold the viewer's eye in one place in the image longer than in another, and compel the viewer to look at your image rather than look away.

NOTE: You can download a file showing White's Illusion on the download page for this book.

The point of all of this is to eventually understand how the unconscious and the conscious eye work in concert. Learning some of the unconscious eye's biomechanics and how the conscious eye perceives what the unconscious eye sees, allows you to control the journey that the viewer of your image takes when they look at your image. Also, by comprehending the capabilities and limitations of the eye, you can better know how to create an image that selectively replicates what you saw.

Most importantly, if you understand how the eye sees and perceives, you start the journey toward understanding why black-and-white photographs (chromatic grayscale in digital) are so emotionally powerful. In very low to almost-no-light situations, we see only in black-and-white instead of color. So when we look at a black-and-white photograph in the bright light of day with our full color vision, there is a part of us that knows that we should not be able to do that. It captures and holds our attention because of this and gives us time to become emotionally involved with the image.

Lastly, it should now be crystal clear that everything you do to an image, every step of the way, is about maximizing your control of the viewer's eye and preserving all of the capture's image structures so that you can best express that moment of capture in the image that others see.

FIGURE 1.56 *The grey rectangles and the four sample points*

FIGURE 1.58 *The grey rectangle with part of the left rectangle removed*

FIGURE 1.60 *The grey rectangle with parts of the left rectangle removed and black horizontal bars added*

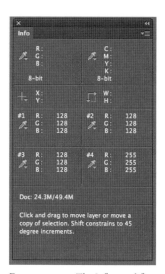

FIGURE 1.57 *The Info panel for just the gray bars*

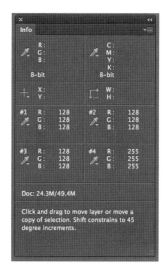

FIGURE 1.59 *The Info panel after removing part of the left rectangle*

FIGURE 1.61 *The Info panel after black horizontal bars are added*

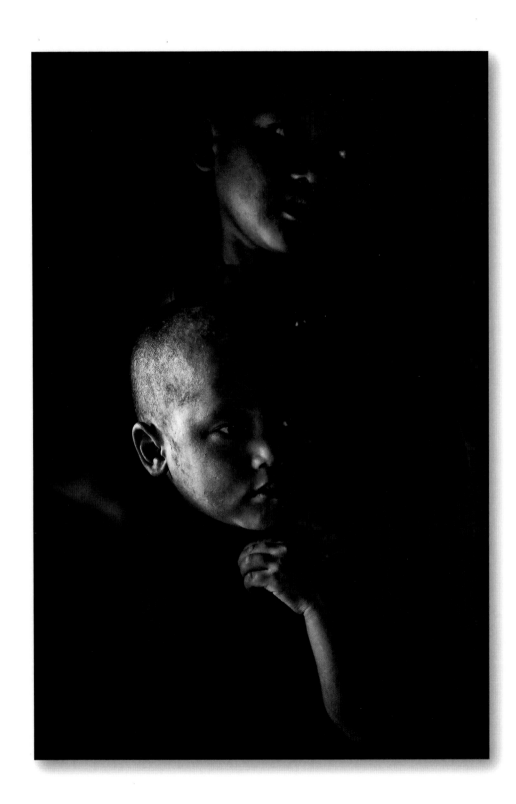

Variations on a Theme

The Power of Hue: The Black and White on the Film and Filter Approach

The enemy of photography is the convention, the fixed rules of "how to do." The salvation of photography comes from the experiment.

—Laszlo Moholy-Nagy

Film and Filter:
Three Approaches

In this chapter, I would like you to think about the full spectrum of colors in your image file as sheet music that, when converted into a chromatic grayscale symphony, will emotionally move your viewers. Also, think about creating an interesting, simple plainness; one with no more or less than the image requires to express what moved you. But, you may be beginning to see that an interesting plainness is a difficult thing to achieve. You may also be beginning to see that there is nothing simple or plain about a file that you choose to convert into chromatic grayscale or the choices that you make when creating what will appear to be an interesting plainness.

Little if anything about making a truly memorable black-and-white photograph is black and white. Things that you think you would never do are sometimes your best option, and what you think is the best may turn out to be no option at all. In other words, there are lots of gray areas in your black-and-white conversion process as you are about to observe in the next series of lessons that make up this chapter.

Approach One: The Classic Film and Filter

The combination of experience and experimentation will ultimately yield a personal sound.

—Mark White

You have been working with the removal of color and addressing issues of contrast. Now it is time for you to start working with the formula to mix color. In the digital world (the world of image sensors, LCD monitors, and inkjet printers), if your eye can see it, it is a color. Gray and white are colors, and black is the queen of all colors. Black-and-white film, as I have discussed, records colors as shades of gray. You must keep this in mind when you try to replicate the kind of black-and-white images with which you may have fallen in love. Those images were recorded on film and printed on silver paper, but you can realize your vision and express your voice in a chromatic grayscale, digitally-created print.

The first of the three ways to approach what is reffered to as a "Film and Filter" conversion is yet another variation of the desaturation approach. Because this approach is best explained using an image with more color components than the previous two images had, you will use an image of the actress Challen Cates (**Figure 2.1**).

NOTE: You will also use this image to compare several other conversion processes.

This first technique was created by Adobe's Russell Brown. The technique uses, not one, but two Hue/Saturation adjustment layers and the Color blend mode. As previously described, blend modes determine how two layers will blend together.

The Color blend mode creates a result color with the luminance of the base color and the Hue/Saturation of the blend color. This preserves the gray levels in the image and is useful for coloring monochrome images and tinting color images. In other words, the Color blend mode preserves the brightness of the bottom layer, while adopting the hue and color of the top layer.

1. Open the File CHALLEN2_.tif (located in the Chapter 2 section of the download page for this book).

2. Select Save As (Command + Shift + S / Control + Shift + S), click on the Create New Folder button (**Figure 2.2**), and name the folder FILM_AND_FILTER. Then, rename the file CHALLEN2_FILM_FILTER, and select the Large Document Format (.psb) file format (**Figure 2.3**) and save it.

FIGURE 2.1 *Challen Cates*

FIGURE 2.2

FIGURE 2.3

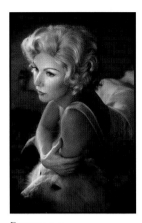

FIGURE 2.5

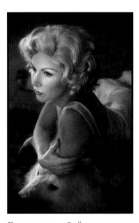

FIGURE 2.7 *Before*

FIGURE 2.4 *Setting the blend mode to Color*

FIGURE 2.6 *Moving the Hue slider to -51*

NOTE: If you are running the Film and Filter action, the Duplicate Image dialog box will show "FILM_FILTER" in the naming box. Insert the specific name of your file in front of FILM_FILTER. Notice that the action flattens the duplicated file so that the file size is reduced which speeds the image editing process.

3. Go to the Create Layer Group icon located at the bottom of the Layers panel and click on it to create a new layer group. Name this layer group C_FILM_FILTER.

4. Go to the Adjustment panel (CS4 and above) or the Create New Fill or Adjustment Layer icon (Photoshop version 3 and above) located at the bottom of the Layers panel and create a Hue/Saturation adjustment layer.

5. Set the blend mode to Color (**Figure 2.4**).

6. Name this Hue/Saturation adjustment layer FILTER.

7. Create a second Hue/Saturation adjustment layer and name this layer FILM.

8. Move the Saturation slider completely to the left (–100) and click OK.

The image should look like **Figure 2.5**.

9. Make the FILTER Hue/Saturation adjustment layer active. Click on the Hue slider and move it to the left until you get the desired effect (–51 for this image) (**Figures 2.6, 2.7,** and **2.8**).

10. From the Colors pull-down menu, select Reds (**Figure 2.9**).

11. Click on the Scrubbing slider icon located in the upper left corner of the Hue/Saturation adjustment layer to make it active (**Figure 2.10**).

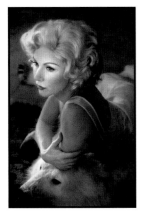

Figure 2.8 *After*

Figure 2.9 *Select Reds*

Figure 2.10 *The Scrubbing slider*

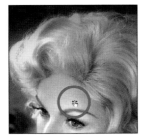

Figure 2.11 *Placing the Scrubbing slider sample point on her forehead*

Figure 2.12 *Increasing the Saturation to +39*

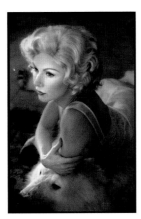

Figure 2.13 *After moving the Scrubbing slider*

12. Place a sample point on an area that you want to adjust, which for this image is Challen's forehead (**Figure 2.11**).

13. Click-drag the Scrubbing slider sample point to the right until you see 39 in the Saturation dialog box (**Figures 2.12** and **2.13**).

14. From the Colors pull-down menu, select Yellows. Click on the Scrubbing slider icon and place the sample point on an area that you want to adjust (Challen's forehead). Set the Saturation to –70 (**Figures 2.14** and **2.15**).

15. Create a master layer (Command + Option + Shift + E / Control + Alt + Shift + E), and name it C_FILM_FILTER.

16. Save the file.

NOTE: You can also move the Hue slider either left or right which allows you to play with all the colors.

Figure 2.14 *The Saturation slider set to -70*

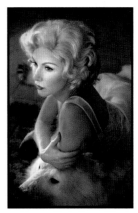

Figure 2.15 *The final image*

Approach Two: Neo-Classic Film and Filter

No amount of experimentation can ever prove me right; a single experiment can prove me wrong.

—Albert Einstein

The main difference in the next variation of the Film and Filter technique and the one that you have just finished is simple, but the effects are profound. Just by changing which of the two Hue/Saturation adjustment layers you convert from the Normal blend mode to the Color blend mode you dramatically affect the image that you create. The idea for changing the blend mode positions came to me during simple experimentation and from asking the question, "If the Color blend mode preserves the brightness of the bottom layer, while adopting the hue and color of the top layer, what happens if the colors of that layer are monochromatic?"

NOTE: To speed this experiment up a bit, you will duplicate the folders that you have already created and change blend modes.

1. Duplicate the C_FILM_FILTER layer group folder. Rename the copy, NC_FILM_FILTER.

2. Turn off (click on the eyeball in the Layers panel) C_FILM_FILTER.

3. Making the NC_FILM_FILTER layer group the active one, open this layer group folder.

4. Change the blend mode of the FILTER Hue/Saturation adjustment layer from Color to Normal.

5. Change the blend mode of the FILM Hue/Saturation adjustment layer from Normal to Color.

6. Create a Master layer (Command + Option + Shift + E / Control + Alt + Shift + E), and name the new layer NC1_FILM_FILTER and save the file.

This is what you should see (**Figures 2.16** and **2.17**).

When you look at two variations of the FILM & FILTER approach (both the chromatic grayscale images and the underlying adjusted color images that produce those grays), this is what you should see (**Figures 2.18, 2.19, 2.20, 2.21,** and **2.22**).

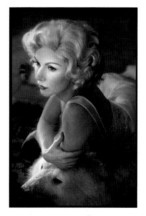

FIGURE 2.16 *Before* FIGURE 2.17 *After*

FIGURE 2.18 *The color image before*

FIGURE 2.19 *The image after Classic Film and Filter*

FIGURE 2.20 *The monochromatic Classic image*

FIGURE 2.21 *The color Neo Classic 1 image*

FIGURE 2.22 *The Monochromatic Neo Classic Film and Filter image*

To better understand what occurs when you change the position or order of the layers or change blends modes from Normal to Color, look at what happens when you boost the saturation of the Reds and Yellows in the image (**Figures 2.23, 2.24, 2.25, 2.26, 2.27,** and **2.28**).

FIGURE 2.23 *Classic Film and Filter approach with the Reds saturation slider and Yellows saturation slider at 100%*

FIGURE 2.24 *The image with the Black-and-White Monochromatic Classic Film and Filter applied*

FIGURE 2.25 *The Neo Classic Film and Filter image Reds saturation slider and Yellows saturation slider at 100%*

FIGURE 2.26 *The Black-and-White Monochromatic Neo Classic Film and Filter image*

FIGURE 2.27 *Closeup of Classic Film and Filter conversion*

FIGURE 2.28 *Closeup of Neo Classic Film and Filter conversion*

Approach Three: Neo-Neo-Classic Film and Filter– Yet Another Variation on a Theme

Using a Layer of Black, White, or Gray and the Color Blend Mode to Create a Chromatic Grayscale Image

Change is inevitable—except from a vending machine.

—Robert C. Gallagher

If the Color blend mode preserves the brightness of the bottom layer, while adopting the hue and color of the top layer, and if the Lighten blend mode takes the lightest pixel from each layer, and if Normal blend simply takes each pixel from the top layer if present, you should be able to create a layer, fill it with a color that has equal amounts of RGB (anywhere between R=0, G=0, B=0 to R=255, G=255, B=255) and create a grayscale image that you can then adjust with a Hue/Saturation adjustment layer. You should also be able to add a tint to the image (to create a warm or cool tone) exactly the same way. Because you can change contrast with Curves adjustment layers and can lighten the image with blend modes, you should also be able increase the contrast and lighten an image at the same time.

1. Open the file LIZZET2_.tif.

NOTE: This image of the actress Lizzet Lopez was originally created for the Acme Educational Nikon Capture NX 2 tutorial. It was lit with a work lamp purchased at a local home improvement store, two daylight balanced 100 watt florescent bulbs, and a Westcott silver/gold reflector to shape the light. This was the first time that I worked on this image in Photoshop, and because the Capture NX2 workflow is different from Photoshop's, it felt totally new.

2. Select Save As (Command + Shift + S / Control + Shift + S).

3. When the Save As dialog box appears, change the file's name to LIZZET_COLOR_MODE_BW.

4. Save the file as a Photoshop Large File Format Document (.psb) and save it to the FILM_FILTER folder that you created in the previous lesson.

NOTE: A .psb file allows for files larger than 2 GB to be saved, while a .psd file does not allow for files to be larger than 2 GB. In order to ensure yourself an exit strategy and so you can keep all of your edits in one file, you will want a file type that can support any size file. This is why I choose to save my images as .psb files. Also, when it comes to workflow, when I see .psd, I know that I have a file with print-specific corrections. When I see a .psb, I know that it is a working file that contains many layers; it is not a printing file. When I see a Tiff, if it does not have a paper size like LIZZET_13x19, which tells me this is a printing file for 13" x 19", I know that this is an intermediate file from my RAW processor (that for me is Capture NX2). I do all of this so that when I look at any file name, I understand the capabilities of that file.

5. Create a new layer (Command + Shift + N / Control + Shift + N), and set this layer to the Color blend mode. Duplicate the layer two times (Command + J / Control + J).

FIGURE 2.29 *Chromatic grayscale image*

FIGURE 2.30 *Adjusting the Hue/Saturation*

FIGURE 2.31 *The image after*

FIGURE 2.32 *The Reds dialog box*

6. Fill the top-most layer with white and rename this layer WHITE_COLOR_BM. Fill the middle layer with 50% gray and rename this layer GRAY_COLOR_BM. Fill the bottom layer with black and rename this layer BLACK_COLOR_BM. (You do this by going to Edit > Fill and in the Contents portion of the Fill dialog, select the respective fill colors for each layer.)

NOTE: Turn all three of the Color blend modes off and on separately and in combination to see what happens. Once done, discard any two of the layers. (I usually keep the white one.) You do not need them and they only increase the file size.

Also, there is an action that creates just the WHITE_COLOR_BM layer.

What you should see is a chromatic grayscale image. No matter which of the three layers you make active or turn on or off, as long as one of them is turned on, the image will be a grayscale one (**Figure 2.29**).

7. Make the background layer active and create a Hue/Saturation adjustment layer. Name this adjustment layer FILTER_NORM (for Filter Normal blend mode).

That there is not much visual drama in the model's face is a significant issue. The next steps will address that issue.

8. Adjust the Hue until it is visually appealing. The left side of the image needs more depth, so set the Hue in the main or Master part of the dialog box to −95 and the Saturation slider to +41 (**Figures 2.30 and 2.31**).

9. Select the Reds (Command + Option + 3 / Control + Alt + 3) and fine-tune the red's saturation by moving the saturation slider to +17 (**Figure 2.32**).

10. Next, select the Yellows (Command + Option + 4 / Control + Alt + 4) and fine-tune the yellow's saturation by moving the saturation slider to −41 and the Lightness slider to −39 (**Figure 2.33**).

You have added depth to the image by changing the image's Hue/Saturations (**Figures 2.34, 2.35,** and **2.36**).

FIGURE 2.33 *The Yellows dialog box*

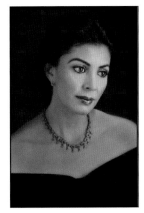

FIGURE 2.34 *Before*

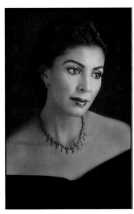

FIGURE 2.35 *After*

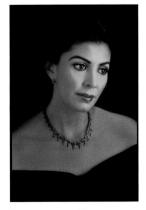

FIGURE 2.36 *The image without the WHITE_COLOR_BM layer active*

Creating a Finer Tune

It is time to further refine this image through the use of selective contrast, as well as selective brightness contrast. Specifically, you will use the layer masks of the adjustment layers.

As I discussed at great length in my book *Welcome to Oz 2.0*, the human eye scans a scene in a predictable sequence. It goes first to patterns it recognizes, then moves from areas of light to dark, high contrast to low contrast, high sharpness to low sharpness, in focus to blur (which is different than high to low sharpness), and high color saturation to low.

In order to make the viewer's eye move across the image in a way that you decide it should so that the image will be seen in the same way you did, you must manipulate the light and dark areas, their contrast, their sharpness, their degree of focus or blur, and their color saturation. This is what you will do in these next steps.

Once you have created the desired look, you will add a warm tone to the final image. Remember, no matter what you do, layer order matters. (Everything dovetails into everything else.)

Lightening with Contrast: Using Curves and Blend Modes

There is value in knowing how to increase contrast using only Curves adjustment layers as well as knowing how to create contrast using the Nik Software Contrast Only plug-in that comes free with this book, so I will give you directions to do both.

11. Create a Layer group and name it L2D_CONTRASTS.

12. Create a Curves adjustment layer, and name it L2D_CONTRAST_SCREEN (L2D = Light to Dark). Select the Screen blend mode.

NOTE: As I discussed earlier, the Screen blend mode looks at each channel's color information and multiplies the inverse of the blend and base colors. The resultant color is always lighter.

FIGURE 2.37 *Before Strong Contrast*

FIGURE 2.38 *After Strong Contrast*

FIGURE 2.39 *Image map*

13. Select Strong Contrast from the Curves presets (**Figures 2.37** and **2.38**).

NOTE: There is an action for doing this in the OZ_POWER_TOOLS action set.

14. Fill the layer mask with black.

You are now going to do selective brushwork to guide the viewer's eye through the image. The journey you want the eye to take in this image is as follows: from the center part of Lizzet's face, to her whole face, and then to her body. The viewer's eye is controlled best by selectively increasing the brightness (or lightness), contrast, and sharpness in the areas that you want that viewer's eye to see first.

In this image, you will be working with brightness and contrast. This is an image map of the areas on which you will be doing brushwork (**Figure 2.39**).

NOTE: The numbers in the image maps are not absolute values. They are meant merely as notations so that you know how to proceed. The concept of image mapping was covered in Chapter 1 of *Welcome to Oz 2.0* and there is a QuickTime movie on the download site for this book that shows you how to create one.

15. Making sure that the foreground color is white and the background black (because you always paint with the foreground color) select the Brush tool (keyboard command B). Set the brush opacity at 50% (see the sidebar: *The Power of 50%* in this chapter) at a brush size of 400 pixels. Brush in the model's face, ears, and shoulders. Bring up the Fade Effect dialog box (Command + Shift + F / Control + Shift + F) and reduce the opacity to 23% (**Figures 2.40, 2.41, 2.42,** and **2.43**).

FIGURE 2.40 *Layer mask before Fade effect*

FIGURE 2.41 *The Fade effect dialog box*

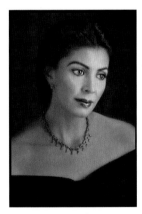

FIGURE 2.42 *After the brushwork*

FIGURE 2.43 *The layer mask after the Fade effect*

16. Keeping a brush width of 400 pixels and 50% opacity, brush the center part of Lizzet's face. Next, brush in the front of her chest, bring up the Fade Effect dialog box (Command + Shift + F / Control + Shift + F) and reduce the opacity to 23% (**Figures 2.44, 2.45,** and **2.46**).

17. Turn off the L2D_CONTRAST_SCREEN.

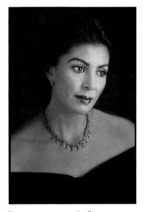

FIGURE 2.44 *Before brushwork*

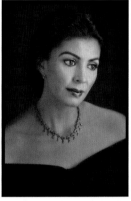

FIGURE 2.45 *After brushwork*

FIGURE 2.46 *Final layer mask*

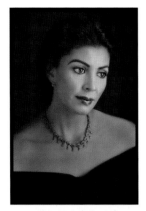

FIGURE 2.47 *Before*

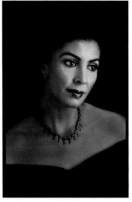

FIGURE 2.48 *After the Strong Contrast*

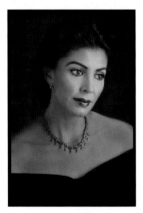

FIGURE 2.49 *Before*

FIGURE 2.50 *Layer mask*

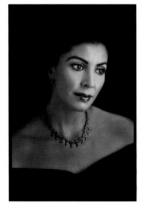

FIGURE 2.51 *After*

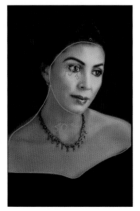

FIGURE 2.52 *Image map*

NOTE: You are turning this layer off so that you can make an informed decision about each type of contrast on its own merits without your last correction affecting what you are doing.

18. Create a Curves adjustment layer, and name it CONTRAST_NORM. From the Curves presets, select Strong Contrast (**Figures 2.47** and **2.48**).

You filled the L2D_CONTRAST_SCREEN layer with black so that you could add brightness to the image, and because you wanted only a specific area to be lit. (See the sidebar: *Unmasking Layer Masks and the 80/20 Rule.*)

In this next series of steps, because you will darken most of the image, you will paint on the L2D_CONTRAST_NORM layer's layer mask with black on white in order to hold back some of the darkening effect.

19. Leave the layer mask white.

20. Making sure that the foreground color is black and the background color is white, and with the Brush tool (keyboard command B) still selected, set the brush opacity at 50% and the brush size to 400 pixels. Brush in the model's face, neck, and a small area of her shoulders just outside of her necklace. Bring up the Fade Effect dialog box (Command + Shift + F / Control + Shift + F) and reduce the opacity to 33% (**Figures 2.49, 2.50, 2.51,** and **2.52**).

21. Keeping a brush width of 400 pixels and a brush opacity of 50%, brush the center part of her face. Leave the opacity at 50% (**Figures 2.53** and **2.54**).

You have made changes based on how you want the viewer's eye to journey through the image. Now, it is time to blend or "chord" the changes that you made to the L2D_CONTRAST_NORM layer with those that you made to the L2D_CONTRAST_SCREEN layer.

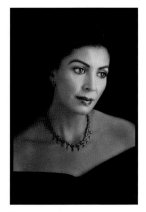

FIGURE 2.53 *After*

FIGURE 2.54 *Layer mask*

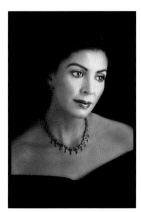

FIGURE 2.55 *Before*

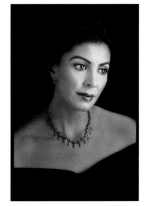

FIGURE 2.56 *After*

FIGURE 2.57 *Before*

FIGURE 2.58 *After*

Chording is a term that is sometimes used in retouching, and it refers to the interplay among different layers. In music, it is like the interplay of notes in a chord; several notes making up a harmonic sound.

22. Turn the L2D_CONTRAST_SCREEN layer on, and observe what the image looks like with the L2D_CONTRAST_SCREEN layer both below the CONTRAST_NORM and above it. Notice that when CONTRAST_NORM is above L2D_CONTRAST_SCREEN, the image is lighter than when the order is reversed.

I think that this image looks better when the L2D_CONTRAST_SCREEN layer is below the CONTRAST_NORM layer, because you are using the Screen blend mode layer to brighten. (Remember to be open to change. What you anticipate and reality may be different.) Now, you will further fine-tune this image by reducing the layer opacity of each of the contrast layers that you just created. This is so that they blend or chord so that the two layers work together harmoniously. Also, by working this way, you better control the cumulative and multiplicative aspects of artifacting in your image.

23. Start by lowering the opacity of the CONTRAST_NORM layer until you have some detail back in the model's hair. I chose an opacity of 49% (**Figures 2.55** and **2.56**).

24. Make the L2D_CONTRAST_SCREEN layer active and reduce the opacity until you have the desired effect at 67% (**Figures 2.57** and **2.58**).

25. Turn off the WHITE_COLOR_BM layer.

26. Create a Master layer (Command + Option + Shift + E / Control + Alt + Shift + E). Name this L2D_CONTRASTS and turn off the L2D_CONTRASTS layer group.

Layer masks are a powerful Photoshop tool and an important way to control the aesthetics of an image. A layer mask works by allowing you to completely or partially hide or reveal filter effects, adjustment layer corrections, or anything else that you want to selectively control.

The best way to remember how to work on a layer mask is by remembering this simple mnemonic: "Black conceals and white reveals." That means that black will block the visibility of the effect that you are creating, whereas white will allow the effect to be visible.

A good way to ensure an efficient workflow is to use what is referred to as the "80/20 rule." If you want to reveal 80% and conceal 20% of the layer, create a white mask and paint with black to conceal. If you want to conceal 80% and reveal 20%, start with a black mask and paint the areas that you want to reveal with white.

Since you are working in grayscale when you are working on a layer mask, varying the levels of black or white opacity determines how much of the effect on that layer you will allow to be seen. In other words, if you are working on a white layer mask, the darker the gray, the less that is revealed, and when you are working on a black layer mask, the lighter the gray, the more that is revealed.

0521 Rule

I have found that there is a relationship between 100%, 50%, 25% and 10% opacity. The 0521 rule is based on this observation. The way the rule works is this: 50% of 50% is 25%. So if you are working at 50% opacity, and you want to increase the effect of the thing on which you are working, you will generally want to increase it about 25%.

In the same way, 20% of 20% is 4%. So if you are working at 20%, you will want to increase the effect about 4%. And if you want a little more, then 20% of 24% is approximately 5%, and so on. The keyboard command for changing the opacity of a brush is: 100% opacity is 0, 50% is 5, 20% is 2, and 10% is 1.

Being in Two Places at Once

What follows is a way to have both the image on which you are working and the layer mask of that image visible at full size on the screen at the same time.

Go to Window > Arrange > and select the New Window for (image name) from the bottom of the menu to open a new window of the same image that is "live." After each stroke, that window will be updated so that you can see the effect of each change that you make.

Put the two images side by side (or if you use dual monitors, put one image on each monitor), and Option-click / Alt-click on the layer mask of whichever of the images has the layer mask that you want to show.

Once you have a layer mask, this is the way to have one that has no missed areas or unwanted overlaps.

When you are working on a layer mask, you are working in grayscale. This means that when you change the opacity of white or black (depending on whether you are revealing or concealing), you are changing the density of the color with which you are working. That change in density manifests itself as shades of gray on the layer mask.

When you are working with opacity on a layer mask, you might miss an area. Because brushing is cumulative, it is almost impossible to match up the areas that you missed with the areas that you did not. Rather than try the conventional approach to brushing, treat the layer mask as a color, the color gray.

Approach 1: Make the layer mask visible at full screen (see the section: *Being in Two Places at Once* in the previous sidebar), and make the layer mask active. Select the Brush tool and set the brush opacity at 100%. Option-click / Alt-click on the area that you want to sample (the Option / Alt key brings up the sample tool eyedropper when you are in the Brush tool), and brush over the area that you missed or in which you have an unwanted overlap. (Remember, you are painting with gray.)

Approach 2: Set the brush opacity to 100%. Option-click / Alt-click on the area that you want to sample. Select the Polygonal Lasso tool. (The keyboard command is the letter L. If you want to scroll through any tool, hold down the Shift key and click on the tool's letter until the desired tool appears.) Click around the area and, when you have the desired area selected, Option + Delete / Alt + Backspace to fill that area with the foreground color. Examine **Figures 2.59** and **2.60** for a visual representation of the correction.

FIGURE 2.59 *Before correcting the layer mask*

FIGURE 2.60 *After correcting the layer mask*

27. Turn on the WHITE_COLOR_BM layer.

NOTE: You turn off the WHITE_COLOR_BM layer, because when you create a master layer, Photoshop combines *all* **the layers that are turned on, both below and above the layer into which you are merging them.**

NOTE: This book comes with five free plug-ins from the Nik Software Color Efex Pro 4 plug-in suite. They are Contrast Only, Skylight, Tonal Contrast, Color Stylizer, and Paper Toner. You can download a QuickTime tutorial from the download site for details on how all five plug-ins work.

Also, before moving on to the next section, be sure to have the Color Efex Pro 4 Promo Edition 5 plug-ins installed.

The Power of 50%

There are three primary things to remember when working with opacity and layer masks. 1) The scale for working on a brush is 0% to 100%. 2) Whenever you do brushwork on a layer, the desired outcome of that brushwork is either going to be more or less than 50%, or exactly 50%. 3) There is no way you can precisely know what the percentage is going to be for you to get the desired effect. You need to use your eye to dial in the exact amount you desire. The key is to use the Fade effect command (Command + Shift + F / Control + Shift + F).

NOTE: This approach was created by John Paul Caponigro and it has saved me hundreds of hours of work.

Lightening with Contrasts Using Nik Software Contrast Only and Blend Modes

Next, you are going to use the Nik Software's Contrast Only filter to create contrast. When you are finished, you will see if chording these two approaches (the one you just did with the two Curves adjustment layers and blend modes with the one that you are about to do) makes for a more interesting image.

28. Make the Background layer active and, beneath the FILM adjustment layer, create a layer group and name it L2D_NIK_CONTRASTS.

In Step 28, you created a layer group because, in Step 29, you will begin working with layers that contain pixels. (As you will see throughout the course of this book, layer order is extremely important when you are working on a chromatic grayscale image.)

Notice that the FILM adjustment layer has seriously shifted the color to create a visually appealing chromatic grayscale image. Any adjustments you are going to make with regard to approaching contrast this way, you should do before you make adjustments to the underlying color image. This workflow sequence is important because, even though all of the colors contained in the chromatic grayscale fit into an 8-bit sRGB file, it is the colors that exist in the layers underneath your active layer that influence the visual nuances of your image. Therefore, you want to start with a 16-bit file in the ProPhoto color space. In the simplest of terms, the more colors there are in the image file, the more data there is in the image file. The more data there is in the image file, the more depth and detail, and the less artifacting you will have in your finalized chromatic grayscale images.

29. Duplicate the background layer (Command + J / Control + J) and place it into the L2D_NIK_CONTRASTS layer group folder.

FIGURE 2.61 *The Contrast Only dialog box*

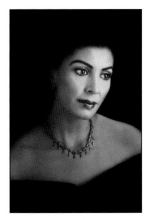

FIGURE 2.62 *After the Contrast Only filter*

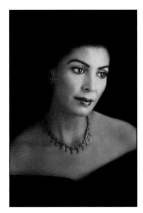

FIGURE 2.63 *Before brushwork*

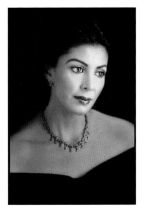

FIGURE 2.64 *After lowering the opacity of NIK_CONTRAST_NORM*

30. Make this layer into a Smart Filter and name it NIK_CONTRAST_NORM.

31. Go to Filter > Nik Software > Color Efex Pro 4 Promo 5 and select Contrast Only from the three filters.

32. Adjust the image until you have the desired effect. I set the Brightness at +21, the Contrast at +44, the Protect Shadows at 27%, and the Protect Highlights at 67%. Click OK (**Figures 2.61** and **2.62**).

33. Add a layer mask.

34. Duplicate the NIK_CONTRAST_NORM layer (Command + J / Control + J) and rename it.

35. Place the L2D_NIK_CONTRAST_SCREEN layer beneath the NIK_CONTRAST_NORM layer.

36. Copy the layer mask from the L2D_CONTRAST_SCREEN layer to the L2D_NIK_CONTRAST_SCREEN. You do this by holding down the Option / Alt key, clicking on the layer mask that you wish to copy, and dragging it into the target layer. When the "Do you want to replace this layer mask?" dialog box comes up, click Yes.

37. Copy the layer mask from the L2D_CONTRAST_SCREEN layer to the L2D_NIK_CONTRAST_SCREEN.

38. Make the NIK_CONTRAST_NORM layer active.

39. Lower the opacity of the NIK_CONTRAST_NORM layer until you have some detail back in the model's hair (at an opacity of 62%) (**Figures 2.63** and **2.64**).

40. Make the NIK_CONTRAST_SCREEN layer active.

41. Lower the opacity of the NIK_CONTRAST_SCREEN layer to 39% or until you have some detail back in her hair (**Figure 2.65**).

42. Turn off the WHITE_COLOR_BM layer.

43. Make the FILTER_NORM layer active.

44. Create a Master layer (Command + Option + Shift + E / Control + Alt + Shift + E). Name this NIK_L2D_CONTRASTS and turn off the NIK_L2D_CONTRASTS layer group.

45. Turn on the WHITE_COLOR_BM layer.

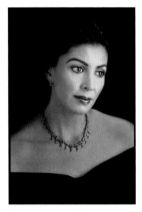

FIGURE 2.65 *After lowering the opacity of NIK_CONTRAST_SCREEN*

Chording Contrasts

As you can see, each approach to manipulating contrast does something different. Before you begin working on an image, you must analyze what about it you like, and then work toward removing everything else. There are things that I like about both the Curves Contrast and the Nik Contrast Only approaches. I like the visual softness of the Curves Contrast and I like the depth of detail and the deep blacks achieved with the Nik Contrast Only approach. So, the goal of this next step is to have both the cake and eat it too—without gaining any weight; something that can happen only in the digital domain.

46. Create a new layer group above the L2D_CONTRASTS layer group and name it CHORDED_CONTRASTS.

47. Drag the L2D_NIK_CONTRASTS Master layer and the L2D_CONTRASTS Master layer into that folder.

Decide which of the two layers contains more of what you want to say. I liked the deep blacks and the detail definition in the L2D_NIK_CONTRASTS master layer, so I made it the lower one.

48. Add a layer mask to the L2D_CONTRASTS Master layer and fill the layer mask with black.

49. Select the Brush tool, set the brush size to 400 pixels, the brush opacity to 50%, the foreground color to white, and the background to black.

50. Brush in the model's hair, face, and shoulders.

51. Rebrush over her face (**Figures 2.66, 2.67, 2.68,** and **2.69**).

52. Fine-tune the image even further by reducing the opacity of the CHORDED_CONTRASTS layer group to 74%.

FIGURE 2.66 *Image map*

FIGURE 2.67 *Layer mask*

53. Make a Master layer and name it FINAL, and save the file.

Examine the image before and after (**Figures 2.70 and 2.71**).

FIGURE 2.70 *Before*

FIGURE 2.71 *After*

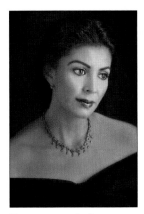

FIGURE 2.68 *Before*

FIGURE 2.69 *After*

Why Knowing This Matters

If you can see it with your eyes, it is a color, and black is the queen of all colors.

—Matisse

At this point, you will have realized that things are not exactly as they appear. At first glance, global desaturation appeared to be absolutely the worst way to create a black-and-white or chromatic gray-scale image. It turns out, however, that sometimes the worst way can be the best way. Not every color image makes a good black-and-white one, and one that plays well in the chromatic grayscale, may sing a completely different and less pleasant tune when viewed in color.

You have seen that changing the blend modes of adjustment layers drastically affects an image, as well as changing the way the adjustment layers behave with regard to the adjustment layers' functionality. In other words, the same numerical color values can create different effects that change the expression of image structure and detail when rendered in the chromatic grayscale. You should now be realizing that everything builds on everything else that you do; that everything dovetails into everything else.

All of the variations on the theme of desaturation that you have just considered represent only the tip of the iceberg that represents all of the methods for creating a chromatic grayscale image. In each step of this lesson, you gathered grains of knowledge. Now, take each of these grains and learn how to create a beach of understanding.

From a Grain of Sand: The Poetry of Being Present

What Is the Shape of a Name?
We are the landscape of all we have seen.

—Isamu Noguchi

Play a game with me for a moment. Say out loud, to no one in particular, "Hi. My name is....." and your full name. Then pause for a moment. This time, again out loud, say, "Hi. My name is Izzy Smith." Unless your name really is Izzy Smith, you should observe a difference in the way those two statements make you feel. It is most likely that the former statement felt comfortable and personal, while the latter felt empty. The difference is that your real name is inhabited by who you are, and the latter is just some words with no meaning to you. This is because your name is your personal icon; the representation of everything you have experienced up to this moment. Think of your name as having a shape that contains everything you have ever said and done, all you have ever seen and felt, and every lesson learned in your life. The shape of your images should contain nothing less.

A Beach Is Made Up of Grains of Sand
Every thing you need to know you will know, when you need to know it if you choose to simply be present at the time you first experience it.

—Tad Z. Danielewski

The impact of Danielewenski's quote requires that you think about what it means to "be present." To me, it means that you approach all experiences with no preconceptions and that you allow yourself to be open to learning at all times. It means realizing that while any lesson may have specific and immediate

significance, it may also have the same or greater significance for things you have yet to experience. It means approaching learning as if it is a giant cloud of knowledge or an infinitely expansive beach of ideas in which things are always in flux.

We need to approach the way we learn the same way we live, poetically and not literally. Poetry is the language of heightened emotion; the form of expression we use when words cannot explain what we feel. Poetry is symbolic; a few words can convey a complex thought. When we express things literally, the words we choose describe a single thought or thing. A poetic approach is expansive, dynamic, and felt within us, while the literal approach, although constructive, is constrictive and static.

But life is dynamic and not static. Life is about the way in which our experiences interact with each other in a nonlinear way, and it is that interaction that results in the poem that is who we are. Just like a beach is made up of grains of sand, every experience we have is a grain that makes up the beach of our lives. They interact and shift, changing the landscape of who we are.

About 4,000 years ago, an Emperor of the Xia Dynasty in China said, "A picture speaks a thousand words." Since I believe this to be true, I then suggest that a photograph is a visual poem, the greatest of which are ones that move us the way the photographer was moved when he or she captured it. I would argue, therefore, that we should approach learning how to express our creativity in the images we create, in the same manner that we approach life, poetically rather than literally.

I think there are two ways to approach learning: literally or granularly and poetically or globally. Traditionally, when we are taught about creativity in photography, we are taught in a granular manner, and not in a global one. We learn to do steps in a set way and sequence to get a prescribed result.

The problem inherent with this approach is that when we learn in a granular way, what we learn tends to be confined to doing things exactly like, or very similar to, the first time that we learned it. Sometimes this leads to techniques being revered as if they were an art form unto themselves. Also, the images that are created by following this path tend to be repetitive.

Eventually, we hit the glass ceiling and gilded cage of photography—the perfection of technique to the point where we create pretty pictures; technically excellent, but sterile in their beauty. We become frustrated with our work and ourselves, and the images that we might create, we do not. We are tourists in the creative world.

Do not misunderstand me. As beginners to anything, we need to learn things in grains of thought. But from the outset of our journey, we need to be open to something more. It is being open and receptive to that something more from the beginning of our granular learning experience that keeps us from experiencing creative stagnation.

If we keep the grains of knowledge within the confines of where and when we learned them, we generate little creative thought. If, however, we allow them to pile up and interact with each other, we come to a more global way of thinking, and perhaps, create an entirely new train of thought. If you allow yourself this level of presence, everything you need to know, you will know when you need to know it.

For example, I teach two techniques for retouching skin. (There are QuickTime videos of these techniques on the download page for this book.) The first is a technique to remove unwanted redness or ruddiness from skin tone, and the second is a way to add texture back to skin once blemishes have been removed by being blurred.

In Chapter Four of my first book, *Welcome to Oz*, pp. 119-120, I wrote about how to diminish contrast or "gray up" an image by clipping a curve to help replicate aspects of the atmospheric haze of light. (You can download a PDF of those pages from the download page for this book.) I use this technique to retouch almost 100% of my color portraits. But I had an image of a yellow orchid that had a green cast, as well as a slightly over-exposed photograph of an actress's face. I found that I could successfully use the same technique that I used for color portraits to remove the green cast from the petals of the orchid and rebuild the blown-out highlights of the actress's face. I now use this technique in almost 100% of my fine art and landscape work, as well as in portraits. I allowed myself to take a piece of knowledge that I knew worked in one instance, and generated a new train of thought.

There is a revolution happening in photography, and we are witnessing it. The digital image allows anyone willing to take it, the pathway to unlimited creativity; a path to a place were impossible is merely an opinion—an opinion held not by the viewer of the image, but by its creator. This means that the photographer's imagination is the only limitation.

Do not focus on technique for technique's sake, but to discover what it means to see rather than to merely look. It is in that direction that you will come full circle and find the creative voice within you. Once you discover that technique is merely a detail, you will be free to create images that will change the world of those who view them.

Become a beach that is ever-changing. Create images that capture the poetic moments of your life, and they will take the viewer of those images, just as those images took you.

I invite you to give yourself permission to become that photographer. We are all waiting to believe with you in what you see.

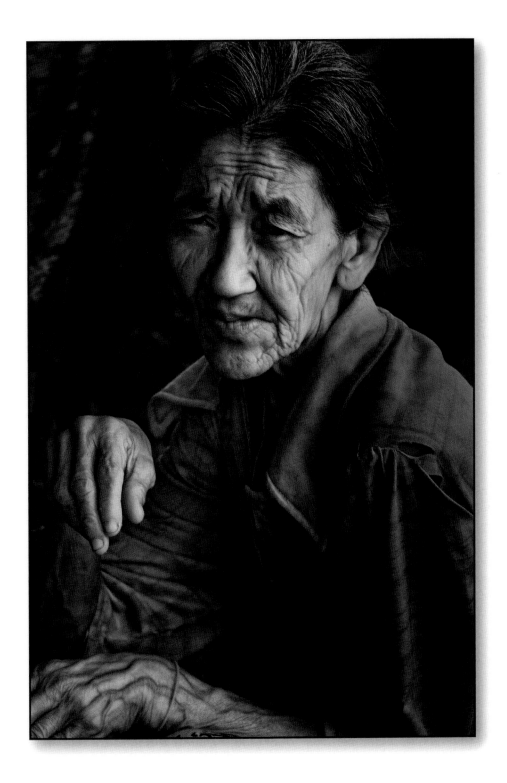

Chapter 3

Defying Logic

The Black and White on Converting to Black-and-White in Camera, Black-and-White Conversion in RAW Processors, and to Grayscale in Photoshop

Belief is the death of intelligence.

—Robert Anton Wilson

The Camera &
the RAW File

The more things change, the more they remain the same.

—Jean-Baptiste Alphonse Karr

Back in the day, which manufacturer of the camera you used did not matter as much as it does today. Camera manufacturers did not make film; they made lenses and camera bodies. They did not concern themselves with what film you used or the chemistry of emulsions and film bases. Their only concern was that the film be manufactured in such a way to fit in the camera. Film was interchangeable. You chose color slide, color negative, black-and-white, infrared, high speed, fine grain, and other film types based on what you needed in the moment. In other words, a camera was just a camera.

Today, things are different. Cameras are built around CMOS or CCD sensors. In a sense, the sensor is the film emulsion, and the file that is produced is the digital negative. You now make buying decisions about a camera not only for the mechanical features you desire, you also purchase a camera based on how the camera records the image. The boon of digital photography is that you have complete and total access to all of the information. The bane of digital photography is that you now have complete and total access to all of the information in the file.

A color file is also a black-and-white file; however, a black–and-white file is not really black-and-white but chromatic grayscale. If you want to shoot infrared (IR), you need to have a camera physically modified and dedicated to shoot just IR. If you need to shoot high ISO, you need to choose a camera—not a film you could put into a camera—to accomplish this. If you want super high resolution, that is yet another camera you will need. Why? Because the sensor is the film, and the camera is the transport device for the sensor.

What has remained the same is this overarching goal: always try to get it right in the camera. What has changed is what that now means. In this chapter, I would like you to think about getting it right in the camera, RAW files, and RAW processors. For some, getting it right in the camera is the start and end of the process; if it is right in the camera, this is the truth that you have captured with the camera, and it is your final product. If you expect more from your captures and shoot RAW files, you have to use some sort of RAW processor. RAW processors are designed to help you get the most of your digital captures (RAW files), and ensure that when you get it close in the camera, you can then make it right. Both the camera and RAW processors are capable of creating chromatic grayscale images—with their own peccadilloes. In the next lessons you will see the possibilities of using in-camera conversions and RAW processor conversions to a chromatic grayscale image.

In Camera Conversion

If you believe as I do that Photoshop is not a verb, but a noun, and that your goal should be to get as much right as possible in the camera, then logically, you should set the camera to capture in black-and-white and be done with it. This is great in theory, but less so in practice. When you set the camera to black-and-white mode, the camera creates a file that has equal values of R, G, and B. That means that there is no difference in grayscale value among the three channels (as you saw in the previous lesson) and that all three channels will be light and dark in exactly the same places. As a tonal reproduction curve goes, all you have recorded is merely luminace. (See sidebar: *Terms of Engagement* in Chapter 1 for a discussion of a tonal reproduction curve.) This means that your file will have all the file size of a full color capture and and none of the interplay among all the colors that is the key ingredient to creating the best possible image. In other words, you have a file that is the same size as the one with which you begain, but with two-thirds of the data missing. In addition, the file is 8-bit and not 16–bit, so the bit depth that is needed to help in the minimization of artifacts during the image editing process leading to conversion from a color image to a chromatic grayscale image is also lost (**Figures 3.1, 3.2, 3.3,** and **3.4**).

NOTE: There is a file that has all of the conversion techniques discussed in this lesson and the previous one. The CH01-03_COMPARE.psb file located in the Chapter 3 section of the download page for this book.

FIGURE 3.1 *RAW digital image*

FIGURE 3.2 *After in-camera conversion*

FIGURE 3.3 *Converted using the Film and Filter technique*

FIGURE 3.4 *Converted using Silver Efex Pro 2 in Photoshop*

Nikon vs. Canon: In-Camera Black-and-White

In the Nikon camera system, you select Monochrome in the Retouch menu, then the Black and White menu in the camera. This creates an image with equal values of R, G, and B and saves this converted image as a JPEG.

In the Canon camera system, the black-and-white mode is in the menu under "Picture Style" and is called "Monochrome." Within that setting are customizable contrast, sharpness, and brightness settings. As with Nikon, this mode creates an image of equal values of R, G, and B and saves the image as a JPEG.

If you shoot in RAW with either Nikon or Canon, you do not lose color data. Simply change the picture style setting back to RGB afterwards, and you will still have the original RAW file (.NEF in Nikon and CR2 in Canon) that you can post-process in Photoshop with all color possibilities. If, however, you set the camera on JPG, then you have baked black-and-white into the file and what is done is done.

The main reason to consider ever using this mode in either camera system is to aid in "learning to see" in black-and-white.

Look at a 16-bit image (in which I have done an Auto Levels adjustment) and its histogram before and after converting from 16-bit to 8-bit. Look also at an 8-bit image (and its histogram) in which I have done the same auto levels adjustment. Note that there is more detail, smoother transitions, and significantly less noise (the 16-bit file). The white gaps in the histogram represent missing information or clipped data (**Figures 3.5, 3.6, 3.7, 3.8, 3.9, 3.10, 3.11, 3.12,** and **3.13**).

As I discussed at great length in *Welcome to Oz 2.0*, artifact creation is cumulative and may be multiplicative. The goal of any fine-art workflow is to develop one that minimizes the cumulative and tries to negate the multiplicative aspects of artifact production. Working in 16-bit and in the ProPhoto color space is a significant step toward achieving this goal.

NOTE: What I have done is for illustrative purposes only. I do not suggest that you ever do this to an image. Also, this image's color is unacceptable after doing an Auto Levels adjustment.

When you compare these images, you will see that there is considerably more image structure to be had from doing the conversion using software rather than doing it in the camera.

FIGURE 3.5 *Before Auto Levels adjustment*

FIGURE 3.6 *16-bit image after Auto Levels adjustment*

FIGURE 3.7 *8-bit image after Auto Levels adjustment*

FIGURE 3.8 *Close-up of the 16-bit image after Auto Levels adjustment*

FIGURE 3.9 *Close-up of the 16-bit image converted to 8-bit*

FIGURE 3.10 *Close-up of 8-bit image after Auto levels adjustment*

FIGURE 3.11 *The histogram of the 16-bit file before Auto Levels adjustment*

FIGURE 3.12 *The histogram of the file after Auto Levels and converted to 8-bit*

FIGURE 3.13 *The histogram of the 8-bit file after Auto Levels adjustment*

Basically, computers know only two things: 1 or 0; on or off. There is no gray; their world is black and white. All images are recorded as a bunch of 1's and 0's. This means that for a one bit image, each pixel will be either pure black or pure white. In the binary world of digital images, the number of tonal values that a pixel can have is equal to 2 raised to the power of the number of bits. For a 1-bit image, the number of levels of gray equals 2^1. To create a continuous tone image, you need to have more than just one bit, so that you can have more choices than $2^1 = 2$. Modern digital cameras record in either 8-bit, 12-bit, or 14-bits with the 12-bit and 14-bit capture being rendered to 16-bits when processed in RAW conversion software. This means that an image that is captured in 8-bit is a file that has 2 to the 8th power (2^8) or 256 levels or "shades" of gray per channel. A 14-bit capture that becomes a 16-bit file during the RAW conversion process, has a 2 to the 16th power (2^{16}) or 65,536 levels or "shades" of gray per channel. An 8-bit, RGB color image will have 256 levels for each color channel or 16,777,216 possible colors, and a 16 bit RGB color image will have 65536 levels for each color channel or 281,474,976,710,656 possible colors.

What this means to your image is that 16-bit files, using a ProPhoto RGB color space, show fewer artifacts because they have the potential for more data. Even though the grayscale aspect of the image can easily be reproduced

in the sRGB color space and in 8-bit, the underlying color image is capable of reproducing significantly more color than can be contained in that space. This is why it is best to work in the ProPhoto color space with its larger number of possible colors. In the ProPhoto RGB color space, you have more information and a greater color range, and that translates into smoother transitions, and less pixilation and banding (**Figures 3.14** and **3.15**).

FIGURE 3.14 *sRGB color space*

FIGURE 3.15 *ProPhoto RGB color space*

In RAW Processor Conversions

The cleanest state the data of your image file will ever be in is in the RAW file that the camera creates at the moment of capture. As soon as you open that file in whatever RAW processor you choose (Lightroom 4, Capture NX2, Aperture 3, etc.) and do anything to it, you are clipping data. And, the instant that you start clipping data from the file is the moment that you start introducing artifacts. All artifacting is cumulative and may be multiplicative, which means that a small amount of artifacting introduced at the beginning of an image's workflow, has the potential of being amplified into something profoundly visible at the end of the workflow.

Therefore, as you work on an image, you want to clip as little of the original source data as possible. If this is true, then one might think that doing one's black-and-white conversions at the RAW file level must be the way to go. Right?

Not quite. It is certainly a way to create a black-and-white image; certainly better than letting the camera do it and certainly acceptable in many cases, but it will never produce optimal results. When it comes to black-and-white, there is considerably more to be squeezed from a file than what can be done with it in the RAW processor.

Also, the conversion from color to chromatic grayscale (black-and-white) is the last thing you want to do to an image before you prepare it for printing. This is because the better defined your image structure, the better your final image will be. Therefore, it is best to retouch a face in a full color image rather than in a black-and-white one. This is true of landscapes and still life images as well.

Lightroom and Adobe Camera Raw (ACR) have extremely similar functions for black-and-white conversion; the function buttons are just in different places, and Lightroom has a cleaner, more elegant user interface (UI). Photoshop CS6 has a black-and-white conversion via the Black & White adjustment layer. (I will discuss this later in this book.)

Lighroom 4, Capture NX2, and Aperture 3 all allow the use of third party plug-ins, but in Lightroom and Aperture, the files must first be converted to a TIFF format. (Only in Capture NX2 can you work directly on RAW data, but there are some plug-ins that Capture NX2 does not allow.) ACR does not allow third party plug-ins, because it is already a plug-in for Photoshop and can be made into a Smart Filter. So when it comes to black-and-white conversion, I suggest that you use Photoshop where you will get the most bang for your buck.

NOTE: Even though there are several more RAW processors available, I will address only ACR and Lighroom 4, because they are the RAW processors with which most people are familiar, and they are available on both Mac and Windows operating systems.

NOTE: Capture NX2 and Aperture 3 information can be found as PDFs on the download site for this book. Aperture 3 is covered as a PDF because it is specific to the Mac operating system. Capture NX2 is covered as a PDF because it only supports Nikon RAW files, and while I'm a Nikon shooter, I wanted the information in this book to be as universal as possible.

To Begin the Beguine

A goal without a method is cruel.

—W. Edwards Deming

Regardless of which of the conversion techniques you use to convert an image from full color to chromatic grayscale, you must first analyze what you want to do with it. In Photoshop, one of the ways to do this is by creating image maps, a series of layers on which you can draw and write so that you can map out your thoughts. These image map layers stay within the file so that your notes are always connected to the image. When you use RAW processors, you must do it with a pad a paper so that your notations are not preserved with the file.

The primary subject of the Multnomah Falls image is the waterfall itself (**Figure 3.16**). Next in importance is the bridge, then the foreground rock face and foliage, and then the background. The great painter, Josef Albers, posited two things. First, that

"shape is the enemy of color," and second, "that patterns are interesting, but patterns interrupted are more interesting." In this part of the lesson, you will explore the use of shape and interruption of pattern to control how the viewer's eye moves through an image, and in so doing, you will see the limitations of trying to work on your images exclusively with RAW processors.

The Multnomah Falls image has a series of vertical patterns with one horizontal pattern. Dark—Light—Dark is the main pattern that you can see. The dark of the trees and rock faces to the right and left of the image are interrupted by the light waterfall in the center. You can see this pattern emerge by: 1) applying a Curves adjustment layer to the image, 2) setting the adjustment layer to the Luminosity blend mode, 3) clicking on the white point anchor (the anchor point located at the upper

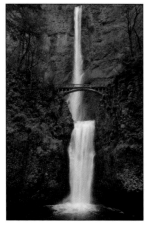

FIGURE 3.16 *The RAW image*

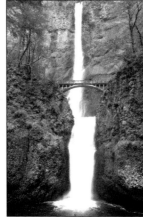

FIGURE 3.17 *After moving the white anchor point*

FIGURE 3.18 *After moving the black anchor point*

right of the Curves dialog box), 4) moving it directly to the center of the vertical axis of the Curves dialog box, 5) clicking on the black anchor point (the anchor point located at the lower left of the Curves dialog box), and 6) moving it directly center to vertical axis of the Curves adjustment layer dialog box (**Figures 3.17** and **3.18**). It is the interruption of the pattern made by the bridge that makes the image more interesting. Without the bridge, it is just another pretty waterfall.

As for every image that you create, your goal should be to control how the viewer's eye tracks through it. The mechanics of how the eye "sees" the image is what will guide the decisions that you will make when editing this image; not some arbitrary rules of composition. The problem inherent in following rules that are supposed to be applicable to every image is that images you might create, you do not, because you believe that you should not.

The first thing to understand about the way the eye "sees" is that it does not want to look at any one thing. It wants to wonder or "retreat," as Josef Albers puts it. The eye works by going first to patterns that it recognizes. It moves from areas of light to dark, high contrast to low contrast, high sharpness to low sharpness, in focus to blur (which is different than high to low sharpness), high saturation of color to low saturation of color, and warm colors appear to move forward in an image, while cool colors appear to recede. Knowing this, you can guide your viewer's eye to travel within your image along a path of your choosing. (See *Welcome to Oz 2.0, Chapter 1.*)

For this image of Multnomah Falls, I wanted the viewer's eye to start its journey at the brightest part of the waterfall, then move up the composition to the upper waterfall, and then see the bridge in relationship to the falls. The viewer then becomes aware of the foliage, and then, the back wall.

If you look at this image in terms of CJ Elfont's Isolate theory, there are light, intermediate (which can be a series of isolates with different brightnesses), and dark isolates. Any one or group of these can be the primary, secondary, or supporting isolates. (The primary isolate is usually light or dark.) The various supporting isolates work in concert to emphasize the primary isolate, and possibly the secondary isolate, and enhance the visual experience for the viewer. (This theory was discussed in Chapter 4 of *Welcome to Oz 2.0, page 228.*)

Since the primary isolate, in this case the waterfall (a light isolate), is bisected by the bridge, the bridge is elevated to the status of secondary supporting isolate because it is the second element of the composition of which the viewer's eye becomes aware. Then, the rest of the composition is made up of supporting isolates that vary from intermediate to dark. In this way, the eye first sees the waterfall, and then travels directly to the bridge to complete those parts of the composition that have the most impact. Then, as the viewer becomes more involved with the composition, he/she begins to appreciate the nuances created by the supporting isolates; the flora and the rock wall. The viewer's eye is kept within the composition because the isolate flow continually draws the eye into the image. Thus, all parts of the composition are essential to one another and allow it to communicate what the photographer felt at the moment of capture.

You should never forget that the tonal range brightness values, in concert with one another, create the ideal composition, such that the viewer sees the primary isolate first, the secondary next, and then the supporting isolates.

Now that you have an idea of what you want to accomplish, look at what needs to be done to get there.

ACR

When opening your RAW files in Photoshop using ACR, click on the settings information at the bottom of the ACR interface. This will bring up the Workflow Options dialog box (**Figure 3.19**). In the Workflow Options dialog box, select the ProPhoto RGB color space, 16 Bit/Channel, and set the resolution to 360 pixels/inch. The Size option can be set either to the native resolution of your camera or the maximum resolution possible, although setting the resolution to the maximum size introduces the possibility of artifacts from interpolation.

Also, I always choose to send my photographs to Photoshop as Smart Objects so that I can go back and tweak the RAW processing at any time without having to start my editing process over again.

I set the Sharpen For option to None because I prefer to apply any sharpening selectively while I am editing in Photoshop.

Figure 3.19 *The Workflow Options dialog box for ACR*

Lightroom 4

Lightroom 4 processes RAW files in the Develop module and makes its edits through metadata, rarely changing any actual pixels in the image. Lightroom 4 does not cook any of the edits into a image until the image is exported out of Lightroom, the image is printed, or if the image is sent to an external editor. Below are the recommended settings for sending a file to an external editor, but each external editor can have its own file settings.

Go to the Preferences for Lightroom. On a Mac, this can be found under Lightroom > Preferences, and on a PC, this can be found under Edit > Preferences. Choose the External Editing tab at the top of the window.

If you are going to be editing in Photoshop from Lightroom, I recommend setting the File Format option to PSD, however, TIFFs support metadata changes more readily than PSD files. PSDs also must be saved in Photoshop with the Maximize Compatibility option turned on for Lightroom to be able to read the file after it has been edited and saved.

Set the Color Space option to ProPhoto RGB, set the Bit Depth to 16 bits/component, and set the Resolution to 360 (**Figure 3.20**).

If you are using an external editor other than Photoshop, you can set up a preset for it in the section just below, the bottom half of the dialog box, and I recommend setting the File Format option to PSD rather than TIFF, and setting the other options to match the editing settings in Photoshop.

FIGURE 3.20 *Editing options for Lightroom 4*

The first issue is the lack of definition between the background and foreground of the foliage-covered rock faces. This occurred because the image was shot on an overcast, somewhat rainy day that was exactly what was needed (maybe not the rain) to maintain the detail of the water while shooting at a long enough exposure to cause the water to streak. Now is your chance to apply the most important lesson that you have learned about desaturation: when desaturated, different colors of the same luminance will produce the same gray.

In this lesson, you are going to look at two different RAW processors: Lighroom 4 and ACR. ACR is essentially everything that Lighroom 4 is, but with a different user interface. Regardless of whether you use only Lighroom 4 or ACR, you will be best served if you learn to use both RAW processor workflows. If you choose not to do both, I highly recommend that you read both approaches so that you can see the thought processes behind the aesthetic choices made to create an acceptable image and to help reinforce your ability to "see" a black-and-white image while it is still a color one.

In Lighroom 4 and Adobe Camera Raw (ACR)

Lighroom 4's develop module and ACR are essentially the same piece of software; much like owning two cars, one from the early 1990s and one from the 21st century, with the same engines and chassis, but with two completely different bodies and dashboards.

Of the RAW processors that I will discuss in this book, the UI of Lightroom 4 is certainly the most elegant. ACR's UI is not as visually friendly. So why own both? Because, although Lightroom 4 is far better organized, and its tools are better and more efficiently placed, it cannot directly work on a file as a Smart Object in combination with layers and pixel editing tools. The major advantage of having both Lightroom 4 and Photoshop CS6 is that you can open up a Lightroom 4 edited file into Photoshop CS6 as a Smart Object, and still edit the RAW data using ACR. This means that you can use Lightroom 4 to do what you want to do to an image from using the catalog functionality of the Library module (Adobe Bridge, which comes with Photoshop, is a browser, with a less intuitive workflow and more limited functions) with global to somewhat limited granular post-processing in the Develop module. If you need to perform further image editing that Lightroom 4 cannot (layers, advanced masking, third party plug-ins as Smart Objects, using multiple images for ExDR—Extending Dynamic Range, which was discussed in Chapters 3 and 4 of *Welcome to Oz 2.0*—of focus, exposure, time etc.) you can open the Lightroom edited file into Photoshop as a Smart Object, so that you can further adjust and work on the RAW file data.

NOTE: The approaches in this chapter start at the point at which you have imported the images into either Lighroom 4 or ACR. Keep in mind that no

FIGURE 3.21 *Lightroom 4 Develop module*

FIGURE 3.22 *The Adobe Camera RAW (ACR) interface*

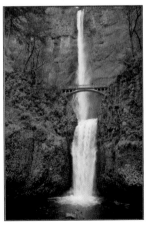

FIGURE 3.23 *The settings in ACR*

FIGURE 3.24 *The image preview in ACR*

matter which application you use, make the image look its best in color, and then do the conversion.

NOTE: For this section, the editing will be done in Lighroom 4, but the functionality for Lighroom 4 and ACR are very similar, and will occasionally be shown side by side.

1. After importing the file DSC0886LR.nef into Lightroom 4, switch from the Library to the Develop module (**Figure 3.21**). (In Adobe Bridge, select the RAW file that you wish to open and double-click on it. This will launch ACR in Adobe Photoshop (**Figure 3.22**).

NOTE: Notice that the image has little contrast, and that there is little separation between the background hillside rock wall and the foreground rock wall.

2. Do whatever global, image specific adjustments that you feel are necessary. For this image, I used the White Balance "As Shot," Tint +8, Exposure +0.05, Contrast +17, Highlights -60, Whites 0, Shadows 0, Blacks 12, Clarity +6, Vibrance 0, and Saturation 0 (**Figures 3.23, 3.24,** and **3.25**).

FIGURE 3.25 *The basic develop settings in Lightroom 4*

FIGURE 3.26 *The B&W mixer and Target adjustment tool*

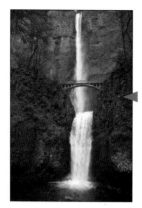

FIGURE 3.27 *Darkening the right wall*

FIGURE 3.28 *The sliders after using the Target adjustment tool*

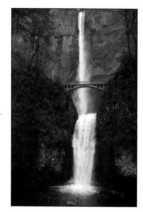

FIGURE 3.29 *After darkening the right wall*

FIGURE 3.30 *Increasing the Clarity*

NOTE: If I were going to use a third party plug-in, it is at this point in the workflow that I would make that decision.

3. Move down the Develop dialog box to the Black and White Mixer, and click on the Target adjustment tool (**Figure 3.26**). Click on the foreground rock wall (**Figure 3.27**) and move the Target adjustment tool downward to darken the image until you get a color mix of Red -10, Orange -20, Yellow -43, Green -49, Aqua -18, Blue +12, Purple +17, and Magenta +4 (**Figures 3.28** and **3.29**).

4. Move back up to the Basic dialog box, zoom into the right side of the rock face in the foreground, select the Clarity tool, and increase the clarity to +20 (**Figures 3.30, 3.31,** and **3.32**).

FIGURE 3.31 *Before increasing Clarity*

FIGURE 3.32 *After increasing Clarity*

There is a lot more to the Adjustment Brush tool that what you see at first glance. If you click on "Exposure" in the upper middle of the dialog box (**Figure 3.33**), you can access the Effects pull-down menu that gives you access to a series of other tools that you can use.

You can change the settings of the Adjustment Brush at any time, e.g., the amount of exposure, brightness, or contrast. Just because you have picked one setting does not mean that you are married to it once you have done your brushwork.

You can reset any of the sliders in the Adjustment Brush dialog box by double-clicking on one.

You can increase or decrease the brush size by using the size slider in the Brush dialog box, the left and right bracket keys, two fingers (the "gesture" for scrolling up and down on an Apple Laptop Trackpad or Magic Trackpad), or the mouse wheel on a PC.

Holding down the Option / Alt key and repeating any of the above actions allows you to subtract from the area on which you have painted.

One of the peculiarities of Lightroom 4 is that each brush has its own brush characteristics. For example, the Erase brush's sizes are different than the Adjustment brush's, so if you want to have both the Adjustment Brush and the Erase brush the same size, you have to set each separately.

Pressing the "O" key gives you an overlay view (like the one that comes up in Photoshop when you hit the "\" key). This allows you to better see the amount of brush feathering and the intensity of the brush opacity.

The "AB" brush setting allows you to apply two separate localized adjustments.

"Auto Mask" confines brush strokes to areas of similar color.

One of the profound draw backs of the Adjustment brush tool (and this is true of all RAW processors that have a Brush tool) is that you have no ability to repair the mask. So if you miss a spot, you have to start over. This is why using the Overlay functionality ("O") is very helpful.

NOTE: You can reset any of the sliders in the Adjustment Brush dialog box by double-clicking on any one of them.

FIGURE 3.33 *Adjustment Brush options*

NOTE: The Clarity algorithm looks at an image and increases the luminosity in the targeted pixels that are 50% (50.01% and above) or greater in luminance value and decreases luminosity in any targeted pixels that are 50% (49.99% and below) or lower in luminance value. This effect is controlled by a change in the radius of the sample area - the targeted pixels. A lower radius takes into consideration fewer pixels and a higher radius, more pixels. This translates into a lesser or greater effect. The final result of the Clarity algorithm is that the effect is removed from the highlights and the shadows, so that it affects only the mid-tone values. The net effect is a contrast and contour enhancement of the mid-tone image components.

The Clarity tool is based on two different contrast enhancing techniques. The first, created by Thomas Knoll, employs minimal sharpening and a high radius setting in Photoshop's Unsharp Mask filter. The other, originally created by Mac Holbert for printing, is the *Midtone Contrast technique* that employs maximal sharpening, a large radius, and a low opacity, High Pass sharpening of a desaturated copy of the image targeted specifically for the mid-tone areas of an image. An action that accomplishes this approach is included in both the OZ_POWER_TOOLS set of actions, as well as the OZ_2_KANSAS_12 set of actions and is called Midtone Contouring. This is to delineate it from Mac's action, because there are some slight differences.

Even though the foreground's rock face has darkened, because the background's rock face contains many of the same colors and hues, you have not achieved as much separation as is needed to be able to create an illusion of depth and to optimally control the eye's travel through the image. This is going to require the use of Lighroom 4's Adjustment Brush tool to further separate out the background from the foreground.

5. Select the Adjustment Brush tool, located just beneath the Histogram dialog box, that opens the Adjustment Brush dialog box (**Figure 3.34**).

6. Set the exposure to 0.52. Set the brush size for this image at 7.7 with a feather and a density of 100. Turn Auto Mask off (See the *Adjustment Brush sidebar*) (**Figure 3.35**).

NOTE: You are using Exposure vs. Brightness because Exposure, though it affects overall image brightness, puts a greater emphasis on the high values of an image (the brighter aspects). Brightness, on the other hand, also affects overall image brightness, but it mainly affects the midtones. You want to brighten up the high value aspects of this image with less emphasis on the mid-tone areas. This will preserve the atmospheric quality of the overcast light and mist caused by the waterfall and rain.

FIGURE 3.34 *Adjustment Brush options*

FIGURE 3.35 *Adjusting the settings for the brush*

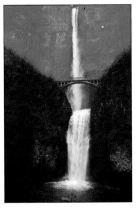

FIGURE 3.36 *The Overlay view*

FIGURE 3.37 *The pins for the brushwork*

FIGURE 3.38 *The image after adjusting the Exposure slider*

FIGURE 3.39 *Setting the Exposure slider to 0.19*

NOTE: You set the brush to 100% because you cannot see the effect of what you do before you set it. Another issue is that, once you do the brushwork, you cannot change the density of the brush opacity. So, you have to create the mask that you want, and then fine-tune the adjustment. However, with Photoshop and Capture NX2, you set the Effect and then decide what the opacity of the brush density should be.

7. Set Lighroom 4 to Overlay View (keyboard command O). Brush in the entire upper area of the background on either side of the waterfall (**Figure 3.36**).

When you are finished, you should notice that there are two dots on the image that are called "pins." The first pin is where you started brushing, and the second pin is where you finished your brushwork (**Figure 3.37**).

NOTE: Controlling the edits made to an image in a RAW processor by placing points, or in this case, pins, on the image, was conceptually introduced in Capture NX. You will see this approach to image editing implemented far more elegantly in Capture NX2.

8. Turn off the Overlay view (keyboard command O) and click on the upper pin. You should see an icon that has left and right arrows. To increase the effect of the selected Adjustment Brush functionality (in this case, Exposure), click-drag to the right. To decrease the effect, click-drag to the left. Decrease the effect, or lower the exposure, until you have something that you like. I chose 0.19 (**Figures 3.38** and **3.39**).

In the course of doing the global brushwork on the background, you lost some of the detail in the trees that are atop the upper left of the darker, foreground

FIGURE 3.40 *The Erase and Auto Mask options*

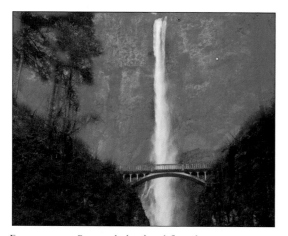

FIGURE 3.41 *Erasing the brushwork from the tree areas*

rock face. You need to bring back the detail in the trees to maintain the illusion of depth that you want to create.

9. Zoom into the area of the trees in the upper, left-hand corner (Command + / Control +). In the Adjustment Brush dialog box, click on Erase, and then click on Auto Mask (**Figure 3.40**).

10. With a brush size of 7.7, and a feather of 100, brush in the area of the trees (**Figure 3.41**).

Now it is time to work on the waterfall and the bridge. You will do that using two separate Adjustment Brush corrections. The first will be to darken the waterfall as well as to increase its contrast. The second will be to increase the sharpness, clarity, and brightness of the bridge.

11. In the Adjustment Brush dialog box, click on New. This will give you a new Adjustment Brush. In the Adjustment Brush dialog box, just to the right of the word Effect, select Contrast from the pull-down menu. With a brush size of 5.5 and feather of 100 (Auto Mask on), brush in the waterfall from the top of the image, all the way down the cascade into the pool at the bottom of the image (**Figure 3.42**).

FIGURE 3.42 *Brushing in the waterfall*

FIGURE 3.43 *The Adjustment Brush settings*

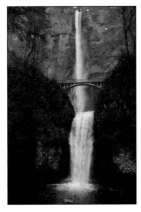

FIGURE 3.44 *The image after the adjustment*

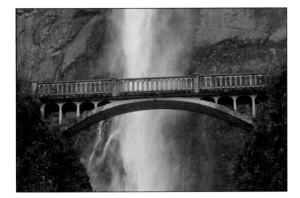

FIGURE 3.45 *The bridge area*

FIGURE 3.46 *The bridge selected*

12. Using the sliders in the Adjustment Brush dialog box, lower the exposure to -0.25 and the contrast to 35 (**Figures 3.43** and **3.44**).

13. Zoom (Command + / Control +) into the area of the bridge (**Figure 3.45**). Set the view to Overlay (keyboard command O).

14. Again, in the Adjustment Brush dialog box, click on New to get another new Adjustment Brush. In the Adjustment Brush dialog box, again select Contrast from the pull-down menu. With a brush size of 4.0 and feather of 100 (Auto Mask off), brush in the base of the bridge. Then reduce the brush to 1.0 and brush in the rail and posts. Use the Erase function to tighten up the mask. When using the Erase function, turn the Auto Mask on so that when you are done, you have a mask that looks something like **Figure 3.46**.

15. Now it is time to fine-tune the bridge. Turn off the Overlay view mode (keyboard control O), increase the Exposure to +0.25, Contrast to 71, Clarity to 35, and Sharpness to 24 (**Figure 3.47**).

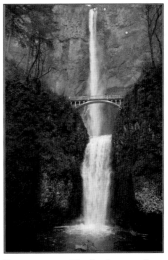

FIGURE 3.47 *The final image after adjustments*

FIGURE 3.48 *The Workflow Options window*

FIGURE 3.49 *Accessing the Workflow Options*

FIGURE 3.50 *Click on Open Object*

16. Export the file (Command + Shift + E / Control + Shift + E) and name it _DSC0886ACR.nef.

NOTE: Adding an underscore "_" will cause the file to be moved to the top of the folder order. Underscores work the same way as does adding a space to the beginning of a file name. You should get into the habit of using underscores instead of spaces because underscores are universally read by all operating systems when included in the names of files, whereas spaces are not always read.

You did this so that you would have a separate file that contains all of the XMP data (the edits that you just did). You now have a file that Photoshop can open and that can be made into a Smart Layer.

In ACR

1. Click on Workflow Options located beneath the Image Preview to bring up the Workflow Options dialog box (**Figures 3.48** and **3.49**).

2. Change the settings from Gray Gama 2.2, 8-bits/channel, 240 pixels/inch to Prophoto RGB, 16-bits/channel, 360 pixels/inch. Leave the Sharpen For set to None and click on Open in Photoshop as Smart Objects. Then click OK (**Figure 3.50**).

NOTE: Leave the Sharpen For option off because that is a one-size–fits-all approach to sharpening your image for either Glossy or Matte papers. Whoever created these presets may not share the same aesthetic sense as you have, and there are more variations in papers than simply Glossy and Matte.

3. Do whatever global image-specific adjustments you feel necessary. I chose Reds = -35, Oranges = -30, Yellows = -24, Greens = +3, Aquas = -96, Blues = -35, Purples = +17, and Magentas = +4 (**Figures 3.51** and **3.52**).

You now have a reasonably fast way to create a monochromatic/grayscale image from a RAW file. But at what cost? If all you needed was a rapid way to change an image from color to black-and-white, you could have used Photoshop's default - Gray Gamma 2.2. But if what you seek is the best possible black-and-white image, then neither the default settings of Photoshop nor the steps I have given you above (which are the most widely accepted and widely taught black-and-white / chromatic gray-scale conversion workflow for this RAW processing software) are necessarily the best option. They may be the best option when "good enough" is just that, good enough.

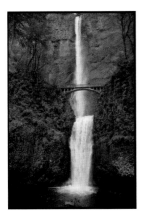

FIGURE 3.51 *The image after converting to black and white in ACR*

FIGURE 3.52 *The settings used in ACR*

In Aperture 3

You can download a PDF of the workflow for this software from the download page for this book. I have chosen to include it in the discussion of RAW processors, because Aperture 3 allows for the use of third party plug-ins. I did not, however, include it in the pages of the book because it is a platform specific RAW processor (it only works on the Apple OS), it has a very limited install base, and my publisher has limits on how many pages this book can be.

In Capture NX2

You can download a PDF of the workflow for this software from the download page for this book. I am a Nikon photographer, and if you use a different camera system, this may be a reading that you might elect to skip. I suggest that you not do this, I feel that understanding how it all works will ultimately add to the base of knowledge from which you draw when you create. If, however, you are thinking of changing to a Nikon camera system or already use a Nikon camera system, it is worth the read. The RAW file that is provided for the Capture NX2 lessons is a Nikon RAW file (.NEF) that works in Capture NX2. On the download page for this book, there is also a link to download a demo version of the software.

Herein Lies Yet Another Rub

Lighroom 4 and Capture NX2 tend to crash less than Aperture 3. Also, Lighroom 4 has a far more elegantly designed UI than ACR, Aperture 3, or Capture NX2. Capture NX2, ACR, and Lighroom 4 are cross platform (Windows OS and Apple OS) whereas Aperture 3 is Apple OS only. Capture NX2 (as a RAW processor), though cross platform, will read only Nikon RAW files (.nef). It will, however, both read and generate JPEGs and TIFFs.

Because you can do a chromatic grayscale conversion in either an RGB color space or in a Lab color space, it is important to me that I explain why I recommend the former rather than the latter. In order for me to discuss the impact that these color spaces have on your control of the chromatic grayscale conversion process, however, I must include a discussion of whether that color space is linear or non-linear.

Why this matters has to do with the fact that human perception and experience is non-linear. What makes this important to a photographer is that human vision is non-linear as is our perception of brightness, which is logarithmic and, therefore, non-linear. A logarithm is a non-linear function.

NOTE: A logarithm is the power to which a base must be raised to produce a given number. For example, if the base is 10, then the logarithm of 1,000 (written log 1,000 or log 10 = 1,000) is 3 because $10^3 = 1,000$.

What is meant when something is referred to as either non-linear or linear might be best explained with an example. Take something as simple as putting sugar into a 30 oz. commuter-cup of coffee. One packet of sugar makes the coffee sweeter. Putting two packets of sugar into the same cup of coffee makes the coffee taste sweeter, but it does not make it taste twice as sweet. If the relationship were linear, two packets

of sugar would make the coffee taste twice as sweet.

NOTE: If an image is captured linearly as it is by a DSLR's sensor, it appears to our non-linear vision to be condensed and unclear. It is only after RAW processing, when a gamma correction is applied, that the image is perceived as non-linear and more acceptable to the human eye.

There are non-linear color spaces, such as Lab, and there are linear color spaces, such as sRGB, Adobe RGB, and ProPhoto RGB. When a color space is described as being logarithmic (i.e., the Lab color space), it is also non-linear. That means that the relationship between the inputs (hue, saturation, and brightness or lightness [HSB or HSL] as is recorded by the camera – like the sugar that you put into the coffee) and outputs (how the information is digitized into a file – how the coffee tastes after the sugar is added), are such that two in does not necessarily equal two out.

To help understand why an RGB color space (even though it is linear) provides you with greater control for your chromatic grayscale conversion, look at what each color space actually contains. The Lab color space has three channels: one channel (the L channel, the only one used in a chromatic grayscale conversion) describes the relationship of light to dark across the entire image, and the other two channels describe the hues in an image (the a channel describes

green-magenta and the b channel describes blue-yellow). Although Lab's L channel provides us with a very useful light-to-dark description of the image, we lose any image structure detail that was contained in the color information. Also, as was discussed in a note in Chapter 2, when you use only the L channel of the Lab color space, you lose two-thirds of your image data, since only this channel describes the image's light-to-dark relationship.

On the other hand, an RGB color space actually describes the relationship of light-to-dark in an image three separate times: once for the responses of red, once for responses of green, and once for responses of blue. An RGB color space's brightness scale is linear; 2 in is 2 out. (In other words, putting 2 packets of sugar into the coffee cup makes it twice as sweet.) With those three separate response descriptions, you have the potential to pull out and combine any mixture of them to create the best chromatic grayscale image.

NOTE: There is a common misconception that the RGB color spaces mimic human vision better than does a Lab color space. What RGB color spaces have in common with human vision is that the human retina is made up of red, green, and blue receptors (called cones), and the RGB color spaces are comprised of red, green, and blue channels. The colors that humans see are RGB additive primary colors. But the response curve of RGB color spaces do not match human vision, because our vision is non-linear, unlike the RGB color space that is linear.

Unlike the RGB and CMYK color models, Lab color is designed to approximate human vision, because it is non-linear and closely matches the human perception of brightness. On the other hand, an RGB color space creates color by combining the individual, pure grayscale representations of the RGB channels.

Conclusion

Where the spirit does not work with the hand, there is no art.

—Leonardo da Vinci

When it comes to black-and-white conversions, RAW processors are best used when good enough, is just that—good enough. A RAW processor is meant to get you your best starting image, not your final one. If you are looking for a higher level of control and quality, then the use of a RAW processor is just one link in the workflow chain. Even though this is something most of us do not want to believe, because we want to complete our image editing as quickly as possible, it is also true for full-spectrum color images.

This creates an interesting dilemma. Your goal should always be to get it right in the camera, which means that in an ideal world, you would to be able to open a file and print it without manipulation; a goal that is the exception, not the rule, in fine art image creation.

Contrary to a popular belief, RAW processors are not the ultimate answer to this problem because they do not have variable opacity on a layer mask that you can fine-tune. You can do brushwork within ACR, Lighroom 4, Aperture 3, and NX, but once you do it, you cannot go back to it if you miss a spot. Also, adjustments are too coarse and tend to be too global in Lighroom 4 and Aperture 3. In NX2, you have more granular control of the image by using control points, but the more control points you have, the slower the software runs. This means you need a lot of RAM and hard drive space, if you plan to use a lot of control points. So the speed benefit of doing image editing on a RAW file diminishes as the number of control points increase. And while it is wonderful that modern RAW processors allow for the use of third party plug-ins, which extend the functionality of the software far beyond the limits of the original application, to use them requires that the image be rendered in a TIFF file format. What occurs, therefore, is that there is no way to preserve what you did to the image using the plug-in, which means you have to start from scratch if you want to correct something. This makes your workflow highly inefficient and destructive.

I will repeat myself—a RAW processor is meant to get you your best starting image, not your final one. However, if you have an image for which a RAW processor is adequate, stop and call it a day. Let the words of Albert Einstein be your guide, "Make everything as simple as possible, but not simpler." Never lose sight of the most important goal; to create an image that reflects your feelings at the moment of capture.

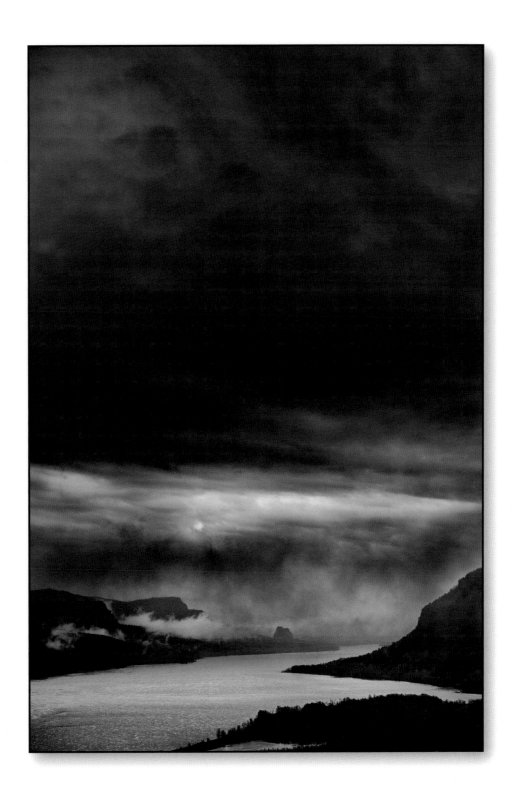

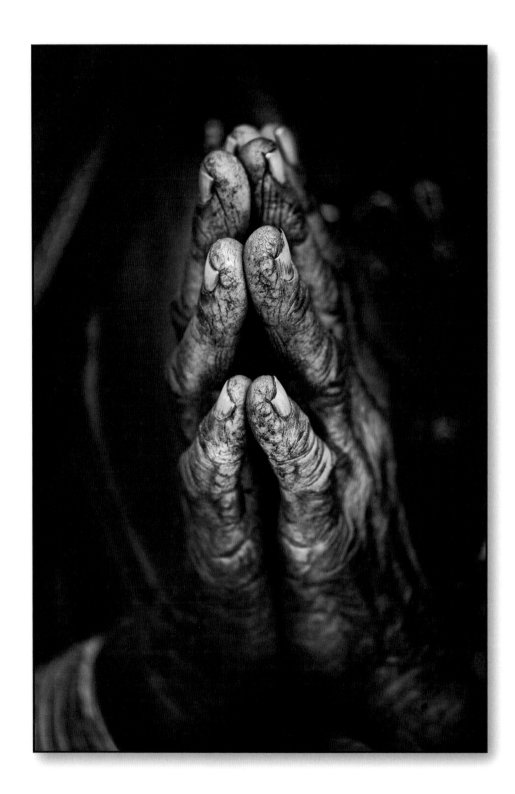

Chapter 4

Defying Reason

Photoshop Conversion Techniques of Mass Image Destruction:
The Black and White on Convert to Grayscale, Split Channel Conversion,
Lab Conversions, and Lab Equalization

There are no rules for good photographs, there are only good photographs.

—Ansel Adams

The Black and White on Convert to Grayscale

Pablo Picasso said, "Every act of creation is first an act of destruction." But there is an exception to that belief, and it is epitomized in the next series of popular and very widely used conversion approaches. They contradict Picasso because even though you are engaging in an act of creativity, the following approaches are as creatively limiting as they are destructive to the image.

You should explore these approaches, rather than simply write them off as "too awful to use," because they show some of the underpinnings of Photoshop and how tonal reproduction curves affect the image editing process. (See the sidebar: *Terms of Engagement* in Chapter 1 for a discussion of tonal reproduction curves.) The more information, the more experience, and better understanding that you have about how the whole process works, the greater the echo of that knowledge will be heard throughout your image editing process.

In Photoshop: Convert to Grayscale

The first of the destructive image conversion techniques is the Convert to Grayscale approach in Photoshop. When it comes to the color and luminance of your image files, Photoshop works by keeping all the color and luminance information as Lab (See the sidebar: *From the Horse's Mouth: Color Scientist Parker Plaisted Explains Lab vs. RGB* later in this chapter) and then translates the file to the space that you have chosen (ProPhoto RGB, Adobe RGB, sRGB, Lab, CMYK, etc.).

When you convert a file to grayscale, using the Photoshop default setting, Photoshop converts the file (depending on the color space that the file is in) into one in which Red, Green, and Blue are weighted 30%, 60%, and 10% respectively. That means that Photoshop uses 30% of the Red channel's information, 60% of the Green channel's information, and 10% of the Blue channel's information to create a grayscale image. This weighting is the equivalent of Photoshop's tonal reproduction curve.

1. Open the image DSC0902_16BIT.tif (located in the Chapter 4 section of the download page for this book) (**Figure 4.1**).

2. Click Save As (Command + Shift + S / Control + Shift + S), create a New Folder and name it DESTRUCTIVE_CONVERSIONS. Save the filename as GS_DSC0902_16Bit.psb and using the Large Document Format (.psb).

3. Go to Image > Mode and select Grayscale.

4. When the Discard Color information dialog box comes up, click Discard (**Figure 4.2**).

You have just created a monochromatic image in which you have lost two-thirds of your image information. You should note that when you convert this file back to RGB in the next step, the file size will be the same as it was before you did the convert to grayscale.

5. Go to Image > Mode and select RGB.

6. Save the file (**Figure 4.3** and **4.4**).

NOTE: The reason that you convert back to RGB is so that you can make a print using all of the inks, not just the blacks.

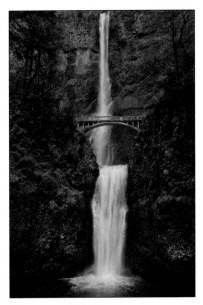

FIGURE 4.1 *Full color image*

The real goal of converting a full-spectrum color image into a chromatic grayscale one (one that never leaves the RGB color space) is to get as much information out of the file as your artistic voice requires.

FIGURE 4.3 *File size of the full color image*

FIGURE 4.4 *File size of the grayscale image*

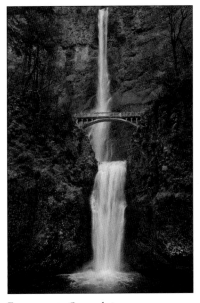

FIGURE 4.2 *Grayscale image*

The Black and White on Split Channel Conversions

It doesn't matter how beautiful your theory is, it doesn't matter how smart you are. If it doesn't agree with experiment, it's wrong.

—Richard P. Feynman

Earlier in the book, you saw that there is a difference between the Red, Green, and Blue channels as they are expressed in grayscale, and that when all three are combined, they create a full-spectrum color image. In this next destructive conversion technique, you are going to "split" out the image's three color channels into three separate files, and then combine them into one master file.

NOTE: In the OZ_2_KANSAS_12 action set, the action to do this is named SPLIT_CHANNELS.

1. Duplicate the file DSC0902_16BIT.tif (Image > Duplicate) and name it SPLTC_DSC0902_16BIT.tif.

2. Make the Channels panel active, click on the Channels Menu (located in the upper right corner of the Channels panel), and select Split Channels (**Figure 4.5**).

Photoshop will create three grayscale TIFFs, one for each of the Red, Green, and Blue channels. You will see that each channel is one-third of the file size of the original (**Figures 4.6, 4.7, 4.8,** and **4.9**).

3. Make the SPLTC_DSC0902_16BIT.tif.Green file active. In the Layers panel, holding the Shift key down, click on the background layer and Shift-drag it to the SPLTC_ALL_DSC0902_16BIT.psd. Rename this layer GREEN and add a layer mask. Make the SPLTC_DSC0902_16BIT.tif.Green file active and close the file. When Photoshop asks you if you want to save this file, click No.

4. Make the SPLTC_DSC0902_16BIT.tif.Blue file active. In the Layers panel, holding the Shift key down, click on the background layer and Shift-drag it to the SPLTC_ALL_DSC0902_16BIT.psd. Rename this layer BLUE and add a layer mask. Make the SPLTC_DSC0902_16BIT.tif.Blue file active and close the file.

5. Make the SPLTC_DSC0902_16BIT.tif.Red file active and convert it back to RGB (Image > Mode > Grayscale to Image > Mode > RGB). Click on Save As (Command + Shift + S / Control + Shift + S) and rename the file SPLTC_ALL_DSC0902_16BIT. Save the file to the DESTRUCTIVE_CONVERSIONS folder and the file as a Photoshop Document (.psd).

This is a somewhat popular approach to chromatic grayscale conversion and, on the surface, it appears to make sense. It is completely reasonable to want to be able to access the grayscale representation of the Red, Green, and Blue channels so that they can be used to create a monochromatic grayscale image. Unfortunately, you wind up losing all of the underlying color information and therefore lose the ability to control how the colors of the image interact with each other once this conversion approach is done. While this technique seems reasonable, on the surface, doing this is akin to taking apart your watch without putting it back together again and expecting it to be able to tell time.

You can nondestructively, and with greater control, get the results used in the split-channel technique by creating three monochromatic Channel Mixers adjustment layers with the Red Channel set to 100% (Blue and Green set to 0), the Green Channel set to 100% (Red and Blue set to 0), and the Blue Channel set to 100% (Green and Red set to 0).

FIGURE 4.5 *The Split Channels command*

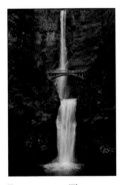

FIGURE 4.6 *The original color image*

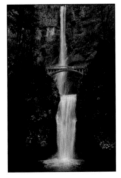

FIGURE 4.7 *The Red channel*

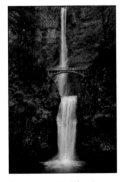

FIGURE 4.8 *The Green channel*

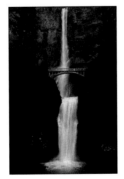

FIGURE 4.9 *The Blue channel*

The only reason you would ever want to do this to an image (physically splitting the channels) would be for the purpose of using these split-out channels as a reference to help inform decisions using other types of chromatic grayscale conversions, specifically a Multi-Channel, Channel Mixer, adjustment layer approach that I will discuss later in this book.

NOTE: A file that contains both the the split channels and the channel mixer adjustment layers set in monochrome mode for red, green and blue is named CH04_COMPARE.psb and is located in the Chapter 4 section of the download page for this book.

NOTE: Even though your file is in RGB when you display the individual channels, they are displayed as grayscale documents, i.e., they are shown in the Grayscale workspace, not in the RGB workspace. So, even if you and I look at the same Adobe RGB document, each of us could see different channels if our grayscale setups were not identical. This is simply a programming error in the Channel Mixer algorithm.

Unless your grayscale gamma agrees with your RGB gamma, problems like grayscale workspace gamma versus RGB gamma are going to occur. Your only choice is to change your grayscale setting to agree with your RGB. In other words, if your normal RGB is Adobe RGB or sRGB, set your grayscale working space to 2.2 gamma. If it is ProPhoto, set it to 1.8. To do this go to Color Settings (Command + Shift + K / Control + Shift + K) and make the change.

The Black and White on Lab Color Space Conversions

If we observed first, and designed second, we wouldn't need most of the things we build.

—Ben Hamilton-Baillie

Earlier in the book, you looked at how to create a black-and-white image by using the Hue/Saturation adjustment layer to desaturate the color. As you saw, simply desaturating the image's color can be anything but simple. Even though you removed all of the color from the image, the workflow that you engaged in was non-destructive. *Non-destructive image editing* occurs when the original file content is not modified during the editing process—only the edits are edited. No matter what type of adjustment layer (e.g., Curves, Levels, etc.) you use, any time you do something to an image, you clip data. Your goal should be to develop a workflow that minimizes this and provides you with a direct path backward to the beginning.

Also, earlier in the book, you saw that there is a direct relationship between how you treat color and how that color manifests itself in the chromatic grayscale. It is important, when conceptualizing a digital black-and-white image, to recognize that there is a difference between grays made up of varying shades or densities of black (printing with only black inks or just the lumance aspect of the image) and grays that are created out of equal values of red, green, and blue.

When you create a chromatic grayscale image from a full-spectrum color image, you are creating your own image-specific tonal reproduction curve. This is important because, as the creative force behind the image, you should decide how the colors in your image should interact, rather than use

a predetermined, one-size-fits-all approach. You should know that when you make a part of an image a specific color, it will be rendered into a specific shade of chromatic gray in your final black-and-white print.

What you are working toward developing by doing every one of these conversion approaches is an ability to see a chromatic grayscale image while looking at one in color. This ability is frequently referred to as developing a visual framework. A visual framework is a global-to-granular approach that gets you from where you are to the vision that you have for your image, which in this case is an optimal chromatic grayscale print.

In this next approach, frequently referred to as the classic black-and-white conversion technique, and is one of the most widely used conversion approaches, you are going to create a chromatic grayscale image in the Lab color space. This workflow is highly destructive, not because you will leave the RGB color space for the Lab color space, but because you will convert this image from Lab color, manually discard the a and b channels, then convert to grayscale in Photoshop using Photoshop's convert to grayscale algorithm, and then back to RGB.

So exactly how much data would be lost from a color image if all the color is removed, and all that is left is the luminance information represented in grayscale? The answer again is that two-thirds of the data is lost. Photoshop works by keeping all the color/luminance information as Lab and then translates it, as necessary, into ProPhoto, RGB, CMYK, sRGB, Grayscale, etc. If you want to see this in action, convert an RGB image into Lab and then

go to the Info panel. Apply the Desaturate command, which discards the a (green-magenta) and b (blue-yellow) color channels and retains only the L channel. Two of three channels are lost (thus two-thirds are lost) and the file size shrinks accordingly. Translating the file back to RGB yields a file of the original size. This is because the L channel has been represented in R, G, and B. All Photoshop had to work with, data-wise, was the L channel, so that you have equal values of R, G, and B in all three channels. The same thing happens if you convert RGB to grayscale; the file size is reduced by two-thirds. Because converting an image straight to grayscale is so destructive, it should not be considered as a useful way to create a black-and-white image.

The Lab Color Space

To best understand the conversion process, you need some understanding of the Lab color space. Of all the color spaces available in Photoshop, Lab is the one that has the closest correlation to human vision. Lab is an "opponent color" space.

The Opponent Color Theory states that the human visual system interprets information about color in an antagonistic manner. In the Lab opponent color space there are three opponent channels: the a channel is magenta versus green, the b channel is yellow versus blue, and the L channel (the Luminance channel) is light versus dark.

NOTE: Another way to conceptualize the L channel is black vs. white because that is how it will manifest itself should you choose to extract the Luminance channel information and convert it into a layer. (You will be doing just this in the first of the three Lab conversions of this approach.)

Where the Lab color space really shines is in the manipulation of the full spectrum of visible color. Enhancing color in Lab tends to look more natural and less noisy because the computation is carried out independently of luminosity. (This cannot be done in RGB in Luminosity mode.) RGB is designed to be perceptually uniform and the reason that black-and-white conversions are best done in RGB is due to that uniformity.

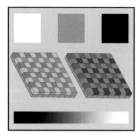

FIGURE 4.10 *Original color image*

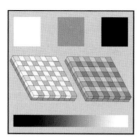

FIGURE 4.11 *Red channel*

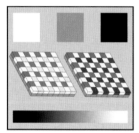

FIGURE 4.12 *Green channel*

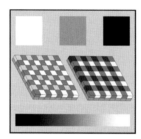

FIGURE 4.13 *Blue channel*

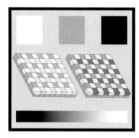

FIGURE 4.14 *L Channel*

FIGURE 4.15 *a channel*

FIGURE 4.16 *b channel*

The Classic Black-and-White and Neo-Classic Black-and-White Conversion Approaches: Two Destructive Pathways to Getting the Hue Out of an Image

A jug fills drop by drop.

—Buddha

Using the equal color values test image that you used in the first chapter (RGB_TARGET.psd) I have created a file named RGB_TARGET_COMPARE.psb (located on the Chapter 4 section of the download page) so you can compare simple desaturation, the Red, Green and Blue channels with this next conversion approach. You should see that you have two different sets of gray values. If you look at the Red, Green, and Blue channels of the this Lab converted image, you will notice that each channel produces a different gray-scale image (**Figures 4.10, 4.11, 4.12,** and **4.13**).

When you do the classic black-and-white conversion technique in the Lab color space, only the luminance channel data should be extracted.

NOTE: You can achieve this same result by creating a Hue/Saturation adjustment layer and setting the Saturation slider to -100.

Look at the color test file converted using individual channels in the Lab color space, the image converted using the Classic Black-and-White Conversion (Approach 1), and the image converted to grayscale (**Figures 4.14**, **4.15**, **4.16**, **4.17**, **4.18**, and **4.19**).

You should see that the L (luminance) channel and the Classic Black-and-White Conversion 1 are identical, and that the Classic Black-and-White Conversion 1 and Convert to Grayscale from RGB are different. You should also notice that the Luminance channel in Lab renders different gray values for colors of the same value, whereas when the RGB version of this file was desaturated, all of the

colors that were different became the same gray (**Figures 4.10** and **4.19**).

It appears that Photoshop applies a tonal reproduction curve to the Luminance channel in the Lab color space. You will notice this because: first; all the colors in the test file are of equal luminance, but they appear to be different grays in the Luminance channel, and second; the 128 middle gray value that is the background of the test file is now lighter. What happened is that Photoshop applied a tonal reproduction curve to the L channel. Although the criteria used by Photoshop to determine this curve may not be important to you, you should know that the same tonal reproduction curve will be applied to every image that is converted this way. At first glance, it appears that the tonal reproduction curve is biased towards the a channel, because the red values of the

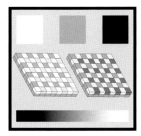

FIGURE 4.17 *After the Classic Conversion process*

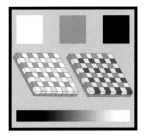

FIGURE 4.18 *Converted to Grayscale process*

FIGURE 4.19 *RGB file fully desaturated*

FIGURE 4.10 *Original color image*

test file tend to be a lighter gray. The problem here, just as it is with film, is that you cannot change the tonal reproduction curve.

Regardless, what you end up with is an image that has been arbitrarily changed to grayscale and one in which you have lost two-thirds of your image data. That is a lot of work for such little return.

If you look at the outcomes of the two variations of the Classic Black-and-White Conversion techniques in the Lab color space (that you are about to do), you will see that the results differ. The second approach will yield a darker image than was achieved with the first. However, when you compare the second approach to Photoshop's Convert to Grayscale, the results are the same. So, once again, you will have done a lot of work to achieve something that can be more simply done elsewhere in the software. In addition, you still end up with a less than optimal result.

In the second way to do a Classic Black-and-White Conversion in the Lab color space, you should note that Photoshop has, again, applied a tonal reproduction curve. It appears that this curve tends to err in the direction of the b channel. And, once again, the result will be less than satisfying.

It important to know how to do both of these approaches because they are both extremely popular ways to do a black-and-white conversion and are touted by many professional photographers as the most accurate ways to create a realistic looking, black-and-white image. When you are finished with these techniques, you will find that you can get a quicker, better result by using two Hue/Saturation adjustment layers (as you did in Chapter 2) and changing the blend mode, than you can by using these conversion techniques.

FIGURE 4.20 *Converting to Lab Color*

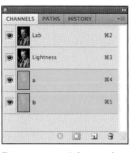

FIGURE 4.21 *Selecting the a and b channels*

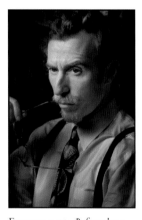

FIGURE 4.22 *Before the a and b channels are discarded*

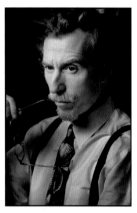

FIGURE 4.23 *After the a and b channels are discarded*

FIGURE 4.24 *Convert to Grayscale*

FIGURE 4.25 *Convert to RGB*

Classic Black-and-White Conversion: Approach One

There are three classes of people: those who see, those who see when they are shown, those who do not see.

—Leonardo da Vinci

(For both Conversion One and Two you will use an image of the actor, Stephen Kearin.)

NOTE: In the action set that comes with this book, there is an action that does this conversion. The action is named RGB_TO_LAB_TO_RGB and it is part of the OZ_2_K action set that is located in the ACTIONS folder that you should have downloaded from the download page for this book.

1. Open the file KEARIN.tif.

2. Duplicate the file (Image > Duplicate).

3. When the Duplicate dialog box comes up, name the file KEARIN_LAB_BW_1.

4. Click on Save As (Command + Shift + S / Control + Shift + S) and save this file in a Large Document format (.psb) to the DESTRUCTIVE_CONVERSIONS folder.

5. Go to Image > Mode and select Lab Color (**Figure 4.20**).

6. Select Channels and, holding down the Shift key, make the a and b channels active. Drag them to the Trash Can located at the bottom of the Channels Panel to discard them (**Figure 4.21**).

See the difference before and after the a and b channels are discarded (**Figure 4.22** and **4.23**).

7. Go to Image > Mode > Grayscale (**Figure 4.24**).

8. Go to Image > Mode > RGB Color (**Figure 4.25**).

9. Save the file.

Now that you have converted this image, look at its individual RGB channels, its individual Lab channels, and the image converted to grayscale. Here is what the image's individual RGB channels looked like before conversion and here is what they look like after the conversion process (**Figures 4.26, 4.27, 4.28, 4.29, 4.30, 4.31, 4.32, 4.33,** and **4.34**).

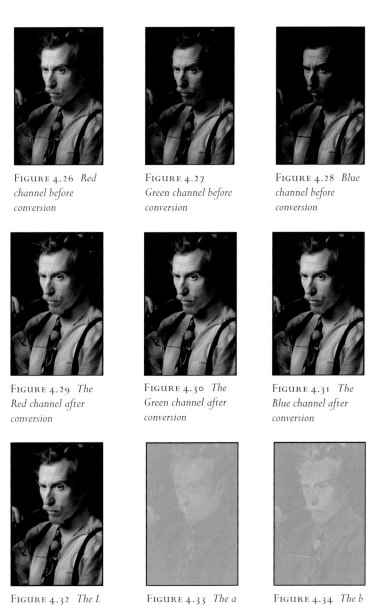

FIGURE 4.26 *Red channel before conversion*

FIGURE 4.27 *Green channel before conversion*

FIGURE 4.28 *Blue channel before conversion*

FIGURE 4.29 *The Red channel after conversion*

FIGURE 4.30 *The Green channel after conversion*

FIGURE 4.31 *The Blue channel after conversion*

FIGURE 4.32 *The L channel*

FIGURE 4.33 *The a channel*

FIGURE 4.34 *The b channel*

Compare the final image to the Luminance Channel and you will see that they are the same (**Figures 4.35** and **4.36**).

NOTE: There is a file named LAB_COMPARE_100ppi.psb that is available on the download page; it has all the conversions as individual layers, which you can look at and compare.

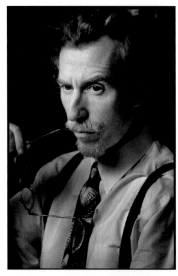

FIGURE 4.35 *Final image*

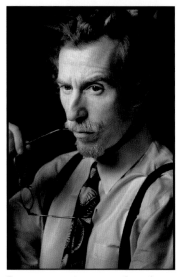

FIGURE 4.36 *Luminance channel*

Classic Black-and-White Conversion: Approach Two

Ignorance is no excuse, it's the real thing.

—Irene Peter

NOTE: In the action set that comes with this book, there is an action to do this. This action is named LAB_DISCARD_AB.

1. Open the file KEARIN.tif.

2. Duplicate the file (Image > Duplicate).

3. When the Duplicate Dialog box comes up, name the file KEARIN_LAB_BW_2.

4. Click on Save As (Command + Shift + S / Control + Shift + S) and save this file in a Large Document format (.psb), and in the DESTRUCTIVE_CONVERSIONS folder.

5. Go to Image > Mode > Grayscale.

6. When the Discard Color Information dialog box comes up, click OK.

7. Go to Image > Mode > RGB.

8. Save the file.

Now that you have converted this image, once again look at its individual RGB channels, its individual Lab channels, as well as the image converted to grayscale (**Figures 4.37, 4.38, 4.39, 4.40, 4.41, 4.42, 4.43, 4.44,** and **4.45**).

Compare the final image to the converted to grayscale image, which was created with Photoshop's convert to grayscale technique, and you will see that they are the same (**Figures 4.46** and **4.47**).

NOTE: You can see this comparison, as well, in the LAB_COMPARE_100ppi.psb file located in the Chapter 3 section of the download page.

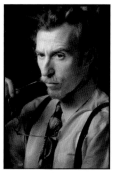

FIGURE 4.37 *The Red channel before conversion*

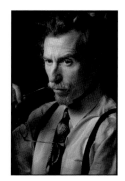

FIGURE 4.38 *The Green channel before conversion*

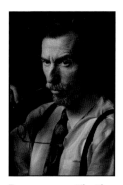

FIGURE 4.39 *The Blue channel before conversion*

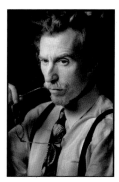

FIGURE 4.40 *The Red channel after conversion*

FIGURE 4.41 *The Green channel after conversion*

FIGURE 4.42 *The Blue channel after conversion*

FIGURE 4.43 *The L channel*

FIGURE 4.44 *The a channel*

FIGURE 4.45 *The b channel*

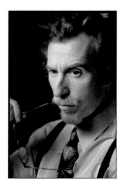

FIGURE 4.46 *The final image*

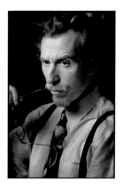

FIGURE 4.47 *The image converted to grayscale*

The Black and White on Equalizing Lab

In a full color image, the use of the Lab color space is one of the most important tools for maximizing the image's color information. There is no better way to increase an image's color saturation than in the 16-bit Lab color space.

In the next part of this lesson, you will equalize all of the Lab channels. The Equalizing Lab technique can be quite useful when working on a chromatic grayscale-converted image derived from a color image, because it can create a layer that is lighter but one that has considerable detail. It can also create a lightened image that is far less contrasty than using the Screen blend mode to lighten. The Equalizing Lab approach to lightening an image is excellent for maintaining image structure and detail in the highlights, as well as in the shadows. Should you find that using either the Screen blend mode or Curves does not give you exactly what you want, consider using this approach.

The Equalize command works by redistributing the brightness values of the pixels in an image so that they more evenly represent the entire range of brightness levels. In other words, Equalize remaps pixel values in the composite image so that the brightest value represents white, the darkest value represents black, and intermediate values are evenly distributed throughout the grayscale.

NOTE: In both the OZ2K and the OZ_POWER_ TOOLS action sets for this book, there are actions to do both Lab Equalization and RGB Equalization. Even though I have found that Equalization is best suited for black-and-white images, from time to time it has been useful for full color images as well.

1. Duplicate the image file KEARIN.tif.

2. Rename this file KEARIN_Lab_EQ, and save it to the DESTRUCTIVE_CONVERSIONS folder.

3. Double-click on the Background layer and rename it Lab_EQ.

4. Desaturate the image (Shift + Command + U / Control + Shift + U).

5. Set the blend mode in the Layers panel to Luminosity.

6. Convert to Lab (Image > Mode > Lab color) (**Figure 4.48**).

7. Go to Image > Adjustments > Equalize.

Compare the figures shown here (**Figures 4.49, 4.50, 4.51, 4.52, 4.53, 4.54, 4.55, 4.56, 4.57,** and **4.58**).

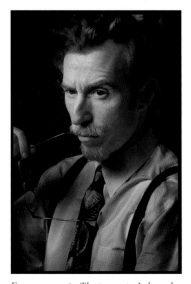

FIGURE 4.48 *The image in Lab mode*

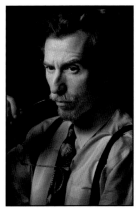

FIGURE 4.49 *Before equalization*

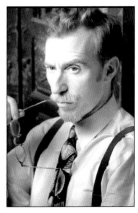

FIGURE 4.50 *After equalization*

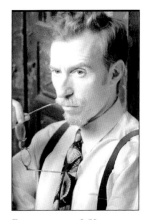

FIGURE 4.51 *RGB equalization*

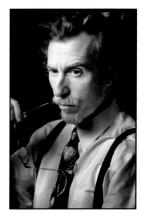

FIGURE 4.52 *The Screen blend mode*

FIGURE 4.53 *Closeup of Lab equalization*

FIGURE 4.54 *Closeup of Lab equalization*

FIGURE 4.55 *Closeup of Lab equalization*

FIGURE 4.56 *Closeup of RGB equalization*

FIGURE 4.57 *Closeup of RGB equalization*

FIGURE 4.58 *Closeup of RGB equalization*

FIGURE 4.59 *Before*

FIGURE 4.60 *With Curves adjustment*

Here is where equalization becomes useful. I have created a version of the KEARIN.tif image using the third variation of the Film & Filter Approach (a layer with equal values of RGB, in this case white, set to the Color blend mode with a Hue/Saturation adjustment layer set to the Normal blend mode) that you learned in Chapter 2, that you will use for the next lesson. The file KEARIN_CB_BW_16BIT.psb is located in the Chapter 4 section of the download page for this book. I have also created a Curves adjustment layer that is turned on and is set to the Screen blend mode. (This halves the density of the image, and therefore causes the image to be lighter.) (**Figures 4.59** and **4.60**).

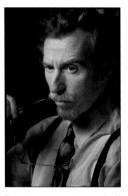

FIGURE 4.61 *Original color image*

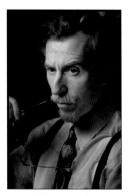

FIGURE 4.62 *Color blend mode conversion with COLOR_BLEND_BW layer*

When the Screen blend mode is applied however, even though the image is lightened, its shadow areas are still blocked up and the highlight areas become blown out. Be sure to look at the image when the Color blend mode layer is turned off in order to see what the actual colors look like (**Figures 4.61, 4.62,** and **4.63**).

8. Open the KEARIN_CB_BW_16BIT.psb.

9. Turn off the SCREEN Curves adjustment layer.

10. Turn on the L2D_SCREEN adjustment layer (**Figures 4.64** and **4.65**).

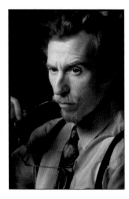

FIGURE 4.63 *COLOR_ BLEND_BW layer turned off*

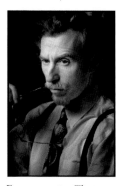

FIGURE 4.64 *The image with the L2D_SCREEN layer on*

FIGURE 4.65 *The layer mask*

From the Horse's Mouth: Color Scientist Parker Plaisted on Explaining Lab vs. RGB

An RGB color space is an excellent color space to use for altering the numbers that delineate the colors in a digital image. The reasons why an RGB color space is superior to the CIELAB color space for this purpose are:

1) RGB colors are easily recognized and rendered by displays (e.g., computer monitors, televisions, projectors, etc.).

2) RGB colors are easily recognized and rendered by inkjet printers.

3) There are no discontinuities for the color coding in RGB color spaces.

The reasons why the CIELAB color space is inferior for this purpose are:

1) Displays require colors to be coded in an RGB color space, and conversion from CIELAB to RGB color coding requires mathematic conversions that start with logarithmic equations from CIELAB to CIEXYZ and then additional equations to convert from CIEXYZ to an RGB color space. If sufficient bit depth is not used in the conversions, then rounding errors will introduce visible artifacts in the digital image.

2) The CIELAB color space is not well suited for altering dark colors and maintaining small linear relationships with adjacent dark colored pixels, because the CIELAB equations shift to different formulas when the ratio of Y to Ywhite is equal to or less than 6/29. Color gradations that span this shift can be adversely affected by the change in the formulas when converting colors from CIELAB /CIEXYZ and then into an RGB color space.

What this technical explanation means is that converting from RGB to CIELAB and back requires the intermediate step of going through CIEXYZ. These conversions from RGB to CIEXYZ to CIELAB to CIEXYZ to RGB have the potential to introduce harmful artifacts in the colors of digital images. This type of artifacting is referred to as rounding error.

11. Make the KEARIN_Lab_EQ file active, go to the Layers panel, and, holding down the Shift key, click on the Lab_EQ layer, and Shift-drag it to the KEARIN_CB_BW_16BIT.psb file.

12. Holding the Option / Alt key, drag the L2D_SCREEN layer mask to the Lab_EQ layer. Lower the opacity until you like the brightness. I chose 69%.

13. Save the file.

You duplicated the layer mask rather than painting a new one because you had already made choices about what looked best bright and what looked best dark, and so on. So rather than re-inventing the wheel, you saved time by duplicating the layer mask that you had already created. You can always do more brushwork on the layer mask you copied. This just gives you a place to start.

Of all the things that you can do to an image intended to be a chromatic grayscale image in the Lab color space, it is my opinion that equalizing in Lab is the most useful. It is also something that is best done when other less destructive ways of doing things, do not work as well as you had hoped.

NOTE: There is a file named kearnin_all.psb that compares convert to grayscale, RGB desaturation, and both Lab conversion approaches. This file is located in the Chapter 4 section of the download page for this book.

The Bottom Line

Education is a weapon whose effects depend on who holds it in his hands and at whom it is aimed.

—Joseph Stalin

Converting an image from RGB to Lab to grayscale to RGB is a long, highly destructive, overly complicated task that involves losing two-thirds of your image data, as well as loosing the ability to control the relationship of color as it translates into a chromatic grayscale image. Of the three approaches that I have described, the first one is the only one that has some merit, if (for some reason) you are in need of the L channel data. The third one is useful if you need to pull image structures out of shadows and brighten highlight areas without losing image detail. But as chromatic grayscale conversions go, what these techniques are good for is showing how not to do something, and what happens when you make something simpler than possible.

When it comes to manipulating color, increasing saturation, or sharpening an image, there is no better color space in which to work than Lab. Enhancing color in Lab tends to look more natural and less noisy because the computation is carried out independent of luminosity. This cannot be done in RGB's Luminosity mode, because it is designed to be perceptually uniform. When converting an image to chromatic grayscale, however, perceptual uniformity is exactly what you want, because you want to bend the colors of the image to your will and not be bound by the tonal reproduction curve applied by Photoshop.

Somewhere Over the Grayscale

Finding All the Shades of Gray in the Rainbow

Fall is inevitable, through all of their life leaves hold within them the power to die and that must color their life.

—Orson Scott Card

If you are reading these words, you have persevered to reach this point in this book. Now it is time to more deeply explore the why of what you have done and what you will be doing. This is where the real fun, but also the real work, begins.

You now know that the conversion of an image from full spectrum color into chromatic grayscale involves more than simply desaturating the colors. You realize that if you do not take into account your image's colors, the chromatic grayscale that you are trying to create will not have the full range of your artistic voice; it can lack detail and tonal range. You also understand that you must be acutely aware of not only the spectral qualities of your image's colors, but how those colors are distributed across the image.

Once you find yourself with an image that calls out that it should not be hidden behind the full spectrum of color, in my opinion, there is no level of care too great that you should exert in the creation of the visual poem; the silent song that will be the final image and the ultimate expression of your voice. For me (and I hope for you), good enough is never good enough.

When creating a chromatic grayscale image, it is within Photoshop that you will find the greatest control for extracting detail, tonal range, and image structure, while minimizing image artifacting. You have seen that creating a chromatic grayscale image is not just about getting the color out, it is about using the color to inform your final image so that it best reflects what you felt at the moment that you pressed the shutter.

In my experience, from the moment of capture, you almost always know for which pictures the conversion to a chromatic grayscale image is inevitable. That inevitability colors everything that you will do with, and to, that image. Never forget that you took the picture, or better yet, the picture took you, and that it is your vision and your voice that brings you to this place.

Hue is hue, saturation is saturation, and brightness is brightness. Hue is not saturation, saturation is not hue, and brightness is neither hue nor saturation. It is an object's hue, saturation, and brightness (HSB) that, when combined, make up what is referred to as color. (In some tools in Photoshop, as well as in some texts, brightness is referred to as lightness, so you may see HSL in place of HSB, but they are identical.) That is the bedrock upon which all color theory and science is built. There is a difference, however, between color science and color theory, and that difference is the same as it is between precision and accuracy. Precision is a measurement. Accuracy is how well precision reflects reality.

John Paul Caponigro said, "Color theory is the language that conceptually and perceptually describes the elements of color and their interactions." Color science deals with the physics of light, how objects derive their color, and the perception of color by animals, including humans. For a photographer, without understanding color theory, color science is just numbers without relevance. Liken this to knowing what an f/stop is but without understanding why you select one versus another. Without understanding the reason (the theory) behind any photographic technique, you are likely to produce paint-by-number, voiceless, forgettable images.

If understanding color theory and color management (the need and reasons for monitor calibration and paper profiling for printing) matter anywhere, they matter most when converting a color image to chromatic grayscale and then printing it. This is because any color contamination, be it from an un-calibrated monitor or using no or poorly made printer profiles, results in printed colors that are not

grays. Something of your vision and of your voice will be lost.

Think about Matisse's quote again and the real power of his statement. "If you can see it with your eyes it's a color." Because the grays that you create in a chromatic grayscale image are made up of equal values of red, green, and blue, gray is most certainly a color. A pure grayscale image (one that contains no RGB data) is made up of only one channel. Also, a pure grayscale image does not define white or black, it merely defines luminance (what is lighter or darker). (See the following note.) Chromatic grayscale image files (those made up of equal values of red, green, and blue) contain color definitions for what is white and what is black, as well as what is light and what is dark. Chromatic grayscale images, therefore, have more information in them than do pure grayscale images.

NOTE: According to physics, the physical difference between a surface that appears black and one that appears white is referred to as *reflectance*. Every surface absorbs some of the light that strikes it and reflects back the rest. The amount of the unabsorbed light expressed as a portion of the light striking an object is referred to as its reflectance. Black surfaces reflect approximately 3% of incident light, while white surfaces reflect approximately 90%. If a black object and a white object are side by side on a flat surface, the white object's surface will reflect 30 times more light than will the black object's. However, if the white object lies in a shadow, it is possible for it to reflect the same amount of light as the black object outside of the shadow. This happens when the illumination outside the shadow is 30 times greater than the illumination inside the shadow.

Luminance is the photometrically measured amount of light emitted from a source or reflected from a surface. But luminance does not correlate with our visual perception of objects. This is why, in a pure grayscale image, it is commonly accepted that there is no black or white, but rather a range of grays from light to dark. It is not until you are in a defined color space (ProPhoto RGB, Adobe RGB, Lab, etc.) that you get a true black and a white.

Because you should do all of your conversions in the RGB color space, gray has to be considered a color. Therefore, it will be the tenets of color theory that will most affect the quality of the image conversion. As you have seen in previous chapters, controlling hue and saturation affects the final outcome of the conversion. When you control the hue and saturation of an image, you create image-specific tonal reproduction curves; a huge advantage of digital photography over analog, silver-based, black-and-white photography.

In the simplest terms, *Hue*, *Saturation*, and *Brightness* (or *Lightness*) (HSB or HSL) are as follows: *Hue* is the name of the color, e.g., red, green, and blue are hues. *Saturation* is the depth, amount, or intensity of the color, e.g., vibrant red, pastel blue, etc. *Brightness* is how light or dark a color appears. (With regard to inks, it is how much or little black ink is mixed into a given color.) The final outcome of a chromatic grayscale conversion is that the hue is removed from an image, and what remains is the relationship between saturation and brightness. They are the key components of the image's tonal contrast. There is a common misconception that hue is of little to no importance to the final image. In my experience, this is not so. As you have seen in the previous chapters, by having the ability to control the underlying hues in an image, as well as having control of saturation and

brightness, you can extract greater image structure detail depending on how you approach the conversion process.

There are many differences between making a chromatic grayscale print from an image captured digitally and one captured on black-and-white film. In digital photography, you print with inks, not sensitized silver papers, and you print an image from a color capture, not a grayscale one. Your goal should be to use what was right and good about silver photography, leaving behind what was limiting, and use what is right and good about digital photography while avoiding its pitfalls. This is what this book is all about.

An important concept to understand when you convert a full color image into a chromatic grayscale one is that, in the words of color management consultant and color theory expert, Eric Magnusson, "RGB is not a color; it is a formula to mix color." Mr. Magnusson's statement intends to correct certain misunderstandings, one of the most common of which involves a misconception of what RGB means. For example, photographers and designers will frequently make statements like, "Our company logo color is Red 126, Green 58, and Blue 141!" They make this statement with great confidence inferring that the RGB values are the actual color, while what they really mean is that it is the RGB formula to mix a color.

The RGB color space consists of three channels of data, ranging from zero (0) to 255. The numbers in those channels function like percentages; so, zero is nothing, and 255 equals 100%. But what is 100%? Who defines it? What color is it? What hue is it? And finally, how bright is it?

On its own, an RGB value is not very helpful because RGB is *NOT* a color. RGB is a three-channel mixing system whose formulas only start to make sense, once you know exactly what red, what green, and what blue you are mixing. When you convert an image from full color to chromatic grayscale, you are mixing the color gray in the RGB color space from an RGB file that will be printed with an ink set that contains multiple black, magenta, and cyan inks as well as yellow, orange, green, red, and blue ones.

NOTE: The Epson UltraChrome HDR K3 ink set has three levels of black (K is what black is named in printing because there are no colors that start with the letter K, but many start with the letter B; K3 indicates three blacks): Black (Photo Black for glossy papers and Matte Black for fine art papers), Light Black, and Light Light Black. In addition, the Epson K3 HDR UltraChrome ink set has two levels of magenta: Vivid Magenta and Vivid Light Magenta, two levels of cyan: Cyan and Light Cyan, as well as Yellow, Orange, and Green inks. (Some of the Epson and Canon printers also have blue inks in their ink sets. In the case of the R1900 Epson printer, the orange/green inks are replaced with red/blue.)

Canon has LUCIA EX inks that use Photo Black and Matte Black, Photo Magenta and Magenta, Cyan and Photo Cyan, Yellow, Green, Red, Gray, Light Gray, and Dark Gray. Both the Epson and Canon ink sets are pigment based. UltraChrome is the name of the ultrasound process that Epson uses to grind pigment particles. (The particles are then coated with a polymer to increase optical density and negate metamerism.) (For the record, I print with Epson printers, was Epson's first beta tester, and the original host of the Epson Print Academy, so I admit to having a bias.)

Epson and Canon have inks of many colors in order to extend the range of colors that can be printed from a full spectrum color image as well as to extend the range of grays that can be printed from a chromatic grayscale (referred to by both

companies as black-and-white). Knowing this matters because you should always keep the final print in mind. The best looking chromatic grayscale image print is obtained from the RGB color space and from an RGB file when you use ALL of the inks; not just the blacks or grays.

NOTE: Prior to CS6, I preferred to print out of Lightroom, because Photoshop was less user friendly when it came to printing. In my opinion, this is no longer the case in CS6. I print only after I have signed off on the image, have completed proofing (I print my proof prints from Photoshop because that is where I make final corrections and adjustments that concern the printed image), and the image has been fractally scaled (using Genuine Fractals, now named Perfect Resize) to the sizes I print and saved as a PSD file.

This is because, as my final step before printing, I create a Midtone contouring layer. Midtone contouring must be size specific. All subsequent prints are printed out of Lightroom. If you use Lightroom for nothing other than printing, the ease of use makes it worth the price. (With regard to printing, this may change for me due to the improvements that Adobe has made in CS6.)

For the reason that I do these things, see the PDF: "The Why To of My How" that you can download from the download page for this book.

Many software-based adjustment tools, like the ones found in image editing software, do not necessarily follow all of the tenets of color theory. In such a case, logic-defying events may occur. It is by understanding how things were meant to work that you will be able to compensate for or use a software's peculiarities to your image's advantage. The Dalai Lama said, "Always learn the rules so you can break them properly." It is with this in mind that you should begin the next part of your journey through this book.

The Black and White on the Black & White Adjustment Layer in Photoshop

You can know the name of a bird in all the languages of the world, but when you're finished, you'll know absolutely nothing whatever about the bird... So let's look at the bird and see what it's doing—that's what counts. I learned very early the difference between knowing the name of something and knowing something.

—Richard Feynman

The Black & White adjustment layer, which was introduced into Adobe Photoshop in version 3 of the Creative Suite, has practically the same set of controls and functionality as that found in Lightroom and Adobe Camera Raw (ACR). The major difference is that in Lightroom/ACR there are two more color sliders (orange and purple) and cyan is called aqua. The Black & White adjustment layer (in Lightroom/ACR and Photoshop) works by using a weighted mix of color channels, depending on the hue to which any specific color is being converted. It first generates a grayscale image by mixing the Red, Green, and Blue channels in the same way that the Channel Mixer adjustment layer does when you check the Monochrome box in the Channel Mixer dialog box. The Black & White adjustment layer further attenuates the reds, yellows, greens, cyans, blues, and magentas. (I will discuss the Channel Mixer at great length later in this book.)

NOTE: The mix that is used by the Channel Mixer when you select Monochrome is 40% red, 40% green, and 20% blue. This approximates the mix for brightness from NTSC color (television) and the mix for sRGB and other similar color spaces.

To create a Black & White adjustment layer, click the Black & White icon or a Black & White preset in the Adjustments panel. Choose Layer > New Adjustment Layer > Black & White. In the New Layer dialog box, type a name for the adjustment layer and then click OK. The Black & White Adjustment Layer dialog box will come up.

NOTE: You can also choose Image > Adjustments > Black & White. But keep in mind that this method makes direct adjustments to the image layer and discards image information.

When the Black & White adjustment layer launches, the Black & White Adjustment Layer dialog box is set to its default mode.

NOTE: It is important to remember that defaults are not fixed and that they are meant to be changed and are merely reasonable, starting points.

The Black & White Adjustment Layer dialog box offers you the choice to: manually adjust the conversion using the color sliders, apply an Auto conversion, or select a previously saved custom mix (**Figure 5.1**).

The main dialog box is broken down into three main areas:

◆ Color sliders allow you to adjust the gray tones of specific colors in an image. Drag a slider left to darken or right to lighten the gray tones of an image's original color.

◆ Preset menu (**Figure 5.2**) allows you to select predefined grayscale mixes or a previously saved mix. To save a mix, choose Save Black & White Preset from the panel menu.

◆ Auto sets a grayscale mix based on the color values of the image, maximizing the distribution of gray values. The Auto mix often produces excellent results, or can be used as the starting point for tweaking gray values using the color sliders.

To adjust a particular color component, select the On-image adjustment tool and then click and hold it in the image. While continuing to hold, drag the slider left or right to modify the color for the predominant color at that location, making it darker or lighter

NOTE: If you are using the Black & White dialog box instead of the Adjustments panel, click and hold on an image area to activate the color slider for the predominant color at that location, and then drag the cursor horizontally to shift the slider.

Click the Reset button to reset all color sliders to the default grayscale conversion.

Preview: Deselect to view the image in its original color mode.

To apply a color tone, select Tint. To fine-tune the tint color, click the color swatch to open the Color Picker.

NOTE: The Black & White adjustment layer also allows you the ability to "tint" the chromatic grayscale image by applying a color tone to the image, e.g., create Cyannotype or sepia tone effects.

FIGURE 5.1 *The Black & White adjustment layer*

FIGURE 5.2 *The Preset menu*

According to Adobe, "The Black & White adjustment lets you convert a color image to grayscale while maintaining full control over how individual colors are converted." Perhaps a better way to describe the Black & White adjustment would be, "The Black & White adjustment converts a full color image into a chromatic grayscale one while allowing you to individually control the underlying luminance of the red, yellow, green, cyan, blue, and magenta color components of your image after the initial chromatic grayscale conversion is complete."

In Chapter 3, *Defying Logic* (specifically in the discussion about chromatic grayscale conversion in a RAW processor), you saw that this approach produced less than optimal results. In light of this, you might ask why I did not discuss the Black & White adjustment layer there rather than here. The answer is that even though the Black & White adjustment layer, which was born out of ACR and Lightroom's Black & White adjustment tool, has several peccadilloes, it is not the Black and White conversion tool that has the inherent flaw; it is the limitations of the RAW post-processing software that is the issue. Photoshop is a better tool for getting the most out of an image, and its Black & White adjustment layer can be a very useful tool, but where it is most useful may surprise you.

The Black & White Adjustment Layer Basics

A technically perfect photograph can be the world's most boring picture.

—Andreas Feininger

Before you move forward into this discussion of the Black & White adjustment layer, you should be aware of its layout and functionality. (See sidebar: *Roadmap of the Black & White Adjustment Layer*.)

The Black & White adjustment layer works by lightening and darkening, the reds, yellows, greens, cyans, blues, and magentas of the image. Do you remember the tenet that is the backbone of color theory and the foundation upon which color science is built? Hue is hue, saturation is saturation, and brightness is brightness. So the first peccadillo of the Black & White adjustment layer is that brightness may affect hue.

Of the six color controls available in the Black & White adjustment layer, three of the six (cyan, yellow, and magenta) are created with equal values of two of the other three colors (red, green, and blue). In other words, there is no green in blue and there is no blue in green, but there are equal values of green and blue in cyan, and so on. Also, there are three parts to a color: hue, saturation, and brightness. This means that if you plan to use only the Black & White adjustment layer, you may lose control over two of the three aspects of your image's color. When this happens, you address only the achromatic aspect of chromatic color (the light to dark aspect) and, as you saw in the previous chapters, hue and saturation play a big part in the creation of a chromatic grayscale image. Also, when you address only the grayscale component of color, you lose much of the control over what makes the objects in an image spectrally distinct. If you have two flowers of the same luminance, one pink and one yellow, and you remove all of their color, they will be the same gray. As you saw in Chapter 1 when you did a global desaturation of the image, what was lost was 100% of the Hue/Saturation, and 1% of file density. The point is that the 1% of density change in the file contained 100% of what differentiated one object from the other. You never want to give up control of the Hue/Saturation aspect of color and address only brightness.

Keep in mind that it is a lot less important to get as many grays as you can in a image than it is to get the grays right. The Black & White adjustment layer's Auto functionality will maximize the potential gray values in your image, often resulting in one that is fairly flat. However, an image with maximum grays can be put to best use by selectively darkening and lightening areas of the images by any means (as you have done in previous chapters), potentially using separate lightening and darkening Curves adjustment layers, applied selectively by using layer masks.

The Black & White adjustment layer uses spectral divisions (the most common way that wavelengths are divided into discernible hues) to impact the lightness/brightness of objects and does not adjust saturation in conjunction with the brightness of the objects. The saturation and brightness of an object should both play a part in the overall conversion from the original color image to the final chromatic grayscale. Since the Black & White adjustment layer does not provide a control for simultaneously controlling the saturation and the brightness of the object, you may not have enough control to fine-tune the tones to satisfy your artistic voice.

To understand the implications of this peccadillo of the Black & White adjustment layer when it comes to chromatic grayscale conversions, I will show you a file that demonstrates what goes on. For this part of the discussion of the Black & White adjustment layer, you will be looking at the image of the actress Challen Cates. The final chromatic grayscale image and the colors that created it are shown in the Comparison Tester image. In Chapter 3, you have already created an image using this technology and approach. Lightroom and ACR handle conversion in a very similar manner. Next, you will look more closely at how this approach works. You are doing this here rather than in Chapter 3, because Photoshop affords a better method to look under the hood. In other words, it does not have the limitations that RAW processors do.

The Basis of the Base Image

Before you go any further with this lesson, I highly recommend that you look at the 100 PPI copy of the master file entitled, CHALLEN_MASTER_CH05_100PPI.PSD. This file shows all of the work that was done to this image, specifically, all of the retouching steps and all of the steps of the Film and Filter approach to chromatic grayscale conversion. I did this to show you all of the actions that brought the image to the point where it was ready to convert to chromatic grayscale.

I used the Film and Filter approach for this image, because it is something with which you should now be very familiar. Also, using the Film and Filter approach will allow you to see just how many hue layers can be involved in creating the optimum chromatic grayscale image. At this point, you may be wondering if there might be a simpler way to do the conversion. Let me assure you that there may be

simpler ways, but knowing the correct way for the image on which you are currently working requires that you know all of them and understand how they all work.

Also, reviewing this file of Challen's image allows you to see what the colors actually look like that create the final chromatic grayscale image. What is important here to understand is that it is not merely about how one learns to *see* a color image as a chromatic grayscale one, but rather about understanding how to *bend* the colors to create the most appealing chromatic grayscale image (**Figures 5.3, 5.4,** and **5.5**).

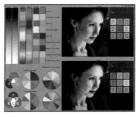

FIGURE 5.3 *The image showing the colors when the Film layer is turned off*

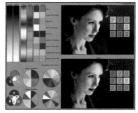

FIGURE 5.4 *The chromatic grayscale image when the Film layer is turned on*

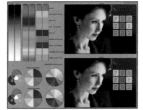

FIGURE 5.5 *The source image*

The comparison image used in this chapter consists of a series of control and variable images, color and grayscale bars, and color wheels.

With every scientific examination, I will utilize a control and a variable set of tools. For my examination of the Black & White adjustment layer, I have created a set of color gradient bars, color wheels, and images. The Control set will remain unchanged by the Black & White adjustment layer or other conversion techniques, and the variable set will reflect any changes made. The goal of the comparison image is to identify what the colors from the control sets convert to when undergoing a black-and-white conversion (**Figure 5.6**).

Starting from left to right, top to bottom:

The first two test bars are a grayscale ramp, which is a gradation of grays from solid black (0) to pure white (255) and all of the grays in between. The second set of test bars is a color gradient ramp, and the third set of test bars is a set of color squares made up of the colors ordered in the same way as the Control sliders in the Black & White adjustment layer. The last three colors of the test strip are made up of unequal RGB values. This is to see what happens to colors that are not made up of just the primary colors or equal values of the secondary colors.

Next to the Control bars is the Control image, which is the image as it existed before any conversion. Moving down are the Control and Change color wheel areas of the comparison tester image. The first set of color circles are made up of 255 Red, 255 Green, and 255 Blue. The color circles are set to the Difference blend mode atop a circular black background that is the same diameter as the individual red, green, and blue circles. By doing this this way, you can see that yellow, cyan, and magenta are created by mixing the red, green, and blue colors where they overlap. The RGB and CYM letters are created in the same manner. The first of the two wheels to the right of the color circles are made up of the colors in the last color test bar, and the second wheel is made up of more colors of varying levels of R, G, and B. The Change Image selection, to the right of the Change control, shows the image with the chromatic grayscale conversion applied.

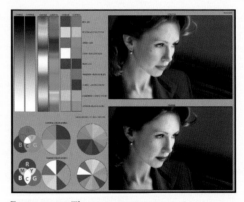

FIGURE 5.6 *The comparison image*

A Quick, Comparative Look at What Went on Before

We protect that which we love.

—Jacques Cousteau

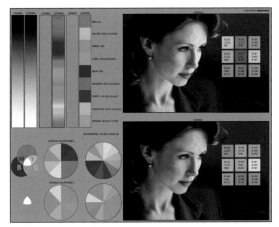

FIGURE 5.7 *Desaturation layer turned on*

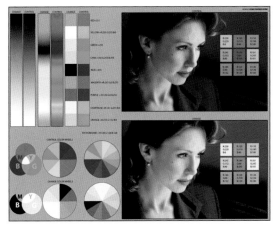

FIGURE 5.8 *Lab_CONVERSION_1 layer turned on*

To better understand the pros and cons of using the Black & White adjustment layer, look at some of the techniques that you have considered as they are applied to the test image for this chapter. Open the file BWA_COMPARISONS.psb (located in the Chapter 5 section of the download page). When you open this file, the folder SEPARATES will be the active one, and in it are several layers; all turned on. What you see is what happens to the colors when they go through different chromatic grayscale conversion processes.

1. In the SEPARATES layers group folder, the first layer is DESATURATION (**Figures 5.7**).

Notice how many of the colors in the Change color strips and color wheels have gone to 128 gray. You can also see that the Control color strips and color wheels are made up of different colors, but when desaturation is applied, many become the same gray. When that occurs, the information that initially caused them to be different is lost, as is any image structure detail. Also, notice that the Change gradient strip is 128 gray, as are the Change RGB color wheels. Additionally, the RGB/CMY letters have disappeared and have also become 128 gray. (Once again, if you have two flowers of the same luminance, one pink and one yellow, and you remove all of their color, they will be the same gray.)

2. Turn off the DESATURATION layer and the next layer that is visible is Lab_CONVERSION_1 (**Figure 5.8**).

After Step 2, you will see that the background that was R:128, B:128, G:128, became R:158, B:158, G:158. In other words, the background became lighter than any other part of the test image. That is, red took on same gray value as the background. Also, the blues went black and any color that contained blue appears to have darkened. Those colors that contained both red and blue became lighter. Obviously, this conversion approach appears to have had a greater impact on colors with reds in them than on colors with blue. Also, of all of the conversion approaches that you have done so far in this book, this is the only one that causes a lightening of the grayscale ramp. Though it may appear that more color information detail is preserved in this conversion process, not every image you convert this way will have this particular gray set. With this conversion approach, the issue is that you have little to no control over what happens in the conversion process. Lastly, as I discussed in the sidebars *From the Horse's Mouth: Color Scientist Parker Plaisted on Explaining Lab vs.* RGB and *As Easy as Falling Off a Log—The* ABCs *of Lab and* RGB, Lab is a logarithmic color space

and RGB is a linear one. You should have already observed that chromatic grayscale conversions are better done in an RGB color space. This is because RGB color spaces are linear (see sidebar: *Terms of Engagement* in Chapter 1), and that allows for greater control of the conversion process.

3. Turn off the Lab_CONVERSION_1 layer and the next layer visible is Lab_CONVERSION_2 (**Figure 5.9**).

Here, the background returns to R:128, B:128, G:128, and anything that is 255 red is gone. The grayscale gradient returns to being unaffected, but there appears to be a significant loss of file information.

4. Turn off the Lab_CONVERSION_2 layer and the next layer is CONVERT_TO_GRAYSCALE (**Figure 5.10**).

Notice here that nothing changes. The Lab conversion approach 2 and the way that Photoshop converts to grayscale are the same.

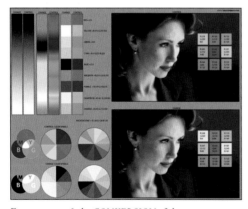

FIGURE 5.9 *Lab_CONVERSION_2 layer*

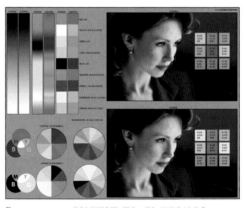

FIGURE 5.10 *CONVERT_TO_GRAYSCALE layer*

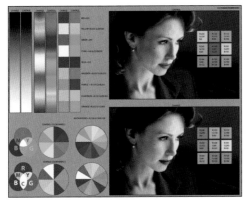

FIGURE 5.11 *FILM_&_FILTER layer*

FIGURE 5.12 *FILM_&_FILTER_COLOR layer*

5. Turn off the CONVERT_TO_GRAYSCALE layer and the next layer visible is FILM_&_FILTER (**Figure 5.11**).

Here, you should see a significant difference between this conversion and the previous ones. None of the colors disappeared or became 128 gray. The colors in the RGB color wheel show as separate grays with different values, as is the case with all of the other colors. In other words, each color has been translated into a different gray.

6. When you turn off the FILM_&_FILTER layer, the next visible layer is FILM_&_FILTER_COLOR (**Figure 5.12**).

Here, you see a shift in colors in the color bars, gradients, and wheels that create the chromatic grayscale image. Also, the colors that have created the black-and-white image (our base comparison image), are decidedly different than the colors of the image before it went through the Film and Filter chromatic grayscale conversion process. Using this conversion process allows you to control the hue and saturation, as well as the brightness, of the colors that make up the image. By having control of all three aspects of color, you have the ability to access all of the image detail and image structure that exists in the light to dark aspects of the colors.

NOTE: There are some additional layers in this layer set folder that I will discuss a bit later in this chapter.

A Not So Quick, Comparative Look at What Goes on Between Channels, the Channel Mixer and the Black & White Adjustment Layers

We cannot protect that which we do not yet understand.

—Jean-Michel Cousteau

Now that you have a visual base line, you will look at the individual Red, Green, and Blue channels separated out, the expression of the Red, Green, and Blue channels in the Channel Mixer, and the Black & White adjustment layer's expression of red, green, and blue.

7. Turn off the SEPARATES layers group folder, and turn on and open the RGB_COMPARE layers group folder.

In this folder, you will find three other folders: RED, GREEN, and BLUE. Each of these folders contain three layers: one that shows the channels split out, one that shows the Channel Mixer adjustment layer, and one that shows the equivalent Black & White adjustment layer applied.

NOTE: A color channel is a pure grayscale representation of the color of that channel. As I previously discussed in this chapter, a pure grayscale image does not contain a true white or a true black, just light tones or dark ones. Color channels are grayscale images representing the tonal values of the color components in an image (RGB or CMYK). It is not until the channels are combined that colors are created, including a black and a white.

The Channel Mixer adjustment layer's options modify a targeted (output) color channel using a mix of the existing (source) color channels in the image. When you use the Channel Mixer (from a source channel), you are adding grayscale data to or subtracting grayscale data from the targeted channel. You are not adding colors to or subtracting colors from a specific color component.

The Channel Mixer Adjustment layer will be discussed at considerable length in Chapter 7 of this book.

8. In the RED folder, observe the RED_CHANNEL layer. Turn off that layer (click on the eyeball) and observe the difference between the RED_CHANNEL layer and the layer beneath it; the RED_CHANNEL_MIXER layer. You should see no difference.

9. Turn off the RED_CHANNEL_MIXER layer so that the BWA_RED layer is visible and observe the difference.

You should see a noticeable one. Even though the BWA_RED layer is red and, in the part of the Black & White adjustment layer that created it, it is called the Red Filter (just as it is in the Channel Mixer), it is visually different. First, there appears to be a little more detail in the midtones, and the Change gradient ramp in the test image has been shortened. In the Change color squares, the cyan square shifts from a gray to a solid black, and the purple and chartreuse squares lighten. There is also a series of shifts in the two Change divided color wheels.

10. Turn off the RED folder. Repeat Steps 8 and 9 for the GREEN folder.

Again, just as you saw with the Red layers in the previous set of steps, even though the BWA_GREEN layer is Green and, in the Black & White adjustment layer it is called the Green Filter (just as it in the Channel Mixer), it too is visually different. The BWA_GREEN layer exhibits an even greater difference between it and the GREEN_CHANNEL and GREEN_CHANNEL_MIXER layers than you saw with the Red.

As you look at the tone shifts among the BWA_GREEN layer, the GREEN_CHANNEL layer, and GREEN_CHANNEL_MIXER layer, there appear to be

significantly more grays in the last two than there is in the BWA_GREEN layer. The red and blue circles of the RGB color circles are black and the green is white. Only the B and Y letters are visible, and B shows as white, while Y shows as black. In the Green Filter of the Black & White adjustment layer, the red circle becomes 128 gray, the blue is black, and there are varying levels of gray in the cyan, green, and yellow areas. Also, M is the only letter that is not visible and the letter B is gray instead of white. The image of Challen is also much lighter than it is in the Green Channel and Green Channel Mixer adjustment layers. There are also considerable changes in the Change color gradient and color squares.

The Change gradient shifts from mostly black and white to various shades of gray, and in the red area of the ramp (which shows as black in the two Channel layers), the Change gradient shows as a light gray. In the Change color squares, the red square shifts from black to a mid gray; the cyan, green, and orange squares lighten; and there are a series of shifts in the two Change divided color wheels.

11. Turn off the GREEN folder. Repeat Steps 8 and 9 for the BLUE folder.

Of the three layer sets, the blue set of layers shows the closest to no change. The change, although it is a subtle one, is significant. If you look at the Change gradient ramp, you will see it shorten in the Black & White adjustment layer's expression of the Blue Filter. Also, in the Change color squares, the cyan square shifts from light gray in the Channels layers to white, there are similar shifts in the color wheels, and the image darkens and loses some detail in the Black & White adjustment layer (**Figures 5.13**, **5.14**, **5.15**, **5.16**, **5.17**, **5.18**, **5.19**, **5.20**, and **5.21**).

As you can see, there are some major differences between the Black & White adjustment layer, the individual color channels, the Channel Mixer layers (in which there was never a difference between the Color channel and the Channel Mixer), and in what are the Red, Green, and Blue Filters of the Black & White adjustment layer. So the question that begs to be asked is, "Is it possible to match the Black & White adjustment layer's tonal ranges to those of the channels of an image or to the Channel Mixer?" (Again, I will discuss the Channel Mixer at greater length in Chapter 7.) The answer is that it is possible (see the Note that follows), but there is no reason to do so, because this is not the goal of the Black & White adjustment layer. The goal of the Black & White adjustment layer is to convert your image to chromatic grayscale, and then give you a set of tools to control the tonality of an image by blending the tone of each color. What is at issue is the way the Black & White adjustment layer blends those tones together, because, if you are not careful, blending the tones can cause artifacting.

NOTE: You can fairly closely (but not exactly) match the Black & White adjustment layer to the image's channels. To match the color mixer and individual channels: for Red, use a mix of Red:100, Yellow:100, Green:0, Cyan:0, Blue:0, and Magenta:100; for Green, use a mix of Red:0, Yellow:100, Green:100, Cyan:100, Blue:0, and Magenta:0; and for Blue, use a mix of Red:0, Yellow:0, Green:0, Cyan:100, Blue:100, and Magenta:100.

FIGURE 5.13 *The Red channel layer*

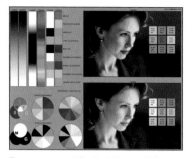

FIGURE 5.14 *The Red Channel Mixer adjustment layer*

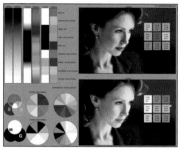

FIGURE 5.15 *The B&W adjustment layer set to the Red filter*

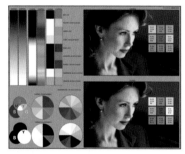

FIGURE 5.16 *The Green channel layer*

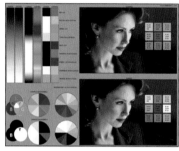

FIGURE 5.17 *The Green Channel Mixer adjustment layer*

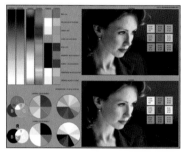

FIGURE 5.18 *The B&W adjustment layer set to the Green filter*

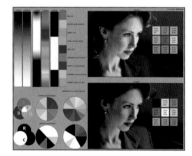

FIGURE 5.19 *The Blue channel layer*

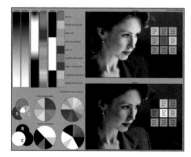

FIGURE 5.20 *The Blue Channel Mixer adjustment layer*

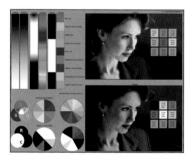

FIGURE 5.21 *The B&W adjustment layer set to the Blue filter*

What Happens When You Shift the Colors and Try to Play an Achromatic Scale

Good judgment comes from experience. Experience tends to be the outcome of bad judgment.

—Tad Z. Danielewski

When you look at the test image once again, there appear to be a lot of gray areas when it comes to the Black & White adjustment layer, so it is time to take a closer look at how it works. First, the Control sliders for the Black & White adjustment layer affect six colors. Second, three of the Control sliders select a color range described by a single color: red, green, or blue; the primary colors of light. Third, the other three Control sliders describe colors that can be created only by combining two primary colors together. These, known as secondary colors, are yellow (a combination of equal parts red and green), cyan (a combination of equal parts green and blue), and magenta (a combination of equal parts red and blue).

Besides the loss of direct control of saturation and hue that occur with the Black & White adjustment layer, or the loss of control of two of the three components of color, there is an overlap or bleed effect among the colors. In other words, when you make an adjustment to red, yellow, green, cyan, blue, or magenta, you may also cause an unwanted effect on other colors. In this next series of steps, you will see this in action. What you will also see is that there is no consistency with which it happens. In spite of this, you can get acceptable results using the Black & White adjustment layer. But if you are not aware of how this adjustment layer works, you can unknowingly and easily create less than acceptable results.

1. Open the file BWA_TEST.psb (located in the folder that you downloaded for this chapter from the download site).

2. If it is not already, make the CHANGE_BASE layer the active and visible one.

NOTE: Do this so that the Control layer is not affected. Make sure that all of your adjustments occur between the CHANGE_BASE and CONTROL_LAYER layers.

3. Go to the Adjustment panel (or the Create an Adjustment Layer icon located at the bottom of the Layers panel) and create a Hue/Saturation adjustment layer. Click on the Saturation slider and move it all the way to the right so that the Saturation is 100% (**Figures 5.22** and **5.23**).

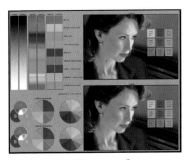

FIGURE 5.22 *The image after moving the Saturation slider to 100%*

FIGURE 5.23 *Moving the Saturation slider to 100%*

FIGURE 5.24 *The Black & White adjustment layer icon*

FIGURE 5.25 *The Black & White adjustment layer controls*

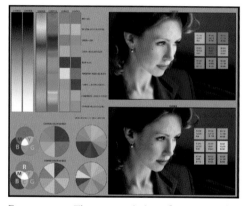

FIGURE 5.26 *The image with the Default settings for the Black & White adjustment layer*

This technique is a quick, effective way to analyze the color of an image whenever you want to see what comprises its actual color components. For example, Challen's skin tones in the Control image appear to be made up of mostly pinks, which means that they should contain a fair amount of red. But when you moved the Saturation slider to 100%, in the Change layer, you see that they are more yellow than anything else. Her jacket is more blue than cyan, the bench contains greens and darker cyans in the lower right corner than you would expect, and there are no magentas in the image. There are, however, a lot of reds and yellows that cause some of the areas to appear orange. You might want to use this technique in the future so that you have a point at which you can begin the adjustment process for your image. Using this technique helps to minimize a lot of the guesswork.

4. Turn off the Hue/Saturation adjustment layer.

5. Go to the Adjustment panel (or the Create an Adjustment Layer icon located at the bottom of the Layers panel) and create a Black & White adjustment layer (**Figures 5.24** and **5.25**).

6. Make sure that the Hue/Saturation adjustment layer is between the BASE_CONTROL and Black & White adjustment layers. When the Black & White adjustment layer opens, it is set to Default and you should see this (**Figure 5.26**).

Notice that the red, green, yellow, and cyan are almost the same gray in the RGB Change wheels. Also, in the Change gradient bar, the magenta part of the gradient is the lightest and in the Change color bars, the purple, chartreuse and orange color squares are almost the same gray with little separation between them.

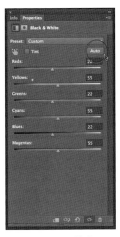

FIGURE 5.27 *Clicking on the Auto button*

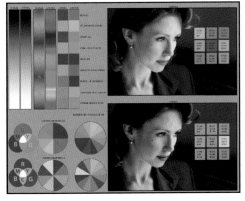

FIGURE 5.28 *The image after clicking on the Auto button*

7. Create a Master layer (Command + Option + Shift + E / Control + Alt + Shift + E). Name this new layer DEFAULT and turn it off.

8. Make the Black & White adjustment layer active. Click the Auto button located in the upper right of the Black & White adjustment dialog box (**Figure 5.27**). You should see this (**Figure 5.28**).

9. Create a Master layer (Command + Option + Shift + E / Control + Alt + Shift + E), name it AUTO, and turn it off.

In the RGB Change wheels, the red and green become a darker gray, as do the magenta, yellow, and cyan. The Change gradient and color squares bars show a change as do the Change color wheels, but there is no change in the blue parts of the test strips and wheels. Also, the middle gray background of the test image (made up of R:128, G:128, B:128) does not change. There is a significant change in the purple, chartreuse and orange color squares; they are all darker and there is slightly more separation among them. In addition, the magenta part of the Change gradient strip is much darker. Lastly, aspects of Challen's image do darken, but not to the extremes of the test strips and wheels. Mostly, just the shadow areas and her jacket darken.

If you compare the DEFAULT Master layer to the Black & White adjustment layer, the latter has more levels of gradation. This is because the Auto button is designed to create the maximum amount of gray in an image. Even though the goal is often to have as many tonal gradations as possible in an image, if all you do is press Auto and move on, conceptually you are no better off than if you did a convert-to-grayscale conversion in Photoshop where you have no control over the conversion process. Defaults are meant to be jumping off points and are not written in stone.

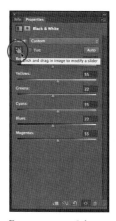

FIGURE 5.29 *Selecting the Scrubbing slider*

FIGURE 5.30 *Adjusting the Blue slider to -96*

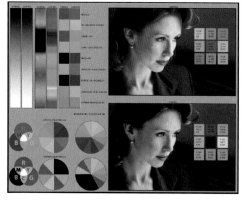

FIGURE 5.31 *The image after moving the Blue slider*

In this next step, you will see what happens when you manually change the colors of the image.

10. Making sure the DEFAULT and AUTO Master layers are turned off and the Black & White adjustment layer is active, click on the Scrubbing slider in the Black & White adjustment dialog box (**Figure 5.29**).

The Scrubbing slider allows you to adjust the colors of an image by placing the eyedropper icon on the area that you want to alter. By moving the Scrubbing slider to the left, you darken the image. (The numbers will move from 0 to -200.) When you move the Scrubbing slider to the right, you lighten the image. (The numbers will move from 0 to +300.)

11. Select any area in Challen's jacket.

No matter which area you select, the Color Selection tool will select the Blue slider.

12. Click-drag the slider to the left until the value in the Blue slider is -96 (**Figure 5.30**). You should see this (**Figure 5.31**).

The Blue part of the RGB Change wheel should appear black. The blues and purples in all of the Change color wheels, Change color squares, and the gradient bar should all be black. In addition, the black appears to move into magenta and cyan areas. The pure magenta and cyan areas in all of the test Control strips and wheels are preserved. The overall manifestation of the change is that Challen's jacket appears darker.

13. Click on the Cyan slider in the Black & White Adjustment dialog box.

14. Click-drag the slider to the left until the value in the Cyan slider is -98 (**Figure 5.32**). You should see this (**Figure 5.33**).

FIGURE 5.32 *Moving the Cyan slider to -98*

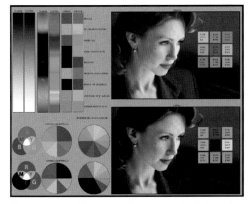

FIGURE 5.33 *The image after moving the Cyan slider*

FIGURE 5.34 *The shoulder before the adjustment*

FIGURE 5.35 *The shoulder after the adjustment*

The blue and cyan parts of the RGB Change wheel are black as is the letter B that is no longer visible. The blues and purples in all of the Change color wheels remain black, while the cyan wedges have shifted to dark gray. The blues appear black in the Change color squares bar and the gradient bar and the blackness appears to have moved even further into the magenta areas, completely through the cyan areas, and well into the green areas when compared with the changes after clicking on the Auto button in Step 8. (Use the AUTO Master layer that you created in Step 9 to compare.) The pure cyan area is now black in all areas of the test control strips and wheels, but the pure magentas are still preserved. The overall manifestation of the change is that not only does Challen's jacket appear darker, but that part of the bench where you saw greens and dark cyans (when you analyzed the colors with the Hue/Saturation adjustment layer in Step 3) is now darker.

But there is an even more significant issue; noise has been introduced into the image. Here is a close-up of Challen's right shoulder before Steps 13 and 14 (**Figure 5.34**) and after those steps (**Figure 5.35**).

This artifacting issue results from the bleed among the colors. At the beginning of this discussion, I explained that three of the colors controlled by the Black & White adjustment layer are made up of one color: red, green, and blue. The other three colors (yellow, cyan, and magenta) are made up of two of the primary ones and are known as secondary colors. In other words, two aspects of the same tool effect a change on the same area.

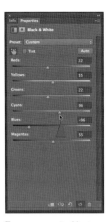

FIGURE 5.36 *Moving the Cyan slider to 96*

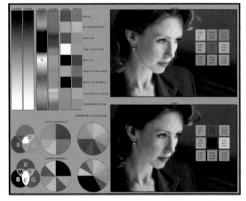

FIGURE 5.37 *After moving the Cyan slider to 96*

FIGURE 5.38 *The shoulder before the adjustment*

FIGURE 5.39 *The shoulder after the adjustment*

Noise artifacting is not the only issue. For example, if you darken or lighten an object or area with a primary color, and lighten or darken another area using a secondary color slider that includes the primary color from the first adjustment (or vice versa), you may lose image structure detail.

15. Click on the Cyan slider in the Black & White Adjustment dialog box and drag the slider to the right until it has a value of 96 in the Cyan slider dialog box (**Figure 5.36**). You should see this (**Figure 5.37**).

The cyan part of the RGB Change wheel is white, as is cyan in all the other test bars and color wheels. The letter B is also white. The overall manifestation of the change in the image is that Challen's jacket appears lighter, and that part of the bench where you saw greens and dark cyans is back to the way it appeared before you started adjusting the blues and cyans. However, if you look closely at the right shoulder of Challen's jacket, you will see a loss of detail and that the grays appear flat or muddy (**Figures 5.38** and **5.39**).

You have just seen a subtle expression of the issues. Next, you will see these problems manifest themselves in a much more pronounced way. You have seen that, although the skin tones in Challen's image appear to be made up of pinks, when you brought the image's colors to their maximum saturation values, they appeared to be made up of mostly yellows with some that were more reddish-yellow. In this next series of steps, you will see what happens when you adjust the yellows and reds using the Black & White adjustment layer.

16. Set the cyans back to -98. (This will darken Challen's jacket.)

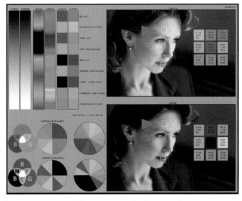

FIGURE 5.40 *The image with the sample sqaures*

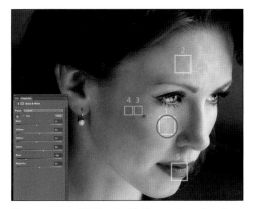

FIGURE 5.41 *Clicking inside Square 1 to select the Yellow slider*

FIGURE 5.42 *Moving the Yellow slider to -3*

17. Turn on the SAMPLE_SQUARES folder. This will turn on a set of squares and numbers to help you select the same area that is being discussed in this book. You should see this (**Figure 5.40**).

18. In the Toolbar, click on the Eyedropper tool and select the Color Sampler tool. This will make the sample points visible, and if you look at the Info panel, the numbers there show where the sample points are located.

19. Make sure that the Scrubbing slider is on. (To do this, click on the icon located in the upper left-hand corner of the Black & White Adjustment dialog box.)

20. Zoom into the model's face so that it fills the frame (Command + Space Bar / Control + Space Bar) and click-drag the area into which you want to zoom.

21. Click on an area inside the Square 1 box. This should immediately select Yellow in the Black & White Adjustment dialog box (**Figure 5.41**).

22. Click-drag the Scrubbing slider to the left until you reach a value of -3 (**Figure 5.42**).

23. Click on an area in Square number 2. Once again, the Yellow slider is selected (do not make an adjustment) (**Figure 5.43**).

FIGURE 5.43 *Clicking inside Square 2*

24. Click on an area in Square number 3. Once again, the Yellow slider is selected (do not make an adjustment) (**Figure 5.44**).

25. Click on an area in Square number 4. This time the Red slider is selected (**Figure 5.45**).

26. Click-drag the Scrubbing slider to the left until you reach a value of -3 (**Figure 5.46**).

You can see that going from an acceptable image to one not visibly appealing can happen very quickly. This occurred because red is made up of just one color, whereas yellow is made up of equal values of red and green. You have just witnessed what happens when two parts of the same tool do not necessarily work in concert. You have also seen that artifacts have been introduced that seem to undo all of the retouching work you did to this image before the conversion process.

If the Black & White adjustment layer is the tool that you choose to use in your conversion approach, you need to pay great attention to this issue. By looking at the test strips and test color wheels, you can see that this issue has a way of dramatically affecting areas of color of which you may be unaware or that you might not want affected.

FIGURE 5.44 *Clicking inside Square 3*

FIGURE 5.45 *Clicking inside Square 4*

FIGURE 5.46 *Moving the Red slider -3*

The Black and White on Using the Black & White Adjustment for Color

In this next section, I examine using the Black & White adjustment layer to extract hard–to–remove colors. This tool is uniquely suited for this purpose.

This is an opportunity for me to remind you that whenever you learn something, do not assume that what you are learning has merely one application. Accumulate knowledge as if each piece of it is a grain of sand meant to mix with other grains of knowledge in an ever-changing pattern. If you allow yourself to accumulate enough grains, frequently you will find yourself on the beach of epiphany and the shore of enlightenment.

Image 1

1. Turn off the Black & White adjustment layer with which you have been working.

2. Zoom out to Full Size Image (Command + 0 / Control + 0).

3. Make the Control Base layer the active one.

4. Create a new Black & White adjustment layer and select the Luminosity blend mode from the Blend Mode pull-down menu located at the top left of the Layers panel. (You should see the chromatic grayscale image go to full color.)

5. Turn on the Scrubbing slider. (To do this, click on the icon located in the upper left-hand corner of the Black & White Adjustment dialog box.)

6. Click on any area of Challen's jacket in the Change image. The Scrubbing slider will be set to Blue. Move the Scrubbing slider to the left until it has a numerical value of -80 (**Figure 5.47**).

7. In the Black & White Adjustment dialog box, click on the Cyan slider until it reaches a value of -98 (**Figure 5.48**).

FIGURE 5.47 *The image after moving the Blue slider to -80*

FIGURE 5.48 *The image after moving the Cyan slider to -98*

8. Click on any area of Challen's lips in the Change image. The Scrubbing slider will be set to Red. Move the Scrubbing slider to the right until you get a numerical value of 14 (**Figure 5.49**).

9. Click on Challen's forehead in the Change image. The Scrubbing slider will select Yellow. Move it to the right until you get a numerical value of 103 (**Figure 5.50**).

10. Make the layer mask of the Black & White adjustment layer active, and fill it with black.

11. Select the Brush tool, set the opacity to 100% (for this image), and brush in Challen's face, neck, hair, and jacket (**Figures 5.51** and **5.52**).

FIGURE 5.49 *The image after adjusted the Red slider to 14*

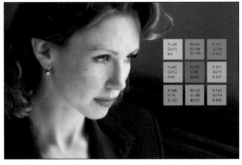

FIGURE 5.51 *The image after the brushwork*

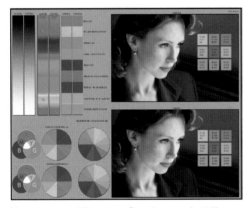

FIGURE 5.50 *The image after adjusting the Yellow slider to 103*

FIGURE 5.52 *The layer mask after the brushwork*

FIGURE 5.53 *The Moab image*

FIGURE 5.54 *The area of importance*

FIGURE 5.55 *The green leaves to use for the adjustment*

Image 2

In this next image, you will use the Black & White adjustment layer to extract image structure from a background in which the structures have similar brightness values, but are too small to mask.

1. Open the file MOAB.psb (**Figure 5.53**).

2. Zoom into the right side of the image and make the bush fill the frame (Command + Space Bar / Control + Space Bar) and click-drag the area into which you want to zoom (**Figure 5.54**).

3. Create a new Black & White adjustment layer and select the Luminosity blend mode from the Blend Mode pull-down menu located at the top left of the Layers panel.

4. Select the Scrubbing slider. (To do this, click on the icon located in the upper left-hand corner of the Black & White Adjustment dialog box.)

5. Click on the greenish leaves of the bush. The Scrubbing slider will be set to Yellow. Move the Scrubbing slider to the right until it has a numerical value of 161 (**Figures 5.55** and **5.56**).

FIGURE 5.56 *The image after increasing the Yellow slider to 161*

FIGURE 5.57 *The image before the brushwork*

FIGURE 5.58 *The image after the brushwork*

6. Make the layer mask of the Black & White adjustment layer active, and fill it with black.

7. Select the Brush tool, set the opacity to 50% (for this image), and brush in the bush (**Figures 5.57** and **5.58**).

As you have seen in these two images, the Black & White adjustment layer in the Luminosity blend mode does a nice job of selecting color. In conjunction with the Black & White adjustment layer's attached layer mask, you can further fine-tune an image.

Before you go on to Chapter 6, I want you to see one last set of comparisons. If it is not still open, open the BWA_COMPARISONS.psb file. In the SEPARATES folder is a folder named ADJUSTMENTS in which you will find the last series of comparisons at which I would like you to look. The first is the Default setting, the second is the Auto setting for the Black & White adjustment layer, and the third creates a layer filled with equal values of RGB, in this case R:128, G:128, and B:128 set to the Color blend mode.

You see that of the three, the Default for the Black & White adjustment layer produces brighter gray values than does the Auto selection in the Black & White adjustment layer. It is the Auto selection in the Black & White adjustment layer that results in the maximum number of grays that appear to be well defined in the color wheels and color bars. So, if all you want out of an image is a maximum number of gray values, this approach does a better job than using the Black & White adjustment layer.

Conclusion

Learning, like a diamond, is forever.

—Richard Zakia

Using the Black & White adjustment layer is a better way to convert an image from full color to chromatic grayscale than are Lab conversions (Chapter 4), Convert to Grayscale (Chapter 4), or simple image desaturation (Chapter 1). Using the Black & White adjustment layer is also the better way to go (even with the loss of the two color sliders [orange and purple]) than is using the ACR/Lightroom version of this algorithm (Chapter 3). It follows then that using the Black & White adjustment layer is a viable way to convert an image from full color to chromatic grayscale if you understand the peccadilloes and how to work with or around them (as is the case with any plug-in or piece of post-processing software). Also, the Black & White adjustment layer comes with a series of default presets, and though it is important to remember that defaults are meant as a starting point from which to leap, in the case of this plug-in, do not leap too far.

The types of images that are best converted using the Black & White adjustment layer are those that are not highly colorful, like those captured with digital cameras that are modified to shoot infrared and landscapes that have easily definable image structures (e.g., where the sky is well separated from the foreground or where mountains do not have a lot of different colors). It is also a good tool to use for images in which you will not need to shift or boost saturation in the underlying color image, or images for which you are more interested in obtaining the maximum numbers of gray than you are in obtaining the maximum amount of detail in the image structure. Another important use of the Black & White adjustment layer is as a quick way to help you decide your strategy for a chromatic grayscale conversion.

The Black & White adjustment layer is also useful in extracting hard-to-remove colors or separating them from the background. It is important to note that using a chromatic grayscale conversion in the Luminosity blend mode to address issues of color is something you might want to consider with any chromatic grayscale conversion approach, not just those that I have used as examples.

What I hope you will take away from these exercises is that a technique that is conceived to perform one function, may be found to be useful for any number of others. It is important to play and experiment with a tool to see what happens when you push that tool to its limits or use it in a manner for which it was not intended.

Finally, regardless of whether the image is made up of achromatic colors (grays) or chromatic colors (full-spectrum colors), how you free your vision from the image follows the same rules as a street fight; there is only one rule—there are no rules. You do what you have to do to create the image that best expresses your vision's voice in print.

The Black and White on the Zone System

Without visualization, the Zone System is just a five-finger exercise.

—Ansel Adams

I believe that any discussion of black-and-white conversion techniques that does not contain a discussion of the Zone System is not a serious one. In the days of film, if you were a serious black-and-white photographer, you were a practitioner of the Zone System. To me, the Zone System is among the most inspired ideas in photography. If it were not for the Zone System and what has been a lifelong pursuit of perfecting its practice, I believe that I would not be the photographer I am today. I cannot repay the debt of gratitude that I have for those who created it and those who taught me how to use it.

Zoning in on the Zone System

There have been many volumes written about the Zone System, from simple, meant-to-be-easy-to-use "how to" field guides to in-depth treatises on the physics behind it. I have chosen to leave the in-depth discussions of the technical aspects of the Zone System to others and will describe here only its basics.

The Zone System is a method for controlling and optimizing tones during the exposure and processing of film so that they appear as you wish them to in the final print. The Zone System solved one of the greatest conundrums of photography—how to provide a way to expose and develop a silver negative such that what you visualized at the moment of capture could be rendered in your print. Prior to this, the reality of the print might not have reflected the reality of the original scene. This happened primarily because negative film has a greater latitude of exposure (an expression of how many levels of gray it can record) than photographic paper can reproduce. In other words, paper frequently cannot reveal the amount of information contained in a negative.

The Zone System allows you to control the considerable dynamic range of film (See the sidebar: *The Dynamics of the Highs and Lows of Dynamic Range* in this chapter) by manipulating its exposure and development so that the information in the negative is compressed in such a way that you can create a printed image of what you visualized at the moment of capture. In the digital domain, there are fewer limitations. If you can imagine something, there is a set of keystroke combinations that, with a little brushwork, render *impossible* into merely an opinion.

My reason for discussing the Zone System at this point in the book is to give you an understanding of the reasons for making the choices that you will make as you execute the techniques in Chapter 7 and 8. Additionally, I want to provide you with a definition of the terms that I use when discussing those choices.

Flipping the Switch on the Zone System

You use the Zone System to expose a negative by first looking at the scene to be photographed and deciding what areas of it you want to be black, very dark gray, dark gray, middle gray, light middle gray, very light middle gray, extremely light gray, and white in the final print. For silver-based, analog photography, the description of each zone for exposure is as follows.

Definitions of the Zone System for Exposure

Zone 0 is pure black with no detail.

Zone I is near black and may show some small signs of image detail, but it is generally regarded as having no identifiable image structure.

Zone II is considered to be a near black, but where Zone 0 and Zone 1 have no identifiable image structure, in Zone II you begin to identify texture in the shadows, although it is difficult to discern image details.

Zone III is the zone in which shadow details are easily recognized.

Zone IV is the zone in which full texture and image structure details are visible in areas that are lighter than those in deep shadow, but darker than those with mid-tone grays.

Zone V is called middle gray and represents 18% reflectance. The Kodak gray card can be used as an exposure guide for this zone.

NOTE: There is some debate on this point. Many believe that 12% gray is more representative of middle gray than is 18% gray. (There is some evidence that light meters actually meter for 12% and not 18%.) But, as the Zone System was originally conceived, Zone V equals 18% gray.

Zone VI is the zone in which strong image structure and texture detail exists in light gray areas.

Zone VII is the zone in which you should place the lightest gray areas and highlights for which you want to preserve important image structure detail and highlights with textures.

Zone VIII is to highlighted image structure and texture as Zone II is to shadow image structure and texture—a zone with very light gray tones in which it is difficult to make out image details.

Zone IX is to highlighted image structure and texture as Zone I is to shadow image structure—almost pure white but not quite. It has extremely light gray tones with just hints of image structure and texture.

Zone X is pure white and contains as much usable detail as Zone 0.

Precision and Accuracy—The Struggle between Veracity and Reproducibility

Different devices capture a differing number of tones. For example, our eyes record many more tones than does a piece of photographic paper. But there are devices that can reproduce 15,849 levels of gray (or have a capture Dmax of 4.2), which is beyond our eyes' ability to differentiate, so all that precision is lost to us.

NOTE: Dmax is a numeric expression of the maximum density or the darkest recordable tone that can be obtained with a particular light-sensitive device, while Dmin is the minimum density or the lightest recordable tone that can be obtained. While the theoretical Dmax of film (4.0) is capable of producing 10,086 different grays, commonly it has a Dmax of 3.0 that is capable of producing 1,024 grays. The Dmax of silver-based photographic paper (2.2) is capable of producing only 158 grays. The Dmax scale works in the same manner as the Richter Scale. Each full numerical increase is an order of magnitude greater.

In my opinion, precision does not necessarily yield accuracy. Accuracy is how close to the true value you are. When it comes to creating an image, the accuracy or the degree of veracity with which you convey your emotional experience at the moment of capture is far more important than the precision with which you reproduce the scene.

There are some important differences between the implementation of the Zone System for exposure and the implementation of the Zone System for output. For example, when determining exposure a Zone System practitioner prefers to use a light meter, known as a spot meter, that measures light in a 1° angle of incidence. The photographer meters the shadow areas for placement in Zone III and meters where, on the Zone System scale, the highlight areas fall. (In theory, there are 11 zones, but when it comes to exposure, generally you concern yourself with only nine of them.) If the highlight area does not fall in Zone VIII, the photographer will adjust development times accordingly. (If you wish to know more about adjusting development times, I refer you to one of the many Zone System books or manuals.) If the shadows are in Zone III and the highlight areas fall in Zone VIII, then the photographer develops the negative for what he/she has determined to be the normal development time for that particular film.

When I was taught the Zone System, the hallmark of a properly printed image was that it included image structures in Zone II (textured blacks) and in Zone IX (textured whites). But there are more grays in a print than just the nine (or 11, if you include Zone X—paper white [the paper base with no tones in it]—and Zone 0—paper black [the darkest possible tone the paper can produce containing no image structure]) that the Zone System describes. A somewhat simplified explanation is that the distance from one zone to the next represents one f/stop or shutter speed, so that each zone is one stop more or less than the zone on either side of it. That means that Zone V is two stops lighter than Zone III and one stop darker than Zone VI. However, there are many levels of gray that exist in the print between each zone. A silver-based photographic paper with a Dmax of 2.2 has the ability to reproduce 158 levels of gray. The Zone System accounts for only 11 of them. That leaves 147 levels of gray unaccounted for. It is important to remember that the other 147 levels of gray are there because there are more than 11 grays in an image—and the more levels of gray, and the deeper the black, the more visually compelling the print.

Ansel Adams' Definitions of the Zone System for Prints

As described in his book, *The Negative*, 1981, p. 60.

Low Values

Zone 0—Total black in print.

Zone I—Effective threshold. First step above complete black in print, with slight tonality but no texture.

Zone II—First suggestion of texture. Deep tonalities, representing the darkest part of the image in which some slight detail is required.

Zone III—Average dark materials and low values showing adequate texture.

Middle Values

Zone IV—Average dark foliage, dark stone, or landscape shadow. Normal shadow value for Caucasian skin portraits in sunlight.

Zone V—Middle gray (18% reflectance). Clear north sky as rendered by panchromatic film, dark skin, gray stone, average weathered wood.

Zone VI—Average Caucasian skin value in sunlight, diffuse skylight, or artificial light. Light stone, shadows on snow in sunlit landscapes, clear north sky on panchromatic film with light blue filter.

High Values

Zone VII—Very light skin, light gray objects; average snow with acute side lighting.

Zone VIII—Whites with texture and delicate values; textured snow; highlights on Caucasian skin.

Zone IX—White without texture approaching pure white, thus comparable to Zone 1 in its slight tonality without true texture. Snow in flat sunlight. With small-format negatives printed with condenser enlarger, Zone IX may print as pure white not distinguishable from Zone X.

Zone X—Pure white of the printing paper base; specular glare or light sources in the picture area.

In **Figures 6.1, 6.2, 6.3,** and **6.4** you can compare the levels of gray in the traditional Zone System to the levels of gray in a digital file.

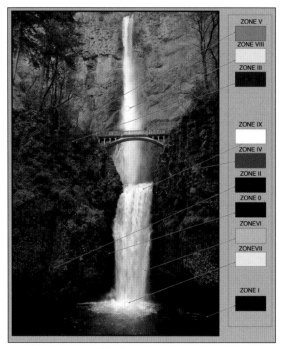

FIGURE 6.1 *Test Image I with 255 levels of gray*

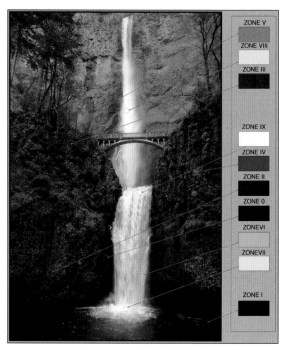

FIGURE 6.2 *Test Image I with 11 levels of gray*

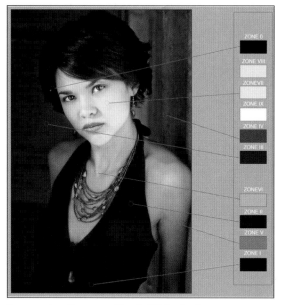

FIGURE 6.3 *Test image II with 255 levels of gray*

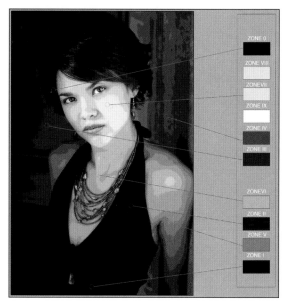

FIGURE 6.4 *Test image II with 11 levels of gray*

That Was Then, This is Now

It takes a long time to bring excellence to maturity.

—Publilius Syrus

Prior to the release of cameras like the Nikon D4 (that Nikon says has a sensor with a Dmax of 4.2 and approximately 14 stops of dynamic range) and Canon's 1Dx (that Canon says has a Dmax of 3.6 and approximately 12 stops of dynamic range), film with its theoretical Dmax of 4 (the practical Dmax of most films was 3) had a greater potential dynamic range than most digital cameras. The sensor on the Nikon D3 is capable of a Dmax of 3 and approximately 10 stops of dynamic range, comparable to the average Dmax of many black-and-white films. In contrast, the best that silver paper had to offer was a dynamic range of 2.2 and this was only after selenium toning in a dilution of 30 to 1 for three minutes (based on Kodak's testing of their black-and-white silver paper). According to Epson, an Epson printer using the Ultra Chrome HDR K3 ink set is capable of a Dmax of 2.5 when printed on Epson Exhibition Fiber paper.

All of this information and technology changes how we implement the Zone System today and how we dance the dance between digital capture and digital output.

NOTE: When you edit, tone-map, compress, or do anything to your digital image, you change the dynamic range of image details that can be printed. Once you selectively edit, you can no longer define an image's dynamic range, because it is unclear if you are referring to the scene dynamic range, the paper dynamic range, the CCD/CMOS dynamic range, or the dynamic range carried from the CCD/CMOS to the paper. The dynamic range is the ratio between the brightest and darkest details in the image. If you alter (retouch/optimize) that in the computer, you modify which detail is the darkest and which is the brightest, so that talking about the image's dynamic range no longer has any real meaning.

A common misconception is that the grayscale breaks down evenly into 11 zones. If you look at the diagram comparing where each of the zones fall on the grayscale with each of the zones of the zone chart, you will notice that the distance between each of the midtone zones is larger than are the distances between either the various dark zones or the light zones (**Figure 6.5**). Be aware that there are fewer levels of gradation in the dark zones and light zones than there are in the mid zones. Another way to look at this is: first, there are more than 11 levels of gray, and second, there are more image details expressed in the midtone zones than in the either the light or dark ones. This is because the Zone System creates a perceptual linearization of gray values, whereas digital technologies use a numerical linearization. Since you are capturing and reproducing your images in a digital world, you should be considering how the values are best separated using the linear system of digital files and reproduction techniques (like inkjet printers) and not the nonlinear system of film and film-based reproduction techniques.

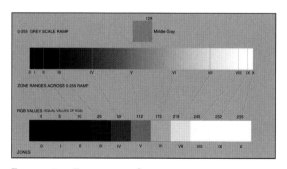

FIGURE 6.5 *Zone to grayscale comparison image*

Dynamic range is the ratio between the maximum (Dmax) and minimum (Dmin) measurable light intensities. It is not a measurement of white and black. As discussed in Chapter 1, as of the writing of this book, there is no way yet known to truly determine what is white or black. We can measure only the varying levels of light source intensity and subject reflectivity.

Therefore, the definition of what you mean when you use the term *dynamic range* is fluid. It depends on whether you are describing a capture device (a camera), a display device (a computer display), an output device and output medium (printer and paper), or the subject itself (scene brightness). For each of these, dynamic range is expressed using the same scale, and all define dynamic range the same way; the term simply means something different in each circumstance.

Dmax is the maximum density or the darkest recordable tone that can be obtained.

Dmin is the minimum density or the lightest recordable tone that can be obtained.

For example, in printing, Dmax refers to the deepest black that a paper and inkset combination can produce. Dmin is limited by the white of the paper.

For a digital camera, measuring and defining Dmax is more complicated than it is for film-based SLRs. DSLRs have sensors that record light in areas called photo-sites that are sensitized areas on the sensor that record light intensities.

The size of the photo-site, as well as the way the recorded light values are measured, determine a digital camera's dynamic range. The dynamic range in a digital camera is the ratio of maximum light intensity measurable (at pixel saturation) to minimum light intensity measurable (above read-out noise). (See the note on the following page.)

The Dmax in film is its very blackest area (completely unexposed for positive film; completely overexposed for negative film). The Dmin is the density of the whitest parts of the film. (All films have an innate density due to the material of which the film is made.)

In all aspects of photography, the Dmax scale is 1.0 to 4.0. This means that any changes in the numerical values to the right of the decimal point are very significant. For example, a glossy, black-and-white, photographic, silver-bromide/silver-halide paper with a DMax of 2.2 (see the note on the following page) is capable of producing approximately 158 levels of gradation from the darkest tone to paper white. (The paper's surface is important because of the intensity with which it reflects light.) So, if the paper's Dmax is 2.3 (e.g., Epson UltraChrome HDR K3 ink set with Premium Luster paper), it would have approximately 200 levels of gradation. If the DMax was 2.5 (Epson UltraChrome HDR K3 ink set with Epson Exhibition Fiber paper), it would have approximately 316 levels of grays, and if it were 2.6, then there would be approximately 398 levels of gray.

NOTE: In digital photography, the measurement unit for DSLR dynamic range is in f/stops and is determined by a multiplier of 2. This means that if you have a contrast ratio of 16,384:1, the DSLR has a dynamic range of 14 f/stops (since 2^{14} = 16,384 or the multiplier "2" to the 14th power). If a zone in the Zone System (see the section: ***Zoning in on the Zone System*** in this chapter) is equal to one full f/stop, in digital photography the potential exists for 14 zones instead of 10 as in film-based photography.

If we apply this to a real-life situation and look at the Nikon D4, according to Nikon the D4 has a dynamic range of 4.2 (or approximately 14 stops), meaning that it has a greater dynamic range and Dmax than the theoretical highest Dmax of film. (A Dmax of 4 represents approximately 10,086 levels of gradation from darkest to lightest, while a Dmax of 4.2 represents approximately 15,849.)

Film Dmax can be changed by the developer concentration, developer type, and length of time in the developer. You can further affect the Dmax when printing by using Selenium toner. Again, concentration and time also affects the Dmax. Thus, Dmax is extremely variable in silver-halide-based films and papers.

When a Dmax of 2.2 was determined for silver-halide/silver-bromide paper, it was based on using Kodak Elite paper processed in Dektol and treated with Kodak selenium toner, 1:30, for a few minutes. This measurement was made with a solid-state, photographic densitometer.

If you want to use the Zone System, determining proper exposure for film is quite different than determining exposure using a digital camera. Once again, this is because film records information *logarithmically* and, digital files record *linearly* (if you are in a RGB color space). Therefore, there is a nonlinear relationship between the density of the film and the amount of light required to achieve that density. When the relationship is a linear one, as is the case of a digital file in an RGB color space (and as it is in the Desaturation of Color lesson in Chapter 1), and you remove all of the color from the image, if you have two objects with colors of the same brightness, they will appear as the same shade of gray. If the same image was captured on film, those two objects will appear as two different grays, because the relationship between the density of the film and the amount of light required to achieve that density is a logarithmic one. (For a discussion of linear versus logarithmic relationships, see the sidebar: *As Easy as Falling Off a Log - The ABCs of Lab and RGB* in Chapter 3.)

According to the Merriam-Webster dictionary, photography is defined as "the art or process of producing images by the action of radiant energy and especially light on a sensitive surface (as film or a CCD chip)." The word *photography* is from the two Greek words *photos* and *graphé*, together meaning to *draw with light*. Thus, when you discuss photography, you must discuss light. Actually, light should be the largest part of any discussion of photography. As a photographer, you are concerned with the qualities of light, specifically *reflectance*, *transmittance*, and *illuminance*.

Reflectance is the amount of light measured as it bounces off of a surface. *Transmittance* is the amount of light measured after it passes through an object,

When shooting RAW, many cameras can capture either a 12-bit or a 14-bit image.

If possible, you should always choose the higher bit depth because a 12-bit image file is capable of 4,096 (212) tonal values, while a 14-bit image file is capable of recording 16,384 (214) tonal values per channel. However, be aware that even though Photoshop and your RAW processor may be set to 16-bit, in reality you are recording image information in either 12- or 14-bits of data, translated into a 16-bit space.

DSLRs have a dynamic range that varies from 5 to 14 f/stops. (For this discussion and to simplify the math, I will use a 10 f/stop range and a 14-bit file.) In the simplest of terms, an increase of one f/stop represents one-half of the light of the previous f/stop, i.e., f/8 lets in half of the light that you would get at f/5.6. As I have discussed throughout this book, DSLR sensors record information linearly. That might lead you to think that a 10 f/stop DSLR would record the same amount of information in each of the 10 stops that make up such a DSLR's dynamic range. But starting from the brightest f/stop, each successive f/stop contains a factor of 1/2 the signal—or data—of the previous f/stop.

Therefore, what actually happens is that the data contained in the first (brightest) f/stop equals 8192 tonal values, which is half of the information of the file. The second, or next brightest f/stop, contains 4096 tonal values, the third contains 2048 tonal values, the fourth contains 1024 tonal values, and so on, with the tenth containing just 16 tonal values. It is also important to realize that while each successive f/stop contains less signal, the relative amount of noise increases. This leads to an increasingly larger potential for noise in the darker regions of the recorded image.

As I have discussed throughout this book, the tonal response curves of photographic film are logarithmic, which also means that they are non-linear. At both the low signal (dark) and high signal (bright) ranges, film has a diminished sensitivity in comparison to the middle signal (mid-tone) ranges. With low light intensities, it takes large changes in light levels to create a difference on the film.

At bright levels, film's sensitivity plateaus. (This happens more slowly than digital sensors, but it does plateau such that changes in bright light levels are not recorded with much differentiation.)

What this means to you is that if you do not expose your image so that you use the right-hand tenth of the histogram for recording some of the image, you will lose half of the available encoding levels of your camera. But herein lies the first rub: just like shooting slide film, if you blow out your highlights, they are forever gone, with the

caveat that the difference with digital capture is that there is the potential for recovering one stop of information from the highlights from a RAW file. Herein lies the second rub: while there is the potential for recovering 2½ stops of information from the shadow areas, the information that is there has considerably more noise than the information in the midtone and highlight areas of the image. So, if you are concerned about using and maintaining detail information in the shadow areas, consider making a second exposure that exposes to the right—utilizing the high tonal range data portions of the file.

See **Figures 6.6** and **6.7** for a visual of what the right exposure for an image should look like. For a more detailed explanation go to: http://www.luminous-landscape.com/tutorials/optimizing_exposure.shtml

NOTE: The histogram display in most of the cameras made today is based on the JPEG that is created for the camera's LCD display. This JPEG is processed out of the RAW data and a special soft tone curve is applied. The reason for this is so that there is abrupt transition to the highlights which was the case with earlier DSLRs.

While there may be some cameras that show a linear histogram, typically they show a histogram with a tone curve and/or a gamma correction applied, making statements difficult about where 'half of the tonal range' is located, as this differs from manufacturer to manufacturer. So it is important to do some experimentation with your specific camera to find out where the exact "sweet spot" of exposure is.

FIGURE 6.6 *An image exposed for the highlights*

FIGURE 6.7 *An image exposed for the midtones*

and *illuminance* is the amount of light measured from a light source. In film-based photography, you control where the zones fall through a combination of over- and under-exposing and over- and under-developing. The axiom that most film photographers using the Zone System follow is to expose for the shadows and develop for the highlights.

In digital photography, you would not expose for the shadows and process for the highlights. Exposure in the digital photography world is like shooting with reversal or slide film. You expose for the highlights, not the shadows, because if you blow out a highlight, there is no digital information to recover. You have upwards of 2½ f/stops of information (depending upon ISO and the noise characteristics of the camera) that you can recover from the shadows. (See sidebar *The Right Exposure* in this chapter.) In digital photography, expanding the dynamic range requires multiple captures of multiple exposure values by bracketing. This works if your subject is not moving and you are using a tripod. I recommend that you approach capturing a moving subject (if you are endeavoring to extend the dynamic range of the image) by making your primary exposure for the subject that made you initiate the capture, and then go back and *image harvest* the individual image elements that you need to make your image more visually successful. I discussed the techniques of Extending the Dynamic Range (ExDR) of your image through image harvesting in Chapters 3 and 4 of *Welcome to Oz 2.0*.

One of the basic goals of all photography is that, ideally, all of your decisions for your image, as well as solving its problems, should be achieved at the moment of capture. You cannot fix a poor image in either the darkroom or Photoshop. The best you can hope for is that you may be able to save it. Although the ideas about exposure in digital photography have changed from those we used for film, the Zone System is every bit as significant today as it once was when it comes to considerations about the final print. Each and every one of those considerations should immediately follow the moment of capture. If at the moment of capture, you think about how you wish the final print to appear, some would say you are pre-visualizing, while others might call it visualizing. And there is a fine line between the two.

What You See Is What Will Take You

If you believe in pre-visualization you deserve what you get.

—Paul Caponigro

I prefer to use the term *visualization*, because it is something that I do right after the moment takes me and causes me to press the shutter. In my opinion, the term *pre-visualization* can be confused with having a preconception of your final image before you allow yourself to become emotionally involved. For me, it carries the ring of clinical analysis, not one of being open to the spontaneity of the moment and to being taken by what I am seeing. I never go into a photographic situation with any preconceived expectation other than being prepared to be amazed. In the field, the Zone System helps you look at image structures and textures after being taken by the moment and clicking the shutter. After commiting that moment to a file, you look at the subject of your image and start collecting, or image harvesting (if the situation and time permits), the elements that you think you might need to make the final print closer to your vision of the image. Understanding the Zone System is the best way that I know to aid you in deciding what bests serve your vision.

Of all the things to remember about the Zone System, perhaps the most important is that it allows for fluidity. There are no rigid rules. If ever there was a way to mathematically express the visual poetry that is a photograph, the Zone System would be that way.

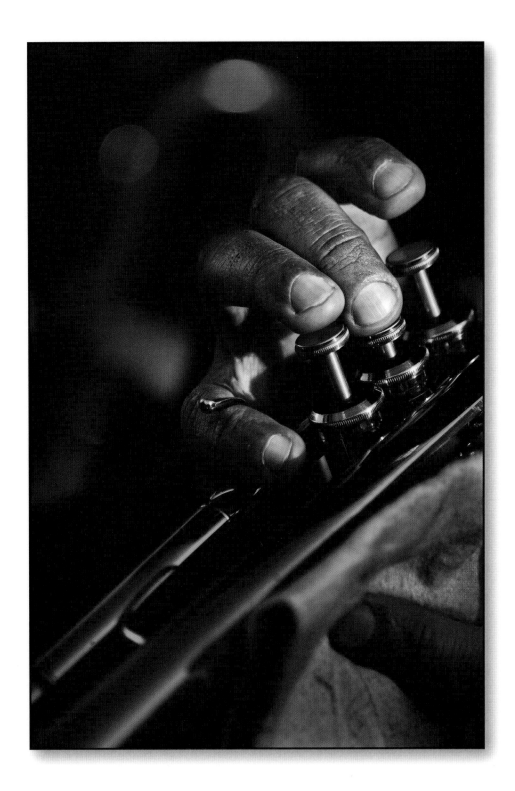

The Black and White on the Channel Mixer Adjustment Layer

I eagerly await new concepts and processes. I believe that the electronic image will be the next major advance. Such systems will have their own inherent and inescapable structural characteristics, and the artist and functional practitioner will again strive to comprehend and control them.
—Ansel Adams

The Soul of the Art of Black-and-White Photography

By his own admission, if Ansel Adams—arguably the most recognized and celebrated of black-and-white, fine art, nature photographers—were alive today, he would be a digital photographer. It was something he eagerly awaited. And if he were alive today, he would be a digital, black-and-white photographer. I doubt that he would totally abandon silver-based photography for digital, but after having studied his books: *The Negative*, *The Camera*, and *The Print*, I can only imagine what level of technical insight he might have brought to the world of digital black-and-white photography.

What Ansel Adams dreamed of doing, you are doing today with technology that you take for granted, and that you have at your fingertips. Over 40 years ago, we sent men to the moon using computers that were nearly the size of the rooms they occupied. Today, the power of those machines is eclipsed by the computing power found in a digital watch.

Aesthetic skills and artistic sensibilities of the photographer aside, much of electronic or digital photography can yield better technical results than can analog photography. But we have a tendency to believe that what *was* is significantly better than what *is*, even though the goal of the technical aspects of black-and-white photography is still the same—that being the complete control and mastery of the tonal rage of the printed image. What we must never forget is that the inherent and inescapable structural characteristics of analog and digital image creation are different.

Remember that black-and-white analog photography preceded analog color photography. To this day, in silver photography, a black-and-white silver photograph has more resolution and is, therefore, sharper than a color silver photograph. Also, a silver black-and-white photograph is capable of producing a purer black and better contrast than is a silver color photograph. What is even more interesting is that, even though the primary pursuit of analog

photography was to produce ever better color films and papers (the secondary pursuit was to create better black-and-white films and papers), a color photograph has always been less archival than was a black-and-white photograph..

In digital photography, color photography came first and black-and-white photography was second, and now the pursuit seems to be about designing better approaches to creating chromatic grayscale images. Also, when it comes to digitally printing an image with today's pigmented inkjet printers, we can produce images both in color and in chromatic grayscale that are equal to or better than those made with analog processes.

What we must not do is throw the baby out with the bathwater. There are characteristics of analog black-and-white photography that are precious and important, and those, we must strive to preserve. There are other characteristics that we should work to eliminate. The same holds true for digital photography. The goal should be to take the best of both and marry the two while shedding what is not desirable.

What I am about to discuss in the next two chapters are conversion approaches that do just that. In this chapter, you will learn the conversion approach that started both my, and this book's, journey into the world of digital chromatic grayscale imagery. This book's path to becoming a standalone book began when it was first a chapter in the first version of my book, *Welcome to Oz*. When I started to rewrite the black-and-white chapter for *Welcome to Oz 2.0*, I realized the revised chapter's length was likely to be the length of the entire book into which it was going.

Back to the Future: Once Again, Traveling a Circle in a Straight Line

Everything on your journey toward understanding the art of the science and the science of the art of creating a chromatic grayscale image from a full-color one is about to be applied in this next technique. You have learned all of the steps; now it is time to mix them together and do the dance.

First and foremost, keep in mind, whether an image is chromatic grayscale or full-color, it is more important that your image be true to what you felt when you saw it, than to what your eyes saw. Once you understand this, it becomes considerably easier to approach the entire process, from color cast removal to chromatic grayscale conversion to final print, as a way to control the viewer's eye as it moves through your photograph.

For me, the black-and-white image has always been the core, the essence, and the soul of photography. By training, I am a black-and-white, film-based, Zone System photographer, and I believe that it is my experience as such makes my digital photography what it is today. It is the discipline of 36 frames per role, or two 4 x 5 sheets of film per film holder that taught me how to be open for the decisive moment, the moment that makes itself evident in an instant and compels you to press the shutter.

Today is a decidedly different place than it was when I wrote Chapter 5 on black-and-white conversion in the first edition of *Welcome to Oz* in 2006. Digital technology, imaging software, and inkjet printers have advanced so far that it is now significantly easier, and frequently much better, to work in the digital darkroom than in the analog version. You can certainly produce an image of equal or greater quality when working digitally, and with no exposure to toxic chemicals and while working in the light of day.

NOTE: You can create a negative from an image that you manipulated in Photoshop and make a silver print. If you would like to read more about this, see the book, ***Making Digital Negatives for Contact Printing*** by Dan Burkholder. You can also go to his website at www.danburkholder.com/Pages/main_pages/book_info_main_page1.htm for his latest thoughts on the subject.

A World of Shadows

The camera doesn't make a bit of difference. All of them can record what you are seeing. But, you have to SEE.

—Ernst Haas

In the film world, to make a print worthy of showing to others, you must have a worthy negative. In the digital world, the negative is a file. That file has to contain quality information or the print that you create from it will be poor. Without good sheet music, the symphony will be worthless.

But what if you have great sheet music, but can no longer create a great symphony from it? Until recently, this was the sorry state of affairs that existed for the great black-and-white negatives produced by such photographic icons as Ansel Adams, Minor White, Edward Weston, and Wynn Bullock. Their prints—the ones with which we fell in love—were made on papers that are no longer available. Today's photographic papers no longer contain heavy metals like cadmium and mercury for environmentally sound, but not necessarily aesthetically, good reasons.

Ironically, these same heavy metals made the older papers archivally stable and gave them great maximum densities. Today, when it comes to silver printing, you can achieve a similar result using selenium-toned papers to regain image stability and maximum density.

The traditional photographic papers commercially available today contain less silver than they once did. Unless you are willing to invest the time and expense to create platinum or other alternative-process prints, it is very hard to capture the subtleties and full range of tones within a black-and-white negative on commercially available, silver-based photographic paper. That is the bad news.

The good news is that digital cameras, software, and inkjet printing technologies let us create black-and-white prints that have even greater resolution and dynamic range than we could ever create in a traditional darkroom.

By now, you have observed that a chromatic grayscale image is not purely black and white; it's monochromatic tones are made up of equal values of red, green, and blue. In analog photography, many variables affect the final tone of a black-and-white print. For one thing, each type of silver-based paper produces a print with a characteristic tone. For example, Agfa Insignia, Agfa Portriga, and Forté Salon are warm-tone papers. Oriental Seagull, Agfa Brovira, and Ilford Galerie are cool- to cold-tone papers. Different developers and developer concentrations can also change a print's tone, as can selenium toning.

In days passed, when we printed on silver-based papers, we chose a particular paper and processed it in our individual way in order to achieve a specific tonality that only we could achieve in our secret darkroom dance. We wanted to make a warm- or cold-tone print with rich, deep blacks; detail in the textured blacks or deep shadows; and crisp, textured whites in the highlights. We wanted a print that had a complete tonal range from dark black to pure white, and that goal has not changed.

If I have learned anything as a digital photographer, I have learned that when it comes to digital photography, impossible is just an opinion. If I can imagine it, I can create it. Most importantly, if I cannot make it happen today, I know that I will be able to do it tomorrow or the next day. Also, if I allow myself to be open to the thought that knowledge is fluid, and that if I treat each thing that I learn as a grain of sand and let it collide with the other grains, eventually all those grains of seemingly unrelated knowledge will form a beach of epiphany. The next technique you are going to learn demonstrates this.

Absinthe-Minded Artist

If you can dream it, you can do it.

—Walt Disney

I conceived this technique quite some time ago while recovering from my first run-in with an absinthe martini. As I rode in a van on my way to photograph a waterfall in Banff, Canada, I was working on an image, and I accidentally clicked on the Channels tab instead of the Layers tab. All of a sudden I found myself looking at the individual Red, Green, and Blue channels of an image, and noticed that each one of them was a different grayscale image. In the third version of Photoshop, Adobe introduced the Channel Mixer and layers. In the fourth version of Photoshop, the version in which I was working at the time, Adobe had introduced adjustment layers.

The Channel Mixer allowed you to modify a color channel using a mix of the current color channels and adjustment layers (with a layer mask attached). This allowed you to perform the adjustment on its own separate layer. This new tool also had a box called Monochrome, and when you clicked on it, it converted the image into grayscale. If you selected

any of the channels (Red, Green, or Blue) from the pull-down menu and selected Monochrome, what resulted was an exact representation of that channel for that image, and it was created as a layer that was separate from the image layer. And you could create as many of them as you wanted! As you saw in Chapter 5, this means that the image as seen in the Red channel in the Channels panel and the image in the Channel Mixer adjustment layer were identical.

Therefore, if you select Monochrome and set any one of the three color sliders—Red, Green, or Blue (which represent each of the three channels)—to 100% and the other two to 0%, you get an exact representation, in grayscale, of the image's channel for that color.

NOTE: You can also accomplish this in Photoshop CS3 and above in the Channel Mixer by selecting the Red filer, Green filter, or Blue filter in the pull-down menu in the Channel Mixer adjustment layer.

If you want to create the highest quality chromatic grayscale images with the greatest control of the conversion process, you should use a Channel Mixer adjustment layer. In this lesson, you will not use just one; you will use four. This technique affords you a level of control unmatched by any other Photoshop-only conversion approach. You will use an action here that comes with this book (everything you have done so far has been made into an action) instead of doing the steps manually as you have up to this point. The actions perform the numerous time-consuming steps that you would have to take to get you (and the image) to a place where you have to make some new decisions. If you are unfamiliar with how to load an action, there is a QuickTime video that you can download from the download site for this book that will show you how to do this.

What Exactly Is a Channel?

All current digital cameras, displays, and printing methods use a small set of colors to generate the entire range of colors in the image. Digital cameras and video displays use an RGB color system, which is an Additive system. An Additive system starts with no light (black: R:0, G:0, B:0) and mixes in the primary colors (red, green, and blue) in various quantities to create all the intermediate tones and hues that you see, including combining the full values of RGB (R:255, G:255, B:255) to create white.

Printers use a Subtractive approach and start with white (the traditional color of the printing substrate—paper) and then use what are referred to as Secondary colors (cyan, magenta, and yellow inks—CMY) for the same purpose. The more ink you add, the darker the image. Black is added to the mix, because if you mixed CMY together (as is done in analog color photography films and papers, since they are dye based), you would not get black, you would get only a muddy gray. (Black is referred to as "K" because there is no color that begins with the letter K. When you add black ink, you get CYMK.) Black ink is added to the mix because inks are usually not transparent. This has to do with the fact that many of today's inks, particularly the archival pigment inks, contain particles of pigment that causes the ink to be opaque. Also, by adding black ink(s) is why you have greater density of black and better contrast in both digitally printed color and black-and-white images than in the ones that are printed using an analog process.

Secondary colors are made up of equal values of two of the primary colors. Cyan is made of a combination of green and blue. Magenta is made up of a combination of blue and red, and yellow is made up of a combination of red and green.

Digital cameras record color using something called a Bayer array. A Bayer array consists of a group of 4 pixels, each group containing one red, two green, and one blue filter. Each pixel records one complete piece of color information. The pattern of one red, two green, and one blue filter per pixel group was chosen since it closely mimics human vision. Twice as much green information was included because the human eye is particularly sensitive to green light. Each one of the color filters sits atop the camera sensor so that each pixel captures just one color. When this information is recorded and stored as a RAW file, it is stored as a linearized black-and-white file, that is then interpolated (using post-processing software) into the color image that you see on the screen. This process is referred to as demosaicing. If the image was captured as either a JPEG or TIFF file, the demosaicing process happens in the camera.

The advantage of shooting a RAW file, versus a JPEG or TIFF, is that shooting RAW gives you greater control over contrast, white balance, and exposure. A common analogy for the difference between shooting a RAW file versus a TIFF or JPEG is that if you shoot in RAW, you have the ability to "un-bake the cake," whereas a TIFF or JPEG file is fully cooked and there is nothing you can do to it.

Each of the primary colors (the red, green, and blue information from the sensor) that make up a digitally captured file is called a channel and can be manipulated separately in post-processing software.

A channel in a digital file is a grayscale image of the same size as the color image, and is made of just one of these primary colors. Just as Unsharp masking (the Craik–O'Brien–Cornsweet illusion that I discussed in *Welcome to Oz. 2.0* and touched on very briefly in Chapter 1 of this book) is a darkroom technique that existed long before Photoshop, color channels are not new either. There were darkroom processes, like tricolor pigment printing and dye transfer, where you worked with each of the colors individually. They were referred to as separations and are the physical equivalent of channels on the computer.

NOTE: Four-color, off-set presses also use physical separations/channels for each of the printing plates that are needed to create prints on paper.

What Exactly Is a Channel Mixer Adjustment Layer?

The Channel Mixer adjustment layer is frequently considered to be one of the most intimidating parts of Photoshop. Actually, the Channel Mixer adjustment layer is one of the most powerful and effective ways to work with the colors of your image and is one of the best ways to do a chromatic grayscale conversion. The Channel Mixer adjustment layer allows you to directly effect a change on the Red, Green, and Blue channels of your image. It does this in the form of an adjustment layer, which is a layer of math that sits above the actual pixels of your image. According to Adobe, "The Channel Mixer adjustment options modify a targeted (output) color channel using a mix of the existing (source) color channels in the image. Color channels are grayscale images representing the tonal values of the color components in

an image (RGB or CMYK). When you use the Channel Mixer, you are adding or subtracting grayscale data from a source channel to the targeted channel." For example, a Red-Green setting of 10 increases the value of the Red channel for each pixel by 10% of the value of the Green channel for that pixel. A Blue-Green setting of 100 and a Blue-Blue setting of 0 replaces the Blue channel values with the Green channel values. In other words, the Channel Mixer adjustment layer allows you to blend percentages of the separate channels into one another (**Figure 7.1**).

Because the Channel Mixer adjustment layer does not contain any pixels (it is an algorithm that sits above the layer that contains pixels and, while it affects the layer that contains pixels, it does not physically change them) and can be turned on or off, using one is a nondestructive way to work on your image. Another advantage of using one, with regard to chromatic grayscale conversion, is that you can exactly replicate the Red, Green, and Blue channels in your image without having to split out the channels. This means that you have all the benefits of having the monochromatic grayscale representation of the individual Red, Green, and Blue channels without significantly increasing the file size or destroying the

FIGURE 7.1 *The Channel Mixer dialog*

FIGURE 7.2 *The presets for the Channel Mixer*

FIGURE 7.3 *The Monochrome checkbox*

FIGURE 7.4 *The additional controls*

image to get these monochromatic grayscale representations of the individual color channels. You also have complete control over the blend of the three channels and, most importantly, you can fine-tune the mix between the individual Channel Mixer adjustment layers through layer opacity or by using the layer masks that are attached to each Channel Mixer adjustment layer. (You do this by selecting one of the presets from the Channel Mixer Adjustment Layer pull-down menu [**Figure 7.2**].) This means that you can create an image specific, as well as image structure specific, tonal reproduction curve.

In the Channel Mixer adjustment layer dialog box, you should notice that there is a button for Monochrome (**Figure 7.3**). According to Adobe, "Monochrome uses the value of the red output channel for the red, green, and blue output channels, creating a grayscale image." That means that when you click on Mononchrome, the Black & White adjustment layer will automatically select a mix of +40 red, +40 green, and +20 blue. Adobe's reason for choosing this specific mix is that it reflects the NTSC standard for video. It does not, however, reflect the human eye's visual response like a digital camera's sensor does. By using post-processing software, this difference can be easily corrected by the end user.

You have additional control of the dance between the channels in the form of the Constant slider (**Figure 7.4**). According to Adobe, the Constant slider "increases or decreases the density of the channel mixer effect." For example, a Red-Constant setting of 100 saturates the "Red channel for every pixel by adding 100% red." In simpler terms, this means that the Constant slider globally lightens or darkens the Channel Mixer's effect on your image.

How to Dance with Multiple Partners on the Channel Mixer Dance Floor

Just as a musician hears notes and chords in his mind's "ear" so can the trained photographer "see" certain values, gestures and arrangements in the mind's eye.

—Ansel Adams

In this chapter, you will convert two images using a Multiple Channel Mixer adjustment layer approach for chromatic grayscale conversion. You will then use the same two files that you create here in the next chapter of this book that discusses the use of Nik Software's Silver Efex Pro 2.0 plug-in. I am having you do this because I frequently use a combination of these two approaches. For the purposes of teaching, however, I am going to separate them. Also, you may not have the Silver Efex Pro 2.0 plug-in. Prior to the advent of the Silver Efex Pro plug-in, what you are about to see is how I (almost exclusively) converted all of my images. This does not mean that I have not or do not use all of the approaches you have used to this point. I do. Taking the risk of being repetitious, chromatic grayscale conversion is a street fight in which the only rule is that there are none.

Before You Begin This Lesson: Loading an Action in Photoshop

If you have not already done so, please load the actions that come with this book.

1. From the DOWNLOAD_FIRST folder that you downloaded from the download site for this book, put the file O2K_ ACTIONS.zip on the desktop and open it. You will see a folder named OZ_2_KANSAS_12.

2. Making sure that Adobe Photoshop is open in the main menu bar, go to Windows, and select Actions (Shift + F9). This brings up the Actions panel (**Figure 7.5**).

3. Choose Load Actions from the Actions panel menu. You do this by clicking on the Actions panel fly-out menu located in the upper right corner of the Actions panel. Select Load Actions to bring up the Load Actions dialog box (**Figures 7.6**).

4. From the Load Actions dialog box, select Desktop, and highlight the OZ_2_KANSAS_12 folder. Click on the Open button located in the lower right corner of the dialog box.

5. In the OZ_2_KANSAS_12 folder, select the OZ_2_K_ACTIONS_12.atn folder, and click on the Open button. You have successfully loaded the action.

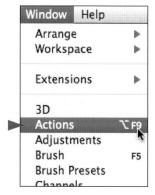

FIGURE 7.5 *Opening the Actions window*

FIGURE 7.6 *Loading the actions*

Image 1: Using a Multiple Channel Mixer Conversion Approach on a Portrait

The photographer must be absorbent—like a blotter, allow himself to be permeated by the poetic moment…. His technique should be like an animal function…he should act automatically.

—Robert Doisneau

As I mentioned previously, the images that you will create in this chapter are the same ones that you will work on in the next chapter. The techniques of the two chapters differ, but dovetail, so while they can be used together, each can stand alone. In the action set, you will see several variations of these two conversion techniques. Once you have mastered the techniques in this chapter and the next, I invite you to play with variations; take them out for a test drive. Also, the two images of this particular lesson are best done if each is done in one sitting, so set aside some time for them.

The action you are about to run, as is the case with every action and action set that comes with this book, is designed to leave you with a flattened image. This is not to say that the layered files are not preserved; they are. The actions are set up this way because we are now capable of producing such profoundly large files that image workflow has to be broken up into multiple files to be able to get things done as expeditiously as possible. In addition, once you have accomplished any particular task, there is no need to keep all of the steps of that task in a file. All you need to move on is the outcome. Maintaining the layers of those steps in individual files preserves an exit strategy.

Since a chromatic grayscale conversion is the outcome of many steps, all you need to keep is that final outcome. This is why all of the actions will first create a Master layer, then save the source file (the one that is being converted to chromatic grayscale), duplicate the file, rename the file, and close the original source file. Because actions can do only what they are told, actions can easily be confused. So it is important, that when you run one of the Oz 2 Kansas actions, that the only file open at the start of running the action is the one that you want to convert. If you do that, the action will take care of most of the heavy lifting.

Step 1: Running the Oz 2 Kansas Action

1. From the folder that you have downloaded for this chapter open the file LILAN_OZCH07.tif.

2. Make sure that the Info panel is open and moved to an area on your monitor's screen that does not cover up an area of the image that will be critical to the conversion process. Usually, this is an area that contains highlights or bright image structures.

NOTE: For this conversion approach, the information contained in the Info panel is of utmost importance. Without it, you are just guessing.

3. From the Actions panel, open the OZ_2_K_ACTIONS_2012 action set by clicking on the disclosure triangle located to the left of the folder (**Figures 7.7** and **7.8**).

4. Click on the OZ_2_K_WITHOUT_SEP action to make it active (**Figure 7.9**).

Figure 7.7 *Expand the action set*

Figure 7.8 *The list of included actions*

Figure 7.9 *Selecting the OZ_2_K_WITHOUT_SEP action*

Figure 7.10 *The Run Action button*

5. Click on the Run Action button located at the bottom of the Actions panel. This will start the action (**Figure 7.10**).

6. The action will duplicate the file and open the Save As dialog box.

7. In the Save As dialog box, you will see a file named OZ_2_KANSAS_BW.psd. Add the name LILAN_OZCH07_ to the beginning of that file name so that it becomes LILAN_OZCH07_OZ_2_KANSAS_BW.psd.

8. Click on the New Folder button located in the lower left corner of the Save As dialog box. Name this folder OZ_2_K_IMAGES and click Save to save the LILAN_OZCH07_OZ_2_KANSAS_BW.psd file to that folder.

As I have already mentioned, I programmed all of the actions in this action set to work this way so that the imaging workflow is nondestructive. This means that you assure yourself an exit strategy; a way to get back to the beginning.

Secondly, the actions work as they do to minimize the amount of data you store. Because the file sizes generated by modern cameras are so large, this issue is even more important. For example, if you open a file from a 24.5 megapixel camera in 16-bit, that file is approximately 150 MB. If you then do 11 things to the image, and of those 11 things, 8 of them involve actual pixels (not adjustment layers), you will have a file that may be upwards of 1.3 GB. That is a big file! I have found that by separating an image into multiple files that I can speed up the workflow and still preserve a nondestructive approach to image editing.

NOTE: As amazing as actions are, and they are truly amazing, they are still all about ones and zeros so that there are some things that they cannot do. For example, an action cannot open the

Info panel and it cannot name and find the folder in which you want to save a file. Therefore, when you run an action in which you want to choose "Save As," you will have to stop the action and find the folder to which you want to save the file. Your action can name a file, but you cannot tell the action to copy the name of your file, because it will not be identical for every image, and actions merely record steps. There is no algorithmic logic involved.

When should you create an action? If you find yourself doing the same series of steps for more than three images, it is a good idea to create an action to do those steps. It is better to spend more time behind the camera being taken by an image and less time in front of the computer being taken away from creating images.

Step 2: The Creation of a Midtone Contouring Layer

Now that you have saved the file, LILAN_OZ_ OZ_2_ KANSAS_SEP_BW.psd, the OZ_2_K_WITHOUT_SEP action will create a layer named MIDTONE_CONTOURING. During the chromatic grayscale conversion process, Midtone Contouring happens "under the hood." Notice that there is a separate action named MIDTONE_CONTOURING in the action set that you have just loaded into the Actions panel. Midtone Contouring (this approach is also known as Midtone Contrast) is such an important part of all of my image printing workflow that I use this technique 100% of the time as the very last step before printing every image (both color and chromatic grayscale) that I create. The master printer, Mac Holbert of Nash Editions, created this technique, which is the basis for the Clarity algorithm in Adobe's Photoshop Lightroom, and taught it to me. Mr. Holbert does this to 100% of the images that he prints.

NOTE: An in-depth description of this technique is located in the **Why To of My How** PDF that you can download from the download site for this book. If you have read **Welcome to Oz 2.0**, then you are already familiar with this technique and action.

Let me reiterate: Midtone Contouring is the *final* thing that you do before you print, and when you are converting a color image to a chromatic grayscale one, it is very important to know how using this technique will impact your printed image. This technique targets the midtone areas of an image and applies a high radius, low opacity, High Pass sharpening to the image using the Blend If functionality of a layer. It is helpful to know what happens when you apply Midtone Contouring, because it can slightly lighten the lighter midtone areas and slightly darken the darker midtone areas of the image.

Mac Holbert recommends that the opacity be set between 20 and 40%, but closer to 20%. So both here, and in the separate Midtone Contouring action, I have set the opacity to 30%, which is exactly in between Mac's recommended 20 to 40. When the action is finished running and makes the final Master layer, the action automatically turns this layer off before merging all of the layers into what will be the final image. Examine the image before and after (**Figure 7.11** and **7.12**).

Be aware that when you apply Midtone Contrast to an image, you must apply it to the image at the size at which you are going to print it at. This is because Midtone Contouring is a form of image sharpening and, as we all know, image size affects how much sharpening you apply.

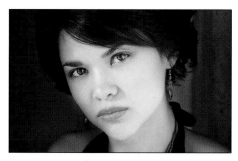

FIGURE 7.12 *Before adding Midtone Contouring*

FIGURE 7.12 *After adding Midtone Contouring*

FIGURE 7.13 *The image after increasing saturation to 100%*

NOTE: The action does not stop to let you adjust the opacity of the Midtone Contouring layer. Adjusting the opacity is not important for the conversion process. So it does not matter if the image is over Midtone Contoured. This layer exists, as a visual aid, to help you create an image that will help you compensate for blown out highlights that may be created when you apply Midtone Contouring. Before creating the final Maser layer, the action will turn off the Midtone Contouring layer.

Step 3: Create a Hue/Saturation Adjustment Layer

The action will create a Hue/Saturation adjustment layer with the Saturation slider moved all the way to the right at 100%. As you did in the previous chapter, this technique is designed to help you analyze the color of an image. By increasing the saturation, you exaggerate the differences between the image's colors making it easy to see which are dominant. The areas that posterize tend to be those with which you will have the greatest difficulty when it comes to the image editing process.

Notice that the colors in this image are very skewed to the yellows and reds (**Figure 7.13**). Knowing which colors dominate will help you decide how to adjust the Channel Mixer layers or additional Hue/Saturation layers for the final adjustments.

Step 4: Sample the Highlights

Next, the action shows you a dialog box that states, "Now, use the Color Sampler Tool to sample up to 4 highlights to observe their densities on the different channels. When done selecting the samples, restart the action."

9. After reading the action instruction, click the Stop button.

10. Using the Color Sampler tool, make sample points of all the highlight areas that are posterized. Do this by Shift-clicking on the area that you want to sample and then releasing the mouse. This creates a set of reference points to help ensure that you do not blow out the highlight areas during the conversion to chromatic grayscale.

NOTE: If you want to, you can move a sample point by click-dragging it.

To spot potential trouble areas, look for extreme color posterization where smooth color gradations turn contrasty and saturated. Posterization usually occurs in areas where highlights are in danger of being blown out.

NOTE: Dark areas can also exhibit the posterization effect. One way to tell if a posterized area is dark or light is to be aware that highlights tend to be represented by areas of brighter posterized colors.

In this image, there are four main areas of concern. I approach the decision process of what is or is not critical to the image like this: I decide which areas in an image are most important. For example, in this image I think that Lilan's face, eyes, and any highlight area(s) on her face, are most important. I certainly do not want her eyes so white that they appear to glow in the dark, and I want to make sure that they contain pixel information. Because I see a highlighted area on the bridge of her nose, I place a sample point there so that I will be able to see the numerical values of the Red, Green, and Blue channels as I make further adjustments (**Figure 7.14**).

NOTE: Since Photoshop allows you to drop only four sample points, you can select only four main areas of concern in any particular image.

My sample points are: Position 1 is in the highlight area of the white of her right eye (toward the subject's left side). Position 2 is on the bridge of the subject's nose. Position 3 is in the left side of the white of the left eye, and position 4 is in right side of the white of her right eye. (**Figure 7.15**).

11. In the Info panel, you will see the numerical values of red, green, and blue for each sample point (**Figure 7.16**).

When working with a digitally captured image file, you have more information in the midtone to shadow areas than you do in the highlights. Thus, if you blow out a highlight, it contains no information. Knowing this, I balance my images towards the highlights, because I know that I can pull information out of the shadows.

NOTE: This is based on a notion called "Exposing to the Right." (See the sidebar: *The Right Exposure* in Chapter 6.)

It is the RGB values of the sample points that you will be watching during the conversion. The goal is to make sure that you fall between 244-247 and do not exceed 247. I generally aim for 96% saturation, or some value between 244 and 247 (with the target being closer to 244) so that the highlights do

FIGURE 7.14 *The area of image importance*

FIGURE 7.15 *The sample areas in her face*

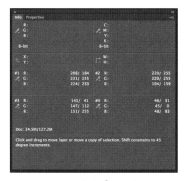

FIGURE 7.16 *The Info panel*

not become blown out. (Specular highlights or pure paper white can go up to 255.) Absolutely the most important thing to keep in mind as you do this conversion, is that all four points do not have to equal a value between 244 and 247; just one does. Whichever sample point goes *hot* first (the one that hits 244 - 247) is the one that matters. The other three are no longer significant.

NOTE: In the Zone System, the RGB values of 244–247 correspond to the end of Zone VIII and the beginning of Zone IX. These are areas of textured white. Though there may be a small amount of information in the 248–250 range, it tends to register as paper white. Shadow detail begins to appear at an RGB value of 7, which corresponds to the tail end of Zone I and the beginning of Zone II. I chose these values to take into account the greater dynamic ranges of DSLR sensors and the greater Dmax of inkjet printers/papers. (See sidebar: ***The Dynamics of the Highs and Lows of Dynamic Range*** in this chapter.) The goal is to hit 244, but with wiggle room up to 247. The risk of losing detail in the highlights increases as you get closer to 255, which corresponds to no data at all / the white of the paper. I will discuss this at greater length shortly.

12. When the sample points are set, restart the action by clicking on the Play button.

Step 5: The Creation of the Neutral Channel Mixer Adjustment Layer (CM Layer 1)

Next, the action will create the first of four Channel Mixer adjustment layers (named NEUTRAL in the layer stack). This first Channel Mixer adjustment layer will be the topmost Channel Mixer adjustment layer and the only one on which you cannot do any brushwork on its layer mask because this is your insurance layer. Monochrome will be selected in the dialog box and the Control sliders are set to equal values of red, green, and blue (+ 33% red, + 34% green, and + 33% blue) that when added together equal +100%. Adding this NEUTRAL layer allows you to do brushwork on the three Channel Mixer layers that are about to be created and that you are about to balance without being concerned that color might bleed through.

Step 6: The Creation of the Green Channel Mixer Adjustment Layer (CM Layer 2)

Next, the action will create the second of the four Channel Mixer adjustment layers (named GREEN in the layer stack). The three Channel Mixer adjustment layers (Green, Red, and Blue) are the key to this approach. The first is for the Green channel, the second is for the Red channel, and the third is for the Blue channel. The Green Channel Mixer adjustment layer will be set to 0% red, 100% green, and 0% blue. The Red Channel Mixer adjustment layer will be set to 100% red, 0% green, and 0% blue; and the Blue Channel Mixer adjustment layer will be set to 0% red, 0% green, and 100% blue. As was the case with NEUTRAL Channel Mixer adjustment layer, Monochrome will be selected by the action when it creates the three Channel Mixer adjustment layers.

You will start with the first of the three Channel Mixer adjustment layers on which you can do brushwork and adjust the balance for green because, as I have previously discussed in this book, the Green channel has twice as much data as either the Red or the Blue channel when it comes to a digital file captured from a digital camera. (Remember, as we discussed in Chapter 1 of this book as well as in this chapter, a Bayer array works in four pixel blocks, with one pixel for red, one for blue, and two for green.) Because the Green channel contains the most midtone data and the human eye is most sensitive to the green/yellow part of the visible spectrum of light, the Green channel is a good one with which to start your adjustments.

Another way to look at this approach to conversion is that the Green channel contains the midtone image structures, the Red channel contains the upper-end image structures (the upper midtone structures to highlight areas) and the lighter, brighter end of contrast, and the Blue channel tends to contain the lower-end image structures (the darker aspect of the midtone areas to the shadows) and the darker aspects of the contrast range of the image.

You are about to balance each individual channel to your visual preference. This is akin to being able to create an image-specific film with a unique tonal reproduction curve. As I discussed in Chapter 5, one of the issues of the Black & White adjustment layer is the amount of color bleed that can occur when using it. This occurs because the Black & White adjustment layer's six Control sliders control six colors (the three primary [RGB] and three secondary [CMY] colors) and, as you saw, sometimes these controls can work against each other and cause serious issues. With the Channel Mixer adjustment layer technique, you are able to fine-tune the relationships between the three primary (RGB) colors that make up the actual channels of the image.

The question you may want to ask is, "Why not use a multiple Black & White adjustment layer technique instead of the Multiple Channel Mixer adjustment layer approach? More sliders means more control, right?" The answer is best explained in the words of Albert Einstein, "Make things as simple as possible and no simpler," or (so the story goes) when Mozart said to the musician Antonio Salieri, "The problem with your music is there are too many notes." For this application, there are too many variables to control to use a multiple Black & White adjustment layer technique, the number of issues would only be amplified. However, the Black & White adjustment layer in Adobe Photoshop is a very useful tool to quickly see where you want to go with an image, and it is a great way to extract hard-to-get-out colors.

When you are using the Channel Mixer adjustment layer technique, as you work on an image, pay attention to the numbers in the Info panel and try to keep them between 244 and 247, staying as close to 244 as possible. As with everything, do not make this dogma. Each image is different, so your choice of percentages will change.

Though it is important to pay attention to all highlight areas, you have to take into consideration the rest of the image. You also have two more Channel Mixer layers (one set for the Red channel and one for the Blue channel), as well as a Hue/Saturation adjustment layer, so that you can further fine-tune the image.

When an image has gone through chromatic grayscale conversion and you look at it from the top down, what has occurred is that the hue has been removed leaving the saturation and varying levels of brightness. If you look at the same image from the bottom up, the base image contains hue, as well as saturation and brightness.

As you have observed when you look at the color channels of an image, frequently there is image structure or image tonality that either is more obvious in one channel than it is in the other two or its tonal aspects are more visually appealing in one or more of the channels.

When using the Multiple Channel Mixer adjustment layer technique, because the Channel Mixer adjustment layer allows you to directly effect a change on the Red, Green, and Blue channels of your image, you will also observe the same differences in image structure and tonality that you saw in the image channels. What the Channel Mixer affords you is the ability to exploit and use those differences. You can also change the layer order and opacity. For example, when it comes to skin tone, frequently a higher ratio of red to green to blue is more desirable. When it comes to clouds and skies, often a balance more towards blue is better. Having the Green Channel Mixer adjustment layer be the first in the layer order frequently produces a more visually appealing image of a landscape. No two images are the same and, therefore, no two workflows are the same.

Many people believe that, when working with the Channel Mixer, the sum of the red, green, and blue values must always add up to 100. This is frequently taught when learning how to use the Channel Mixer adjustment layer. However, when doing a chromatic grayscale conversion using the method described in this chapter, you will find that the sum of those numbers will range from the high 80s to the low 130s. Rather than trying to match some arbitrary number, I recommend that you depend on your built-in spectrophotometer, densitometer, and colorimeter: your eyes.

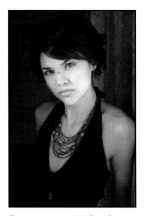

FIGURE 7.17 *With a default Channel Mixer adjustment layer*

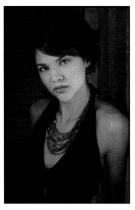

FIGURE 7.18 *The image at 79% Green*

FIGURE 7.19 *The Channel Mixer adjustment layer dialog*

FIGURE 7.20 *The Info panel*

The reason that you select the highlights areas over the shadows areas to favor in an image for this conversion process is because, in a digital image, if you blow out the highlights you will have completely lost all the information in those areas. This is not necessarily true with the shadows in a digital file. Depending on the ISO at which the image was shot, as well as the file type that was used, if you shot the file in the RAW file format, you have upwards of two-and-one-half stops of detail that can be extracted out of the shadows (keep in mind that though this is true, there tends to be more signal noise in this aspect of the file). Thus, when you balance the image, it is best to begin with the highlights. Also, each Channel Mixer adjustment layer comes with an attached layer mask. This allows you an extraordinary level of granular control over how the Channel Mixer adjustment layers interact with each other.

When you bring up the Channel Mixer adjustment layer dialog box, the image will look like **Figure 7.17**.

NOTE: When running actions, Photoshop CS6 uses the older version of the Channel Mixer dialog box. If you reopen the Channel Mixer adjustment after running the action, the dialog box will have the CS6 interface. There is no difference in functionality— just appearance.

13. Click on the Green slider (which is set to 100%) and move it to the left until the center gray values are slightly less than optimal and appear slightly flat. I selected 79% (**Figures 7.18, 7.19,** and **7.20**).

NOTE: When determining which of the three Channel Mixer adjustment layers with which to begin working, do what the musician, Brian Eno, says about how he works, "*Go to an extreme* and *retreat* to usable position." You do this by moving the slid-

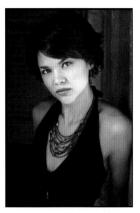

FIGURE 7.22 *Adjusting the Red, Green and Blue sliders*

FIGURE 7.21 *The image*

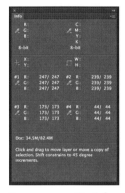

FIGURE 7.23 *The Info panel*

ers back and forth, all the way to the left and then the right, until you find the "usable position."

Remember, the Green channel usually contains more information about relative image brightness than the Red or Blue channels. Those contain information about relative image contrast, so they should be used to darken or lighten specific areas.

Your next step is to adjust the Red and Blue sliders in the Channel Mixer adjustment layer dialog box. As you make these adjustments, keep in mind that you have already placed four sample points on the image, each of which registers a series of RGB values that show up in the Info panel dialog box. Only one of these sample points is going to matter. Once this sample point goes hot (meaning the sample point reaches between 244-247), that becomes the one to which you will pay most attention. The other three become just information. It is also important to keep in mind that among the three separate Red, Green, and Blue Channel Mixer adjustment layers, which sample point goes hot can change from one Channel Mixer adjustment layer to another. You will find use for all this information in the second phase of this process; doing brushwork on each of the Channel Mixer adjustment layer's layer masks.

14. Adjust the Red and Blue sliders to create an image with appealing midtone values without blowing out the highlights, blocking up the shadows, or flattening the image with an overall gray cast. I chose +16% red, +80% green, and +13% blue, with the Constant at 0% (**Figures 7.21, 7.22** and **7.23**).

You should see that sample point 1 is at 247, the upper limit of the target value. Again, the reasoning for this is based on what is visually important to the image. Sample points 1, 3, and 4 are located in the whites of Lilan's eyes and sample point 2 is located on the bridge of her nose—the highlight area of her

face. Because the decision was made to place the adjustment at the upper limit of the adjustment range, the whites of her eyes should be textured white. By choosing a setting of 247, you place the area of sample point 2 in Zone IX. This choice also gives you the brightness on her face that you desire. As it is with all images, all of the decisions that you make are based on controlling the eye of the viewer and taking it on the visual journey through your image that you have predetermined.

Remember the discussion of White's illusion at the end of Chapter 1—how you control both the light and dark grays in an image, where you place them in relation to each other, and how you control contrast, sharpness, and blur, will all determine, not only how the viewer's eye travels through your photograph, but the illusion of three dimensionality as well. You are playing a visual mind game with the viewer of your image that, after all the image manipulation is done, should produce an image to which it should appear nothing was done. Everything dovetails into everything else. What you do with the image at the beginning affects the final print. Just as the artist, Matisse, believed that "black is the queen of all colors," a black-and-white photograph (a chromatic grayscale) is the queen of all images. It takes a special image to withstand the abstraction to just its gray values and not every photograph is worthy.

NOTE: In the Channel Mixer adjustment layer dialog box, notice that the total of the three channels equals 109%. One hundred percent is not your goal. Your goal is whatever appeals to your eye.

15. Click OK.

Step 7: The Creation of the Red Channel Mixer Adjustment Layer (CM Layer 3)

Once you click OK, the action turns off the Green Channel Mixer adjustment layer and creates the third Channel Mixer adjustment layer (named RED in the layer stack) that is balanced for red. The Channel Mixer adjustment layer dialog box has the Red slider set to 100% and the image looks like **Figure 7.24**.

16. Click on the Red slider (which is set to 100%) and move it to the left until you reach the center gray values that are slightly less than optimal or that appear slightly flat. I chose 86% (**Figures 7.25, 7.26,** and **7.27**).

17. Adjust the Green and Blue sliders to create an image with appealing midtone values without blowing out the highlights, blocking up the shadows, or flattening the image's overall gray cast. I selected +86% red, +13% green, and +14% blue, with the Constant at 0% (**Figures 7.28, 7.29,** and **7.30**).

Once again, the sum of the three channels is greater than 100%. For this adjustment, they add up to 113%. Also, there was a change in which sample point went hot first. When you adjusted the Green Channel Mixer adjustment layer, sample point 1 was the first to go critical; but when you adjusted the Red Channel Mixer adjustment layer, sample point 2 went critical first. The reason for this, as you observed in Step 3 when you created a Hue/Saturation adjustment layer and increased the saturation to 100%, has to do with the color content of the two areas. One of the things to keep in mind during the Hue/Saturation phase of this process (the one where you determine where the sample points are to be placed) is to use that step to observe the colors that make up your image. Understanding the

FIGURE 7.24 *The image at 100% Red*

FIGURE 7.25 *The image at 86% Red*

composition of the colors in an image can greatly inform your decisions on the path to grayscale conversion. I have found that the hue of your image, as it exists beneath the conversion process, matters greatly.

18. Click OK.

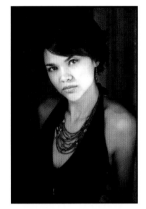

FIGURE 7.28 *The image with the adjusted values from Step 17*

FIGURE 7.29 *The Channel Mixer adjustment layer*

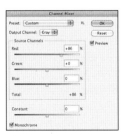

FIGURE 7.26 *The Channel Mixer adjustment layer*

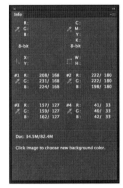

FIGURE 7.27 *The Info panel*

FIGURE 7.30 *The Info panel*

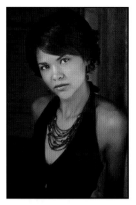

FIGURE 7.31 *The image at 100% Blue*

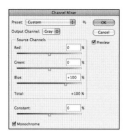

FIGURE 7.32 *The Blue slider set to 100%*

Step 8: The Creation of the Blue Channel Mixer Adjustment Layer (CM Layer 4)

Once you click OK, the action will turn off the Red Channel Mixer adjustment layer that you have just adjusted, and the action will create the fourth and final Channel Mixer adjustment layer (named BLUE in the layer stack) balanced for blue. You will see the Channel Mixer adjustment layer dialog box and the image will appear to look like this. (**Figure 7.31, 7.32,** and **7.33**).

Notice that this particular Channel Mixer adjustment layer is decidedly different than the Green and Red Channel Mixer adjustment layers that you have just fine-tuned. The Green Channel Mixer adjustment layer was all about the midtones, the Red Channel Mixer adjustment layer was lighter than the Green one (though more similar to the Green Channel Mixer adjustment layer than the Blue Channel Mixer adjustment layer appears to be), and that the model's skin in the Red Channel Mixer adjustment layer appears creamier (smoother, with less obvious pores and blemishes) than it did in the Green Channel Mixer adjustment layer. In the Blue Channel Mixer adjustment layer, the skin tones are much darker than they were in the Red and Green Channel Mixer adjustment layers, and the skin is mottled and less creamy than it was in the Red Channel Mixer adjustment layer. So, even though all three Channel Mixer adjustment layers show tonal similarities, they are decidedly different.

19. Click on the Blue slider, which is set to 100%, and move it to the left until you reach center gray values that are slightly less than optimal or that appear slightly flat. I chose 89% (**Figures 7.34, 7.35,** and **7.36**).

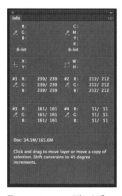

FIGURE 7.33 *The Info panel*

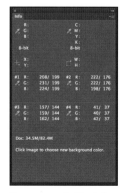

FIGURE 7.34 *The image at 89% Blue*

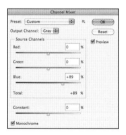

FIGURE 7.35 *The Blue slider set to 89%*

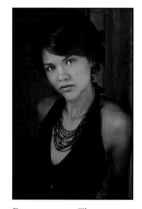

FIGURE 7.36 *The Info panel*

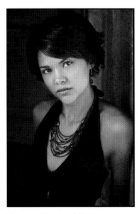

FIGURE 7.37 *The image after Step 20*

FIGURE 7.38 *Channel Mixer adjustment layer*

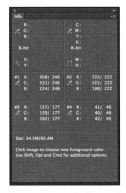

FIGURE 7.39 *Info panel*

20. Adjust the image once again, paying attention to the Green and Red sliders so that you create an image with appealing midtone values without blowing out the highlights, blocking up the shadows, or flattening the image's overall gray cast. I selected +11% red, +10% green, and +89% blue, with the Constant at 0% (**Figures 7.37, 7.38,** and **7.39**).

NOTE: Remember that this is a dance, and sometimes you have to readjust your settings. For example, the Blue channel was readjusted after the Red and Green sliders were adjusted. The decision process combines what looks most visually appealing with ensuring that the range of 244-247 not be exceeded.

21. Click OK.

FIGURE 7.40 *The Green channel before*

FIGURE 7.41 *The Green channel after*

FIGURE 7.42 *The Red channel before*

FIGURE 7.43 *The Red channel after*

Yet again, the total percentage of the fine-tuned Blue Channel Mixer adjustment layer is greater than 100%; it is 110%. You have just adjusted three channels to your vision of them and created a chromatic grayscale image that preserves the spectral relationships among R, G, and B in the same manner that they would have been recorded if the image had been shot on black-and-white film. To best understand the significance of what you have just done, compare the original source channels before any chromatic grayscale conversion had occurred and what the individual adjusted Channel Mixer adjustment layers look like after conversion (**Figures 7.40, 7.41, 7.42, 7.43, 7.44,** and **7.45**).

NOTE: Located in this chapter's folder (that you downloaded from the download site for this book) is a file named LILIAN_CM_2_CHANNEL_COMPARE.psd in which you can compare the adjusted Channel Mixer adjustment layers to the actual color channels.

FIGURE 7.44 *The Blue channel before*

FIGURE 7.45 *The Blue channel after*

Step 9: Comparison of the Adjusted Red, Green, and Blue Channel Mixer Adjustment Layers

Now that the action has created the four Channel Mixer adjustment layers and you have completed fine-tuning them, the action will show you how they appear individually. This is necessary so that you may determine what aspects of each you like and dislike.

22. A dialog box will come up with the following message: "Now, you'll be shown each color channel individually. This is the Blue channel." (**Figure 7.46**)

23. Once you determine what aspects of the image you like and dislike, click Continue.

24. A new dialog box will come up with the following message: "This is the Red channel. Click Continue to view the Green channel." (**Figure 7.47**)

25. Determine what aspects of the image you like and dislike, and click Continue.

26. A new dialog box will come up with the following message: "This is the Green channel. Now click Continue." (**Figure 7.48**)

27. Determine what aspects of the image you like and dislike, and click Continue.

28. The following dialog box will come up: "Now adjust the opacities for each color channel adjustment layer and selectively paint the desired tonalities in using the layer masks. Also consider switching the order of the layers. Then restart the action."

29. Click Stop.

FIGURE 7.46 *The Blue channel*

FIGURE 7.47 *The Red channel*

FIGURE 7.48 *The Green channel*

Step 10: Further Fine-Tuning the Red, Green, and Blue Channel Mixer Adjustment Layers Using the Attached Layer Masks

One of the great advantages offered by Photoshop to the (as Ansel Adams put it) "artist and functional practitioner" is the fine control that you have over every image. As you have just seen, you can remix the individual Red, Green, and Blue channels to match your aesthetic needs. Then, you can further fine-tune those adjustments using layer masks and layer opacity.

In the next steps, you will address isolated areas in the image so as to allow the colors of the base image to filter upward and through to the layer above and so on. When working with layers, keep in mind that when a layer is at 100% opacity, nothing beneath that layer comes through. As you lower the opacity of the top layer, less of the top layer becomes visible and more of the layer below shows through. Also, the layer masks that are attached to each of the Channel Mixer adjustment layers allow you to even more selectively control the layer's opacity.

It is important to remember that the bottom-most Channel Mixer adjustment layer (the Green Channel Mixer adjustment layer) is the *primary layer*, which means that this is the layer that has the most influence on the way this image looks. If you want to change that, you either have to switch the position of that Channel Mixer adjustment layer or use the attached layer masks. Be aware that sometimes it will appear that you are working backwards. For example, my decision process for this image was as follows. I liked the overall appearance of the Green Channel Mixer adjustment layer. I liked the creamy skin tones in the Red Channel Mixer adjustment layer, and I liked the deepness of the skin tones in the Blue Channel Mixer adjustment layer.

What I did not like in the Green Channel Mixer adjustment layer was the level of contrast in the subject's skin tone and lips. I did not like the flatness in the skin tones of the Red Channel Mixer adjustment layer, and lastly, I did not like the mottled skin tone in the Blue Channel Mixer adjustment layer. The way to address all of these issues is by doing brushwork on the individual Channel Mixer adjustment layer's layer masks.

To give you a visual guide to what I liked and disliked about this image, look at the image maps that I created as a guideline to the brushwork that you are about to do (**Figure 7.49**). As I discussed on page 6 of *Welcome to Oz 2.0*, an image map is a Photoshop layer (that sits on top of the image layer stack) on which you can make notes and lists of what you are planning to do to an image. You can also use it to make notations on the various steps you will take, but what it does best is to teach you how to create image-specific workflows. An image map is basically a planning device that helps you see the trees from the forest.

When you create an image map, keep in mind that you are not married to the percentages that you write down. For example, I might write a notation of "75%" in one area, "50%" in a second area, "30%" in a third, and "25%" in a forth. What this means to me is that I want more of the effect in the 75% area than in the 50% area, etc. Also, I use a + or a – to indicate whether I am adding or subtracting an effect. (See the sidebar: *Unmasking Layer Masks and the 80/20 Rule* in Chapter 2.)

Look at the image map starting with the one for the Green Channel Mixer adjustment layer's layer mask. The areas in which you will do brushwork is shown in **Figure 7.49**.

As you can see by the image map, you are going to diminish the amount of the Green Channel Mixer

adjustment layer's effect on the subject's face and chest more than you should on her arms. I chose -75% on her face and chest, and -50% on her arms and back shoulder.

NOTE: For all of the layer masks that have been created throughout this book, follow the approach to layer mask creation discussed in Chapter 2 in the sidebar: *Error-Free Layer Masks*.

Figure 7.49 *The Green channel adjustment layer's image map*

Figure 7.50 *The image with just her face and neck brushed in*

Figure 7.51 *The layer mask*

Though I recommend that you use either a tablet-based approach to image editing (Wacom Intuos tablet) or, my favorite, a pen display approach (Wacom Cintiq) for the creation of layer masks, you can create reasonably precise layer masks using a mouse, trackball, or track pad. All you need is practice.

To see how to create an image map, there is a QuickTime movie that you can download from the download page for this book.

30. Turn off the Blue Channel Mixer adjustment layer by clicking on the eyeball to the left of the layer.

You should have the Neutral Channel Mixer adjustment layer, the Red Channel Mixer adjustment layer, and the Green Channel Mixer adjustment layer turned on.

31. Make the Green Channel Mixer adjustment layer the active one, and make the Green Channel Mixer adjustment layer's layer mask active by clicking directly on the layer mask.

32. Making sure that the foreground color is black and the background color is white, select the Brush tool (keyboard command B) in the Tools panel.

33. Set the brush opacity to 50% (keyboard command "5").

34. Set the brush width to a diameter of 200 pixels and brush in her face, neck, and chest.

35. Bring up the Fade Effect dialog box (Command + Shift + F / Control Control + Shift + F) and move the slider to the right until you reach the desired effect. I chose 78%.

You should see this (**Figures 7.50** and **7.51**).

FIGURE 7.52 *The image with her face, neck and shoulders brushed in*

FIGURE 7.53 *The layer mask*

FIGURE 7.54 *The colors beneath the conversion*

36. With the brush opacity still set to 50%, lower the brush width to a diameter of 125 pixels using the left bracket key, and brush in her back shoulder, front shoulder, and arm.

37. Bring up the Fade Effect dialog box (Command + Shift + F / Control + Shift + F) and move the slider to the left until you reach the desired effect. I selected 42%.

You should see this (**Figures 7.52** and **7.53**).

If you were to turn off both the Neutral Channel Mixer adjustment layer and the Red Channel Mixer adjustment layer, you would see an image consisting of both chromatic grayscale and full color areas. The colors have filtered up through the layer mask of the Green Channel Mixer adjustment layer to the next Channel Mixer adjustment layer that is balanced for red. In other words, the colors from the layers beneath the chromatic grayscale conversion process affect the way the conversion process looks as they filter upwards (**Figure 7.54**).

38. Turn on the Blue Channel Mixer adjustment layer by clicking on the eyeball.

39. Make the Red Channel Mixer adjustment layer the active one and make the Red Channel Mixer adjustment layer's layer mask active by clicking directly on the layer mask.

40. Using the right bracket key, increase the brush width to a diameter of 200 pixels, and brush in her face, neck, and chest. Bring up the Fade Effect dialog box (Command + Shift + F / Control + Shift + F) and move the slider to the right until you reach the desired effect. I chose 14%.

You should see this (**Figures 7.55** and **7.56**).

41. With the brush opacity still set to 50%, use the left bracket key and lower the brush width to a diameter of 125 pixels. Brush in her back and front shoulder, and her arm.

42. Bring up the Fade Effect dialog box (Command + Shift + F / Control + Shift + F), and move the slider to the left until you reach the desired effect. I selected 42%.

You should see this (**Figures 7.57** and **7.58**).

If you were to turn off the Neutral Channel Mixer adjustment layer, and leave on the Red and the Green Channel Mixer adjustment layers, you would see an image consisting of both chromatic grayscale and full color areas. Not only have the colors filtered up through the layer mask of the Green Channel Mixer adjustment layer, they have affected the next Channel Mixer adjustment layer; the one that is balanced for red. Again, the colors of the layers beneath the conversion process affect the way the conversion process looks as they filter upwards (**Figures 7.59** and **7.60**).

You are in the home stretch of the Multiple Channel Mixer adjustment layer conversion approach. Next, you will further fine-tune the underlying colors of this image by using the Hue/Saturation adjustment layer that this action created at the very beginning; the one that you used to analyze the color of the image and to find the highlight areas that you wanted to protect.

FIGURE 7.55 *The image with her face and neck brushed back on the Red Channel adjustment layer*

FIGURE 7.56 *The layer mask*

FIGURE 7.57 *The image with her face, neck, and both shoulders brushed back*

FIGURE 7.58 *The layer mask*

FIGURE 7.59 *The color image with both adjustment layers on*

FIGURE 7.60 *The color image with just the Red Channel Mixer adjustment layer on*

Step 11: Filters Without Filter Factors: Super Granular Color Control Using Hue/Saturation Adjustment Layers

One of the things that I love most about being a digital still photographer is that not only can I have my cake and eat it too, I can have extra buttercream frosting and not gain any weight. One of the great advantages of digital photography is that the only filters that you need to carry in the field are UV filters to protect your lenses, a polarizer, two gradient neutral density filters, a variable density filter and, perhaps, a close-up filter like the Canon 500D or the Tiffen close-up filter set.

NOTE: The Canon 500D close-up lens screws onto the front of all but one of my lenses like a filter. (It is referred to as a lens and not a filter, because it is made up of two elements.) All of the filters that I use are Tiffen: specifically the Tiffen polarizer, variable neutral density, UV, and close-up filter set. I use both the Canon 500 D close-up filter and the Tiffen close-up filter set because they have different qualities of bokeh. When I use these close-up filters and lenses, I prefer to shoot with zoom lenses instead of prime lenses because zoom lenses allow me to change my framing without changing my perspective. Also, these filters allow me to convert all my lenses into macro lenses.

You no longer need to carry any of the colored filters that were once required to change what happened to the color of the light as it hit the black-and-white film inside your film camera, and you no longer need be concerned with a filter factor. A filter factor refers to the multiplicative amount of light that a filter blocks. What that means is that when you put a piece of colored glass in front of your lens, you had to either slow down the shutter speed or open up

the aperture to allow in more light. And, of course, you could not undo the effect because it was forever cooked into the negative. With digital technology, this is no longer an issue. You can add the same types of effects that you could achieve with color filters without having to actually put one in front of the lens. Other pluses are: you no longer need be concerned with filter factors, you can selectively filter any area of the image, and you can use multiple colored filters selectively.

In this step, you will selectively adjust one area of the image; the subject's mouth, because something was lost in this area of the image while doing the brushwork on the individual Channel Mixer adjustment layer's layer masks. In the visual journey that the viewer's eye takes through this image, I want the journey to begin with her eyes, and end at her mouth. Everything that I did to the image during the image editing process before chromatic grayscale conversion was to reinforce these choices. However, after doing brushwork to the layer masks of the Green and Red Channel Mixer adjustment layers' layer masks, the detail in the subject's mouth was reduced, thus lowering its visual appeal. These next steps correct these issues.

43. Zoom into the area of the subject's mouth (**Figure 7.61**).

44. Make the Hue/Saturation adjustment layer the active one.

45. From the Hue/Saturation adjustment layer's color pull-down menu, select Reds (**Figure 7.62**).

46. Click on the Saturation slider and move it right to 100%. (Remember: Go to an extreme and then retreat to a usable position.) (**Figure 7.63** and **7.64**)

47. Click on the Lightness slider and move it left to -63%. (Notice how this darkens her lips and begins

FIGURE 7.61 *The area of the mouth*

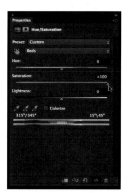

FIGURE 7.62 *The Reds in the pull-down menu*

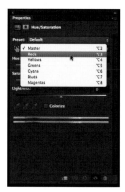

FIGURE 7.63 *The Hue/ Saturation adjustment layer dialog*

FIGURE 7.64 *The area of her mouth at 100% saturation*

to add detail back in.) (**Figures 7.65** and **7.66**)

48. Click on the Hue slider and move it left to -14%. (Even more detail is added.) (**Figures 7.67** and **7.68**)

FIGURE 7.65 *-63% Lightness slider*

FIGURE 7.66 *The mouth at -63% lightness*

FIGURE 7.67 *-14% Hue slider*

FIGURE 7.68 *The mouth at -14% hue*

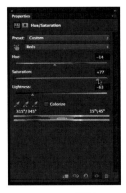

FIGURE 7.69 *77% Saturation*

FIGURE 7.70 *The mouth at 77% saturation*

FIGURE 7.71 *The color image before the adjustment*

FIGURE 7.72 *The color image after the adjustment*

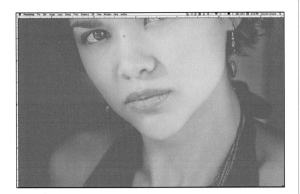

FIGURE 7.73 *The image in Ruby-Lith mode*

49. Click on the Saturation slider and move it left until the banding in the image disappears. I chose 77%. (You can still see banding at the edge of her face.) (**Figures 7.69** and **7.70**)

This is what the subject's mouth area looks like in color before and after you made the adjustment (**Figures 7.71** and **7.72**).

50. Make the Hue/Saturation adjustment layer's layer mask active and fill the layer mask with black.

51. Making sure that the brush opacity is set at 50%, the foreground color is white, and the background color is black, select a brush width of 25 pixels.

52. Zoom out so that her face fills your screen and click on the backslash key (\). This puts Photoshop in Ruby-Lith mode. (This makes it easy for you to see where you painted on the layer mask.) (**Figure 7.73**)

53. Brush in the entire area of her mouth. (Be sure to do this in one pass. Do not brush multiple times. If there are any areas that you missed, they are easily corrected once you achieve the desired final opacity.) (**Figures 7.74** and **7.75**)

54. Click on the backslash key (\) to take Photoshop out of Ruby-Lith mode.

55. Bring up the Fade Effect dialog box (Command + Shift + F / Control + Shift + F) and move the slider to the left until you reach the desired effect. I selected 42% (**Figures 7.76, 7.77, 7.78,** and **7.79**).

FIGURE 7.74 *The lips after brush back*

FIGURE 7.75 *The layer mask*

FIGURE 7.76 *The lips before*

FIGURE 7.77 *The lips after*

FIGURE 7.78 *The layer mask*

FIGURE 7.79 *The final image*

Step 12: The Last Act of the Action

You have already created the relationship between the Red, Green, and Blue Channel Mixer adjustment layers that you find visually appealing. You have also adjusted specific areas of the image with both the individual Channel Mixer adjustment layer's layer masks and with the Hue/Saturation adjustment layer so that you have what you feel is the optimal interplay of color. From RAW file to output, I recommend that your workflow should always go from global to granular. This means that once you create your desired relationships between layers, adjustments, etc., then you should fine-tune those relationships. When you click on the layer set that contains all of the Channel Mixer adjustment layers, you should see that sample point 1 is now at 251— four points above optimum. (Remember, the goal is to stay between 244 and 247 in the highlight areas of the image.) In other words, the highlight on the bridge of the model's nose is now blown out. You will address this issue using the Constant slider, which is the fourth slider in the Channel Mixer adjustment layer dialog box.

The Constant slider works by adding a black or white channel of varying opacity to the Channel Mixer adjustment layer. When the slider is negative, it acts as a black channel and globally darkens the Channel Mixer adjustment layer. When it is positive, it acts as a white channel and globally lightens the Channel Mixer adjustment layer. I have found that the latitude of compensation should never be more than plus or minus 10%. If it is over 10%, then you should consider readjusting the mix of the Channel Mixer adjustment layer. You may often get a relationship of red to green to blue that you find appealing, but you also may find that the highlights are blown out or the deep shadows are too dark. The Constant slider lets you compensate for this.

Because the issue in this image is one of blown out highlights, and you have already created relationships among the channels that you like, you can proceed in one of several ways. You could go back to the offending Channel Mixer adjustment layer and selectively brush in the blown out area on that Channel Mixer adjustment layer's layer mask, but that may cause several new problems. You could lower the opacity of one of the Channel Mixer adjustment layers, but this may change how the colors filter through the individual Channel Mixer adjustment layers. Because I believe in making things as simple as possible, but no simpler, I would change the density of one of the channels. The issue is to determine to which of the three Channel Mixer adjustment layers to add density.

Of the Red, Green, and Blue Channel Mixer adjustment layers, you did brushwork on only two, the Red and Green. Because the Blue was untouched, it is the one in which the areas that have not received brushwork on the Red and Green Channel Mixer adjustment layer's layer masks have the least effect on the image. Therefore, the only areas that are signifigantly influenced by the Blue Channel Mixer adjustment layer are in the subject's face, neck, chest, and arms. The Blue Channel Mixer adjustment layer has little effect on the background and her hair.

When you change the Constant percentage in the Channel Mixer adjustment layer, the overall density of the Channel Mixer adjustment layer that you were affecting will lighten or darken. Since you will be darkening to lower the area of the highlight on the subject's nose, there will be some areas in this image that you will want to protect from darkening; specifically, the deep shadow areas in her hair and dress. If you decrease the Constant value in the Green Channel Mixer adjustment layer, which is the primary Channel Mixer adjustment layer, you will

significantly darken those areas. If you also decrease the Constant value in the Red Channel Mixer adjustment layer, which is the secondary Channel Mixer adjustment layer, once again - though not as much - you will significantly darken those areas. By adjusting the Blue Channel Mixer adjustment layer in this image; the one that exerts the smallest effect on the image, you preserve the relationships between the three Channel Mixer adjustment layers that you wanted as well as addressing the issues of the blown out highlights.

NOTE: I invite you to play with the Constant values of the Red and Green Channel Mixer adjustment layers. Do this so that you can see for yourself what happens when you adjust the Constant value on each of them.

56. Make the BLUE Channel Mixer adjustment layer the active one.

57. In the Channel Mixer adjustment layer dialog box, click on the Constant slider and move it left until you reach the desired effect. I chose -2%.

Even after lowering the Constant you should notice that the Info panel is showing sample point 1 at 255 and sample point 2 at 250. The target is still 244-247, so further fine-tuning of the BLUE layer is needed.

58. Click on the Blue slider and move it to the left until sample point 1 in the Info panel falls into the 244-247 range, which for this image is at 87% (**Figures 7.80, 7.81, 7.82** and **7.83**).

59. Restart the action. It will create a Master layer and then save the file.

60. The action will then duplicate the file that you just converted.

FIGURE 7.80 *Adjusting the Blue slider to 87%*

FIGURE 7.81 *The Info panel after the adjustment*

61. The Duplicate Image dialog box will come up. Replace the word "copy" in the dialog box with "_FINAL" and what you should see in this dialog box is LILAN_OZCH07_OZ_2_KANSAS_BW_FINAL.

62. Click OK.

63. The action will Save As the duplicated file and, in the Save As dialog box, make sure that the name is LILAN_OZCH07_OZ_2_KANSAS_BW_FINAL. The action will then save this file as a TIFF file.

Examine the final image (**Figure 7.84**).

NOTE: It is at this point that I normally tone the image. I will not discuss toning of black-and-white photographs, because this book is about converting color images to chromatic grayscale ones. Toning is an aesthetic choice that you make post-conversion.

FIGURE 7.82 *The image before the final tweak*

FIGURE 7.83 *The image after the final tweak*

FIGURE 7.84 *The final image*

Image 2: Using a Multiple Channel Mixer Conversion Approach on a Landscape

For the second lesson of this chapter, you will again run an action that converts a color image to chromatic grayscale using the Multiple Channel Mixer adjustment layer conversion approach. But, with this image, you will change the layer order.

In this lesson, I list all the steps (nothing critical is omitted), but I have left out the discussions of why the choices are made; those were covered in the previous lesson. Anything not covered in the last lesson, will be expounded upon here.

Step 1: Running the Oz 2 Kansas Action

1. From the folder that you have downloaded for this chapter, open the file MIST_OZCH7.tif.

NOTE: Make sure that the Info panel is open and moved to an area on your monitor's screen that does not cover up an area of the image that will be critical to the conversion process. The information contained in the Info panel is of utmost importance for this conversion approach. Without it, you will be guessing.

2. From the Actions panel, open the OZ_2_K_AC-TIONS_12 actions set by clicking on the disclosure triangle located to the left of the folder.

3. Click on the OZ_2_K_WITHOUT_SEP action to make it active.

4. Click on the Run Action button located at the bottom of the Actions panel. This will start the action.

5. The action will create a Master layer, duplicate the file, and open the Save As dialog box.

6. In the Save As dialog box, the file is named OZ_2_KANSAS_SEP_BW.psd. Add MIST_OZCH7_ to the beginning of that name so that the file name becomes MIST_OZCH7_ OZ_2_KANSAS_SEP_BW.psd.

7. Open the OZ_2_K_IMAGES folder, click Save, and save the MIST_OZCH7_ OZ_2_KANSAS_SEP_BW.psd file to that folder.

Step 2: Creating a Midtone Contouring Layer

The action will create a Midtone Contouring layer. (See *Step 2: The Creation of a Midtone Contouring Layer* for *Image 1: Using a Multiple Channel Mixer Conversion Approach on a Portrait* earlier in this chapter for a detailed description of the action.)

Step 3: Creating a Hue/Saturation Adjustment Layer

The action will create a Hue/Saturation adjustment layer with the Saturation slider moved all the way to the right and set to 100% (**Figure 7.85**).

Step 4: Sample the Highlights

Next, the action shows a dialog box that states, "Now, use the Color Sampler Tool to sample up to 4 highlights to observe their densities on the different channels. When done selecting the samples, restart the action."

8. After reading the action's instructions, click the Stop button.

9. Using the Color Sampler tool, make sample points of all the highlight areas that are posterized.

FIGURE 7.85 *The image set to 100% saturation*

FIGURE 7.86 *The areas of importance*

FIGURE 7.87 *The Info panel*

NOTE: You do this by Shift-clicking the area that you want to sample and then releasing the mouse. To spot potential trouble areas, look for extreme color posterization where smooth color gradations turn contrasty and overly saturated. If necessary, you can move a sample point that you have already placed by click-dragging a previously placed sample point.

In this image, the four main areas of concern are located in the upper part of the waterfall (**Figure 7.86**).

10. In the Info panel, you will see the numerical values of red, green, and blue for each sample point (**Figure 7.87**).

NOTE: Because you have more information in the midtone to shadow areas than you do in the highlights, watch those values during the conversion, and make sure none exceeds 244–247. In the Zone System, 244–247 corresponds to the end of Zone VIII and the beginning of Zone IX. These are the areas of textured white.

11. When the sample points are set, restart the action by clicking on the Play button.

Step 5: Creating the Neutral Channel Mixer Adjustment Layer (CM Layer 1)

The action creates the first of four Channel Mixer adjustment layers (named NEUTRAL in the layer stack). This Channel Mixer adjustment layer will be the topmost one and is the only one on which you cannot do any brushwork.

FIGURE 7.88 *The image at 79%*

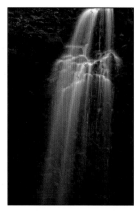

FIGURE 7.89 *The image after adjusting the Channel Mixer*

FIGURE 7.90 *The Info panel*

FIGURE 7.91 *The Channel Mixer dialog box*

Step 6: Creating the Green Channel Mixer Adjustment Layer (CM Layer 2)

Next, the action creates the second of the four Channel Mixer adjustment layers (named GREEN in the layer stack). (For further discussion, see Step 6: *The Creation of the Green Channel Mixer Adjustment Layer (CM Layer 2)* of *Image 1: Using a Multiple Channel Mixer Conversion Approach On a Portrait* earlier in this chapter.)

NOTE: In all four Channel Mixer adjustment layers, the monochrome mode is selected.

12. Click on the Green slider, which is set to 100%, and move it to the left until you reach center gray values that are slightly less than optimal or that appear slightly flat. I selected 79% (**Figure 7.88**).

NOTE: You determine the starting level for any one of the three Channel Mixer adjustment layers by moving the sliders back and forth to the extreme left and right until you find the usable position.

Remember, the Green channel generally contains more information about relative brightness than either the Red or Blue channels.

Next, you will adjust the Red and Blue sliders.

13. Adjust the Red and Blue sliders to create an image with appealing midtone values without blowing out the highlights, blocking up the shadows, or flattening the image with an overall gray cast. I chose +13% red, +79% green, and +20% blue, with the Constant at 0% (**Figure 7.89, 7.90,** and **7.91**).

Based on what is visually important to the image, sample point 1 should be at 245.

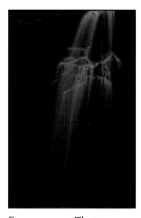

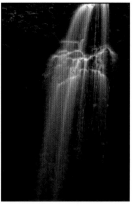

FIGURE 7.92 *The image at 72% Red*

FIGURE 7.93 *The image at 72% Red, 18% Green, 21% Blue*

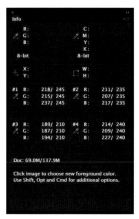

FIGURE 7.95 *The Channel Mixer dialog box*

FIGURE 7.94 *The Info panel*

NOTE: In the Channel Mixer adjustment layer dialog box, the total of the three channels equals 112%. What looks good to your eye is important, not that the total equals 100%.

14. Click OK.

Step 7: Creating the Red Channel Mixer Adjustment Layer (CM Layer 3)

The action creates the third of the four Channel Mixer adjustment layers (named RED in the layer stack). (For further discussion, see: *Step 7: The Creation of the Red Channel Mixer adjustment Layer (CM Layer 3)* for *Image 1: Using a Multiple Channel Mixer Conversion Approach On a Portrait* earlier in this chapter.)

15. Click on the Red slider, which is set to 100%, and move it to the left until you reach center gray values that are slightly less than optimal or that appear slightly flat. I selected 72% (**Figure 7.92**).

16. Adjust the Green and Blue sliders to create an image with appealing midtone values without blowing out the highlights, blocking up the shadows, or flattening the image with an overall gray cast. I chose +72% red, +18% green, and +21% blue, with the Constant at 0% (**Figures 7.93, 7.94,** and **7.95**).

NOTE: The sum of the three channels is 111%, i.e., it is greater than 100%. Also, there was a shift in which sample point went hot first.

17. Click OK.

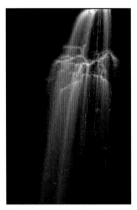

FIGURE 7.96 *The image at 92%*

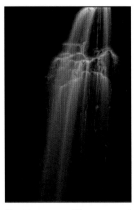

FIGURE 7.97 *The image at 9% Red, 3% Green and 92% Blue*

FIGURE 7.98 *The Info panel*

FIGURE 7.99 *The Channel Mixer dialog*

Step 8: Creating the Blue Channel Mixer Adjustment Layer (CM Layer 4)

Next, the action creates the last of the four Channel Mixer adjustment layers (named BLUE in the layer stack). (For further discussion see: *Step 8: The Creation of the Blue Channel Mixer Adjustment Layer (CM Layer 4)* under *Image 1: Using a Multiple Channel Mixer Conversion Approach On a Portrait* earlier in this chapter.)

18. Click on the Blue slider, which is set to 100%, and move it to the left until you reach center gray values that are slightly less than optimal or that appear slightly flat. I selected 92% (**Figure 7.96**).

19. As you adjust the image, pay close attention to the Green and Red sliders so that you create an image with appealing midtone values without blowing out the highlights, blocking up the shadows, or flattening the image with an overall gray cast. I chose +9% red, +3% green, and +92% blue, with the Constant at 0% (**Figures 7.97, 7.98**, and **7.99**).

20. Click OK.

Once again, the total percentage of the fine-tuned Blue Channel Mixer adjustment layers is greater than 100%; it is 104%. To best understand the significance of what you have done, do a side-by-side comparison of the original source channels before any chromatic grayscale conversion with each adjusted Channel Mixer adjustment layer (**Figures 7.100, 7.101, 7.102, 7.103, 7.104,** and **7.105**).

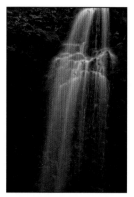

FIGURE 7.100 *Original
Red channel*

FIGURE 7.101 *Red Channel
Mixer adjustment*

FIGURE 7.102 *Original
Green channel*

FIGURE 7.103 *Green Channel Mixer adjustment layer*

FIGURE 7.104 *Original
Blue channel*

FIGURE 7.105 *Blue Channel Mixer adjustment layer*

Step 9: Comparing the Adjusted Red, Green, and Blue Channel Mixer Adjustment Layers

The action has created the four Channel Mixer adjustment layers and you have fine-tuned them. Next, the action will show you each one. This gives you the opportunity to look at each Channel Mixer adjustment layer and decide what about each you like and dislike. Once you have done that, go to the next step.

21. Click Continue.

22. A new dialog box will come up with the following message: "This is the Red channel. Click Continue to view the Green channel." Click Continue.

23. A new dialog box will come up with the following message: "This is the Green channel. Now click Continue." Once you have observed how this adjusted Channel Mixer adjustment layer looks and evaluated what about it you like and dislike, click Continue.

24. The following dialog box will come up: "Now adjust the opacities for each color channel adjustment layer and selectively paint the desired tonalities in using the layer masks. Also consider switching the order of the layers. Then restart the action."

25. Click Stop.

Step 10: Further Fine-Tuning the Red, Green, and Blue Channel Mixer Adjustment Layers Using the Attached Layer Masks

Now that you have created the individual Red, Green, and Blue Channel Mixer Adjustment layers and balanced each of them to your liking, you will further fine-tune those adjustments using layer masks, layer opacity, and layer order.

NOTE: Once again, when a layer is at 100% opacity, nothing beneath that layer comes through. As you lower the opacity of the top layer, less of the top layer becomes visible and more of the layer below it shows through.

Currently, the bottom most Channel Mixer adjustment layer is the Green one. This makes it the primary layer and, as such, it has the most influence over the way this image looks. When looking at the individual Channel Mixer adjustment layers, I thought that the Blue Channel Mixer adjustment layer held the most drama, especially in the rock and foliage areas on either side of the waterfall. In particular, I liked that these areas fell solidly in Zone II and III. The combination of the Green and Red Channel Mixer adjustment layers is where I found the greatest detail and texture in the waterfall. Based on these observations, it made the most sense to me to choose the Blue Channel Mixer adjustment layer as the primary one with the Red still as the secondary and the Green Channel Mixer adjustment layer replacing the original position of the Blue Channel Mixer adjustment layer (the one just below the Neutral Channel Mixer adjustment layer).

I decided where to do brushwork based on the following: I liked the appearance of the rocks and foliage in the Blue Channel Mixer adjustment layer, but when just the Blue Channel Mixer adjustment layer was visible, I did not like the overall darkness and flatness. When the Red Channel Mixer adjustment layer was visible, I liked the upper-end details in the foliage and rocks, but not the flatness in the waterfall or aspects of the rocks and foliage in the upper left-hand corner of the image. When just the Green Channel Mixer adjustment layer was visible, I liked the waterfall's punch and brightness, but I disliked the brightness in the foliage and rocks. I also wanted to pull back some of the brightness and punch from the upper part of the fall as well as from some of the side areas.

Knowing all this, from a workflow standpoint, it made sense to begin with the Blue layer, then go to the Red one, and finish with the Green. I determined how and what to brush back on the individual layer masks as follows: Starting with the Blue Channel Mixer adjustment layer, I decided to brush back some of the image areas to allow some of the underlying colors to come through and be filtered by the Red and Green Channel Mixer adjustment layers. Then I decided to make the necessary adjustments to the Red and Green Channel Mixer adjustment layers. What has changed between what you did with the first image and what you will do with this one is that you will address doing the brushwork on the layer mask differently. In the portrait image, you filled the layer mask with black concealing some of the adjustments that you made, and painted with white revealing others. (See the sidebar: *Unmasking Layer Masks and the 80/20 Rule* in Chapter 2.) In this image, you will do the opposite. This is because you want to reveal more than you want to conceal. This is the image map of the brushwork on the Blue Channel (**Figure 7.106**).

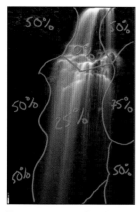

FIGURE 7.106 *The Blue Channel Mixer image map*

FIGURE 7.107 *The image with the sides brushed back*

FIGURE 7.108 *The layer mask*

26. Turn off the GREEN and RED Channel Mixer adjustment layers by clicking on the eyeball to the left of the layer.

The NEUTRAL and BLUE Channel Mixer adjustment layers should be on.

27. Make the BLUE Channel Mixer adjustment layer the active one and make its layer mask active by clicking directly on the layer mask.

28. In the Tools panel, select the Brush tool (keyboard command B) making sure that the foreground color is white and the background color is black.

29. Set the brush opacity to 50% (keyboard command 5).

30. Set the brush width to a diameter of 400 pixels and brush in the area to the left of the waterfall, from the top of the image to the bottom.

31. Bring up the Fade Effect dialog box (Command + Shift + F / Control + Shift + F) and move the slider to the right until you obtain the desired effect. I selected 51%. Repeat this on the right side of the waterfall.

You should see this (**Figures 7.107** and **7.108**).

32. Brush in the area of the waterfall from just below the middle part of the upper fall, down to the bottom of the image. (See the image map in **Figure 7.106**.)

33. Bring up the Fade Effect dialog box (Command + Shift + F / Control + Shift + F) and move the slider left until you get the desired effect. I chose 31%.

FIGURE 7.109 *The lower waterfall brushed back*

FIGURE 7.110 *The layer mask*

FIGURE 7.111 *The right middle side of the waterfall brushed back*

FIGURE 7.112 *The layer mask*

FIGURE 7.113 *The image with both color and chromatic grayscale areas*

FIGURE 7.114 *The chromatic grayscale image*

You should see this (**Figure 7.109** and **7.110**).

34. With the brush opacity still set to 50%, using the left bracket key, lower the brush width to a diameter of 300 pixels. Brush in the area to the right side of the waterfall from just above the top of its middle to just below the middle (the area of the image map that is marked 75%). Do not bring up the Fade Effect dialog box. In this instance, the re-brushing gives you the desired effect. (See the sidebar: *Unmasking Layer Masks and the 80/20 Rule* in Chapter 2.) You should see this (**Figures 7.111** and **7.112**).

If you were to turn off the Red, Green and the Neutral Channel Mixer adjustment layers, you would see an image that consists of both chromatic grayscale and full color areas. (**Figures 7.113** and **7.114**)

Once the brushwork on the Blue Channel Mixer adjustment layer is done and fine-tuned, there are still some issues to address on the other Channel Mixer adjustment layers. The layer that needs the most adjustment is the Green Channel Mixer adjustment layer.

There are two ways to approach image-editing workflow: global to granular or granular to global. In the type of image editing where you build the image from the RAW file to finished print, it is best to go global to granular and solve your biggest problems first. If, however, you are ever in the position to have to fix the poor Photoshop technique of others (if you are printing someone else's image for them), your workflow would be reversed (granular to global) because the cumulative, and frequently multiplicative, aspects of image artifacting can amplify small problems into bigger ones. Once a file has been edited, data has been clipped, so there is just so much damage that you can undo.

FIGURE 7.115 *Without the Green Channel Mixer on*

FIGURE 7.116 *With the Green Channel Mixer on*

FIGURE 7.117 *The image map of areas to be brushed back*

Every time you clip data, you introduce artifact. There is an old adage, "measure twice and cut once." In this lesson, this is what you are doing. You are observing how everything interacts with everything else, so that you can effect the greatest change in the image with the smallest impact on the data. In *Welcome to Oz 2.0*, I discussed this principle in depth so that you learned an image-editing workflow, the goal of which was to minimize artifact from the pressing of the cable release to final output.

Next, look at what you like and dislike about the Green Channel Mixer adjustment layer. I like the brightness in this layer and the boost of contrast that it adds to the overall image, but there are certain parts of the image in which the brightness and contrast are not appealing to me and interfere with the journey that I want the viewer's eye to take. These are areas that will require some brushwork on the layer mask. I want the viewer's eye to be drawn to (and return to) the main part of the waterfall (the part that is just below the top fall where the water hits and appears to protrude outward). Also, I would like to open up some of the shadows in the Zone II and Zone III areas of foliage and rocks that are at either side of the waterfall. If you turn off the Green Channel Mixer adjustment layer before any further adjustment, those areas are a little flat, and when you turn the Green Channel Mixer adjustment layer back on, they pop a little too much. Lastly, I want the back part of the waterfall to appear further back than the main part of the waterfall. I can create that illusion by diminishing the brightness and contrast of that part of the image that popped too much when the Green Channel Mixer adjustment layer was turned back on (**Figures 7.115, 7.116,** and **7.117**).

35. Make the Green Channel Mixer adjustment layer active and visible by clicking on the eyeball and then on the layer.

36. Make the Green Channel Mixer adjustment layer's layer mask active by clicking on the layer mask.

FIGURE 7.118 *With brushwork done on the Green Channel Mixer adjustment layer and the Neutral CM adjustment layer off*

FIGURE 7.119 *With brushwork done on the Green Channel Mixer adjustment layer and the Neutral CM adjustment layer on*

FIGURE 7.120 *The layer mask*

37. With the brush opacity still set to 50%, set the brush width to a diameter of 400 pixels. Brush in the top part of the waterfall and the areas to either side of the waterfall as indicated on the image map.

NOTE: For this image, 50% opacity was the correct amount. Remember three things about the opacity of the layer mask. It will be more or less or equal to 50%. You do not know which of these it will be until after you do the brushwork. In this instance, 50% was perfect.

38. Next, in the area marked 75% on the image map, set the brush width to a diameter of 175 pixels using the left bracket key, and brush in the area of the waterfall.

NOTE: There is no need to bring up the Fade Effect dialog box; 50% of 50% is 25%, and 25% + 50% equals 75%. An opacity of 75% appears to be the correct amount. Always trust your eyes to make the right decision for you.

You should see this (**Figures 7.118**, **7.119,** and **7.120**).

The next step is to observe what occurs in this image when you turn on the Red Channel Mixer adjustment layer. (There is a 100 PPI version of this file that you can look at in the folder for this chapter from the download site.) If your sample points are placed in the same place as mine in the Info panel, sample point positions 1, 2, and 4 are out of the desired range. Sample position 1 is at 255, sample position 2 is at 250, and sample position 4 is at 255.

Decide what you like and dislike about the Red Channel Mixer adjustment layer. When the Red Channel Mixer adjustment layer is turned on, it adds a lot of pop to the image, however, by adding that pop, the

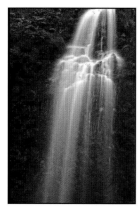

FIGURE 7.121 *The image with the Red Channel Mixer turned on*

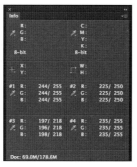

FIGURE 7.122 *The Info panel*

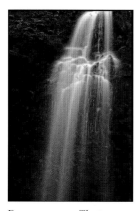

FIGURE 7.123 *The image after using the Constant slider*

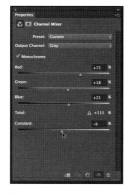

FIGURE 7.124 *The Constant slider*

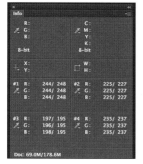

FIGURE 7.125 *The Info panel*

waterfall becomes blown out. Also, there is too much punch in the foliage in the upper left-hand corner (in the lighter gray aspects of the image structures). You will adjust for this by using the Constant slider, the fourth one in the Channel Mixer adjustment layer dialog box (**Figures 7.121** and **7.122**).

39. Make the Red Channel Mixer adjustment layer active and visible by clicking on the eyeball and on the layer.

40. Make the Red Channel Mixer adjustment layer's layer mask active by clicking on the layer mask.

41. In the Red Channel Mixer adjustment layer, click on the Constant slider and move it to the left (into the black area of the slider) until you reach the desired effect. I selected -9%. Sample point 1 is now at 248. (**Figures 7.123, 7.124,** and **7.125**)

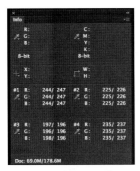

FIGURE 7.126 *The Info panel*

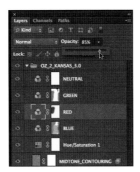

FIGURE 7.127 *The Opacity set to 59%*

FIGURE 7.128 *The image before*

FIGURE 7.129 *The image after*

FIGURE 7.130 *The image map*

42. Click on the Master Opacity dialog box and move the slider until the Info panel shows sample point 1 registering 247. I used 85% (**Figures 7.126, 7.127, 7.128,** and **7.129**).

43. With these simple adjustments, you have addressed most of the issues of the Red Channel Mixer adjustment layer. But frequently, when one door opens, another door closes. (I have taken the liberty of reversing the thoughts in this old adage.) In the process of using the Constant to address most of the issues of the Red Channel Mixer adjustment layer, the area of the rocks to the left of the main part of the waterfall is now blocked up. You will address that issue by brushing back that area on the layer mask of the Red Channel Mixer adjustment layer.

44. With the brush opacity still set to 50%, set the brush width to a diameter of 400 pixels. Brush in the area to the left of the main part of the waterfall (**Figure 7.130**).

45. Bring up the Fade Effect dialog box (Command + Shift + F / Control + Shift + F) and move the slider to the right until you reach the desired effect. I selected 82%.

You should see this (**Figures 7.131, 7.132, 7.133,** and **7.134**).

Step 11: Filters Without Filter Factors: Super Granular Color Control Using Hue/Saturation Adjustment Layers

In this image, this step is not needed. Not all images require that all aspects of the action need be utilized. Not all images require brushwork on all of their Channel Mixer adjustment layer's layer masks. Some images require only lowering of the opacity of one or two of the Channel Mixer adjustment layers. The important thing to remember is that workflow is dynamic, not static, and it is image specific.

FIGURE 7.131 *The image before*

FIGURE 7.132 *The image with the Red Channel Mixer on and the Neutral CM off*

FIGURE 7.133 *The image after brushwork and the Neutral CM on*

FIGURE 7.134 *The layer mask*

Step 12: The Last Act of the Action

46. Restart the action. It will create a Master layer (Command + Option + Shift + E / Control + Alt + Shift + E) and save the file.

47. The action will then duplicate the file that you have just converted.

48. The Duplicate Image dialog box will come up. Replace the word "copy" in the dialog box with _ FINAL so that you see MIST_OZCH7_ OZ_2_KANSAS_SEP_BW_FINAL in the dialog box.

49. Click OK.

50. The action will Save As the duplicated file. Make sure that the name is MIST_OZCH7_ OZ_2_KANSAS_SEP_BW_FINAL in the Save As dialog box. The action will save this file as a TIFF file.

Conclusion

I do not object to retouching, dodging, or accentuation as long as they do not interfere with the natural qualities of photographic technique.

—Alfred Stieglitz

Instead of one grayscale channel that contains just the luminance aspect of the image or one grayscale channel that is a predefined composite of the color channels, with this approach, you have three separate grayscale channels, each one containing variations of the image. Each one of these channels may contain information that can be decidedly different than in the other two. Also, this technique allows you to refine the Red, Green, and Blue channel information in a way that affords you maximum control over the image. Compared to working with only one channel or shooting on film, this approach gives you a panel of grays that is three times greater and with three times the range.

The technique that I have described in this chapter is certainly the most difficult of the lessons in this book. But once mastered, it is something that you can do in a few minutes. The recipe for attaining mastery (and with mastery comes real understanding) is variation of repetition. Practice does not make perfect. Perfect practice makes perfect. Great innovation does not come by following the rules, but by experimenting with the rules and seeing how they can be bent. You should approach this and any technique as if it is a game, and what you are doing is playing, because playing is fun.

The technique that you have just completed in this chapter (prior to the creation of the software that I will discuss at length in the next chapter) was, for years, my primary way of converting a color image into chromatic grayscale. Frequently, I combine this technique with the one that you will learn in the final chapter. That combination allows me to create images significantly closer to my vision than I ever previously accomplished.

Lastly, before you go to the next chapter, even if you do not have the Silver Efex Pro plug-in or have no intention of acquiring the Silver Efex Pro plug-in, I still suggest that you download the demo version of the software and do the lesson. Doing this allows you to experience the continuing discussion of how aesthetic choices give you control over the viewer's eye as it travels through your grayscale image.

The Black and White on Silver Efex Pro 2

If you must sleep, do not fall asleep with your head on the keyboard. It ruins the code.

—Nils Kokemohr

Every technique that you have used to this point is one that you could do using only Photoshop. Even in the discussion about RAW processors in Chapter 3, (in which I compared Lightroom/Adobe Camera Raw [ACR] and, in the Rubbing Your Nikon RAW File the Right Way PDF discussion of Capture NX2 with its built-in Black and White conversion plug-in), you could still approach the conversion process with just Adobe Photoshop. For me this is an important consideration, because I currently believe that the best chromatic grayscale conversions are achieved in Photoshop. Although you can frequently achieve acceptable, usable chromatic grayscale conversions using RAW processing software (Lightroom 4, Aperture 3, Capture NX 2, etc.), Photoshop affords you the most control over your image. In this chapter, you are going to work with a piece of software, Nik Software's Silver Efex Pro plug-in (now in its second version), that makes Photoshop even better.

Of all of the black-and-white conversion software on the market today, Silver Efex Pro is considered by all but a very few to be the best of class. Certainly nothing with which I have worked—and I make it a point to work with every piece of black-and-white conversion software that comes out—comes even close to the ease of use, variety of choices, and the amount of granular control that this plug-in affords the end-user. In my opinion, it is an elegantly designed piece of software.

NOTE: In the spirit of full disclosure, I have been involved with the development of this software since it was a twinkle in Nils Kokemohr's eye. I was part of the original alpha testing group, as well as the software's first beta tester.

The lessons that are this chapter build on the work that you did on the images in the preceding chapter. (The chromatic grayscale conversion that I currently use for my digital, non-infrared photography is mostly done with a combination of what you did in the previous chapter and what you are about to do in this one. For my digital infrared photography, I almost exclusively use the Silver Efex Pro 2 plug-in.) I have created a QuickTime tutorial with Josh Haftel, the senior product manager for Nik Software, that goes over, in great detail, the "button-ology" of the Silver Efex Pro 2 plug-in. Before you go any further in this chapter, I recommend that you take the time to watch this tutorial that can be found on the download page for this book.

It is important for you to have watched the QuickTime tutorial for the Silver Efex Pro 2 plug-in before you move on to this chapter's lesson because the emphasis in this chapter is more on the aesthetics (the whys rather than the hows of the technology) and applying the theories that you have learned up to this point, than it is on which button does what. (For easy reference, in addition to the QuickTime tutorial, I have included an extensive overview of the Silver Efex Pro 2 plug-in in this chapter. See: *The Black and White on the Silver Efex Pro 2 User Interface*.)

Since this is the last chapter of the printed book, you should be adept at doing chromatic grayscale conversions. It is at that level that I will begin the next lessons. Once again, you will be using actions. What I have endeavored to create is a series of actions that take into account every possible scenario in which you may find yourself when it comes to making a chromatic grayscale conversion. I believe that your photographic life should be more about being behind the camera and being pulled through the lens, than it should be about sitting in front of the adult videogame known as Photoshop. With that thought in mind, once you have watched the tutorial and read the next section, you should be ready to move on to the Silver Efex Pro lesson.

The Black and White on the Silver Efex Pro 2 User Interface

Before you start playing with an image, it is a good idea to have an understanding of the tool that you are about to use. This section gives a brief overview on how the Silver Efex Pro 2 user interface is laid out and how it works. To reiterate, in addition to this overview, you will find this information as a QuickTime tutorial that you can download from the download site for this book.

NOTE: If you do not have a copy of the Silver Efex Pro 2 plug-in, you can download a 15-day trial from www.niksoftware.com or click on the link located on the download page for this book.

Silver Efex Pro 2 offers a complete workflow solution for converting color images into chromatic grayscale ones. The interface of Silver Efex Pro 2 is set up with an efficient workflow in mind: from global to granular and from left to right (**Figure 8.1**).

By default, on the left side of the interface, you have a Preset Browser that offers traditional and creative starting points for changing the overall appearance of your image (**Figure 8.2**). The default option is Neutral and is an unmodified chromatic grayscale conversion from color. Other options include presets based on traditional film processing and printing techniques such as push and pull processing and simulated toning solutions; and traditional shooting techniques such as high key and low key lighting, using a graduated neutral density filter, and under/over exposing the film. The creative techniques provided within the Preset Browser include stylistic options to enhance detail, to mimic cinematic film styles from the early 20th century, and alternative photographic processes like pinhole photography. In addition to the presets that are built in to the software, you can also create and share your own.

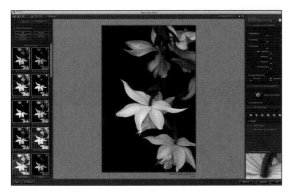

FIGURE 8.1 *The Silver Efex Pro 2 interface*

FIGURE 8.2 *The Preset Browser*

FIGURE 8.3 *The right side of the interface*

Also available on the left side is the History Browser, which allows you to view the sequence of adjustments that you make while editing an image and to compare any two steps in that sequence. The history sequence is separated into sections by the type of adjustment that was made. The last adjustment is shown at the bottom of the list.

On the right side of the interface, the controls are divided into a suggested workflow, from global to granular (**Figure 8.3**). Many of the adjustments in Silver Efex Pro 2 are based on traditional photographic concepts. As an example, the Color Filtration section is based on glass filters that photographers might put in front of the lens while photographing to change the tonal relationship of colors. Additionally, there are recreations of film types based on the grain quality, color sensitivity, and tonal reproduction curves of black-and-white films, and the use of alternative finishing adjustments such as vignettes, toning solutions, and image borders. Each major adjustment section within Silver Efex Pro (the Global Adjustments, Selective Adjustments, etc.) has the option to turn the effect on and off in order to preview the adjustments within that section.

The Global Adjustments section offers a Brightness, Contrast, and Structure slider set, with Tonality Protection (**Figure 8.4**). Each of the global Brightness, Contrast, and Structure sliders has a subsection with an additional slider for greater control based on the tonality range that you wish to create.

The Brightness and Contrast sliders work as you would expect; moving the Brightness slider brightens or darkens the image, and moving the Contrast slider increases or decreases the image's contrast. The Dynamic Brightness slider is a control unique to Silver Efex Pro 2. Developed by Nik Software, it provides you with the ability to brighten or darken

FIGURE 8.4 *The Global Adjustments section*

FIGURE 8.5 *The Selective Adjustments section*

the overall image while maintaining a consistent contrast ratio throughout the image. The Brightness slider set offers a refined control for your image at the start of editing.

The Contrast slider set acts in a way similar to the Brightness slider set so that you can separately control the black or shadow areas' contrast and the white or highlight areas' contrast. The last control within the Contrast slider set is the Soft Contrast slider. This separates the image into unique elements, and then applies contrast within each of them. It also applies a softening effect to provide smoother transitions between the areas in which the contrast is changed, resulting in a more natural effect.

The Structure slider set is designed to provide localized contrast within objects in the image and separates the image into unique elements so that the contrast inside of those elements can be individually controlled. This provides greater overall enhancement of fine details in the image.

The Selective Adjustments section of Silver Efex Pro 2 is one of the most important (**Figure 8.5**). Built into Silver Efex Pro 2 are control points that allow for the adjustment of any object or area in an image simply by placing a control point on that object or area.

Each control point has a Size, Brightness, Contrast, Structure, Amplify Whites, Amplify Blacks, Fine Structure, and Selective Colorization slider. The Size slider controls the extent of the area defined by the control point and is determined by the color, tone, texture, and location in which the control point is placed. As the Size slider is increased, the area affected is increased.

FIGURE 8.6 *The Color Filter section*

FIGURE 8.7 *The Film Types section*

The Brightness, Contrast, Structure, Amplify Whites, Amplify Blacks, and Fine Structure sliders for any particular control point function the same way as do the global controls, but on a selective basis. The Selective Colorization control allows you to bring color from the original image back into the black-and-white, one if you desire.

The Color Filter section of Silver Efex Pro 2 mimics glass filters that photographers might put in front of their lens when shooting black–and-white film to enhance contrast (**Figure 8.6**). A color filter would brighten the areas that had the same color as the glass filter and darken the complementary color. The Color Filter section provides you with greater control over your image than did traditional glass filters, because you can dial in the exact color and amount of filtration desired.

The Film Types section in Silver Efex Pro 2 simulates the grain quality, spectral sensitivity, and tonal curves of 18 different black-and-white films (**Figure 8.7**). These simulated films include those available and once available, from Agfa, Fuji, Kodak, and Ilford. They are great options to explore as a beginning step for editing the image, because the adjustments will affect the overall brightness, contrast, and tonal relationships of the image.

The Grain subsection has two sliders: the Grain Per Pixel slider and the Soft/Hard slider. The Grain Per Pixel slider controls the amount of grain introduced into the image. The smaller the number on the Grain Per Pixel slider, the more noticeable the grain will be in the image, because each pixel will be made up of larger grain elements. The Soft/Hard slider controls the contrast between the grains introduced, offering a fine-tune control for the grain's appearance.

FIGURE 8.8 *The Finishing Adjustments section*

FIGURE 8.9 *Toning section*

FIGURE 8.10 *Vignette section*

The Sensitivity, Levels, and Curves controls of the Film section provide tools to control how the image globally translates colors into tones and the overall tonal curve of the image.

The Finishing Adjustments section of Silver Efex Pro 2 provides tools to add a finishing touch to your image when you have completed your major editing (**Figure 8.8**). The Finishing Adjustments contain controls for toning, adding vignettes, burning in the edges of an image, and applying image borders.

The Toning section of Silver Efex Pro 2 adds tints to the image, many of which are based on traditional toning solutions used in traditional film photography (**Figure 8.9**). There are also tools to fine-tune the toning on the image or to create your own tone using the Silver Hue and Paper Hue sliders. The Silver Hue slider adds a tint to the dense areas (or shadows) and the Paper Hue slider adds a tint to the highlighted areas. The Balance slider controls where the two sliders will interact in the midtones.

The Vignette controls allow you to evenly add a lightening or darkening effect to all edges of the image (**Figure 8.10**). The sliders control the lightness or darkness of the effect, its shape, how much of it goes into the image, and around what the effect is centered.

FIGURE 8.11 *The Burn Edges section*

FIGURE 8.12 *The Image Borders section*

The Burn Edges controls allow you to add density to any edge (**Figure 8.11**). The controls adjust the edge's darkness, the extent of the area affected, and how quickly or slowly it transitions from the full effect to no effect. There are also four separate controls so that each edge can have an effect that is unique.

The Image Borders section adds stylistic borders that mimic film borders that you might have obtained with filed negative carriers when printing in the darkroom (**Figure 8.12**).

Image 1: Using a Single Silver Efex Pro 2 Smart Filter Layer

The image that you will use for the first lesson in this chapter is the same one that you used in the second lesson of the previous chapter. For both this image, as well as the second one in this chapter (which was the first image you worked on in the previous chapter), you will, once again, run an action. By now, you should have watched the QuickTime tutorial for this chapter. If an idea or concept has already been discussed in this book, or in the QuickTime tutorial, it will not be repeated and only the steps will be listed. I have not, however, left out any *critical* step. My focus from this point forward is directed to the aesthetics of choice—the *whys* of what you will do—because you should already have a good understanding of the *hows*.

Step 1: Running the Oz 2 Kansas Action

Pre-Step:

If you have just installed the Silver Efex Pro 2 plug-in or if you are planning to run it in demo mode, it is important to run it at least once before you run any of the actions that use it. Also, if you are running in demo mode, when you launch Photoshop, you may need to open the plug-in before you run the action. This is because when the plug-in is in demo mode it launches the registration window with every new launch of Photoshop.

You have to do this because there is no way to tell an action to be aware of these circumstances. Actions expect things to happen the same way every time, and this issue only occurs some of the time. To save yourself the hassle of unwanted issues, and to practice a little preemptive tech support, if you are running the plug-in in demo mode, open up the plug-in before you run the action.

1. Open the file MIST_OZ_CH08.tif (located on the download page for this book).

NOTE: This is the same file that you worked on in the previous chapter. There is an additional copy of this image in the Chapter 8 section of the download page to make it more convenient for this lesson.

Also there is a variation of this action that will combine the Multiple Channel Mixer approach with the creation of a Silver Efex Pro 2 Smart Filter.

2. From the Actions panel, open the OZ_2_K_AC-TIONS_12 actions set by clicking on the disclosure triangle located to the left of the folder.

3. Click on the SEP2_ONLY action to make it active.

4. Click on the Run Action button located at the bottom of the Actions panel. This will start the action.

5. The action will create a Master layer, duplicate the file, and open the Save As dialog box.

6. In the Save As dialog box, the file is named SEP_SINGLE_SA.psb. Add MIST_OZCH8_ to the beginning of the file name so that it becomes MIST_OZCH8_SEP_SINGLE_SA.psb.

7. Locate the OZ_2_K_IMAGES folder, open it, and click Save. The MIST_OZCH8_ SEP_SINGLE_SA.psb file is now saved to that folder.

Step 2: The Creation of a Single Silver Efex Pro 2 Smart Filter Layer

This variation of the Silver Efex Pro 2 action goes through a series of "under the hood" events that are designed to maintain both a non-destructive (as well as an exit strategy) approach to image editing workflow. Once the action has saved the file on which you are running the action, it will duplicate the layer, make it a Smart Filter, and then launch the Silver Efex Pro 2 plug-in. The Silver Efex Pro 2 dialog box will be open set to its default setting—Neutral Preset. You should see this (**Figure 8.13**).

NOTE: Use the keyboard command F, if you want to put the Silver Efex Pro 2 plug-in into full-screen mode when the Silver Efex Pro dialog box is open.

Also, you can scroll through the Preset menu using the up and down arrow keys, something that I suggest you do. However, for both of the images used in this chapter's lessons, you will use the Neutral Preset.

FIGURE 8.13 *The Silver Efex Pro interface*

As you look at the image, think about what aspects of it you like as well as what you might like to change. Whenever you are analyzing any of your images and find yourself saying, "I hate this image," before you delete it, consider this—it is not the image that you do not like, it is aspects of the image that you do not like. When you decided to take the image, or ideally, when you were taken by the image, something compelled you to fire the shutter. In that moment, you liked the image. Hopefully, if you did not like it, you would not have taken it. So, instead of abandoning the image, take a moment or two and analyze its individual components. For example, if you find yourself with an image that you do not like because it is made up mostly of reds, it is not that you do not like the color red; rather it is that you do not like aspects of the color red in that particular image. Think a moment. If you have a photograph that is mostly red, at the moment of capture, it must have been the red that captured you. What you have is an image with aspects of the red that you do not like. Perhaps you think that the red is too flat and lacks contrast. If that is the case, then what you must do is to increase the saturation and boost the contrast. If the reds are too orange, you will need to lower the yellow content of the red. When you analyze your own images, think of them in a positive way; think about what they can become. Also, when thinking about what you will do with an image, ask yourself simple questions—ones in which the answers are as close to yes or no as possible. The seemingly complex question of what to do with an image is actually made up of many simple choices.

FIGURE 8.14 *Showing the Loupe & Histogram section*

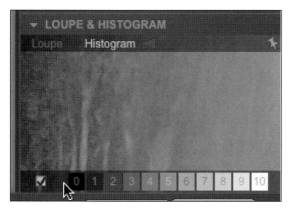

FIGURE 8.15 *The Histogram area*

FIGURE 8.16 *The image after turning on zones 1, 2, and 3*

Step 3: Analyze the Image Using Loupe & Histogram

In the Silver Efex Pro 2 dialog box, look at the image on which you are working. If you move down to the lower right-hand corner of the dialog box, you will find the Loupe & Histogram part of it. There you will find a series of squares that are numbered from 0 to 10 and range from black to white. These 11 squares are the 11 zones of the Zone System that I discussed in Chapter 6. Normally, one of the first things that I do when I use Silver Efex Pro 2 is to see into which zones the image structures and image textures of my image fall. Also, I find that the Histogram information is more helpful than the default Loupe mode.

8. Click on the Loupe & Histogram section. To open it if it is closed, click on the disclosure triangle. (**Figure 8.14**).

9. Click on Histogram (**Figure 8.15**).

The histogram shows that the image structures fall mainly in the lower and mid-zones with very few in the upper zones. Next, you will use the Zone Scale located at the bottom of the Loupe & Histogram dialog box to see into what zones your image structures and textures fall.

10. Starting from the left and moving to the right, individually and collectively, click on and off the gray squares 1, 2, and 3. This shows you which areas of the image fall in each of those zones. (Each zone is represented as a series of colored lines.) This is what you should see if gray squares 1, 2, and 3 are turned on (**Figure 8.16**).

11. Click off the gray squares 1, 2, and 3 (if you have not already). Individually and collectively, click on and off the gray squares 4, 5, 6, and 7. This shows you which areas of the image fall in each of those zones. (Again, each zone is represented as a series of colored lines.) This is what you should see if gray squares 4, 5, 6, and 7 are turned on (**Figure 8.17**).

12. Click off the gray squares 4, 5, 6, and 7 (if you have not already). Moving right to left this time,

FIGURE 8.17 *The image after turning on zones 4, 5, 6, and 7*

FIGURE 8.18 *The image after turning on zones 8, 9, and 10*

individually and collectively, click on and off the gray squares 8, 9, and 10. This shows you which areas of the image fall in each of those zones. (Again, each zone is represented as a series of colored lines.) This is what you should see if gray squares 8, 9, and 10 are turned on (**Figure 8.18**).

You should have observed that the image structures are heavily weighted to Zones I—III in the rock and foliage area, while the waterfall falls exclusively in the mid-zones, specifically Zones IV—VII. Except for two very small areas at the top of the waterfall and one directly in the middle of its main section, there are no significant image structures in any of the upper Zones, specifically Zone IX—X. Knowing where the tonality of the image structures lie is extremely important before you make aesthetic decisions about your image.

What you know about this image is the following:

- Because most of the image structures fall in the lower zones, you will need to pay attention to not creating more Zone I and Zone 0 areas (unless that is the desired effect you want).
- You can, should you decide to, deepen (darken) the Zone III and IV image structures and image textures.
- There are some image structures in the upper left of the image that contain mid-zone values. You should move those structures into the lower zones because, if the area in the upper left-hand corner is the same brightness as areas of the waterfall, potentially, the viewer's eye may be pulled from the waterfall to that area of the image. As I discussed in Chapter 3, you want the viewer's eye to go first to the waterfall (the primary isolate) and then to areas like those in the upper left-hand corner that are secondary isolates.

This brings me to a discussion of the waterfall image structures and textures. These structures and textures fall almost exclusively in the mid-zones. One of the things that you want to achieve in this image is a sense of *dimensionality*, a sense that the image appears to have three dimensions and a depth that you can almost feel. Also, you want to control where the viewer's eye goes first and where it lingers longest.

One of the primary goals for which you should strive as you edit the image is to have complete control of both the viewer's *unconscious* and *conscious* eye (For a complete discussion, see: *Believing Is Seeing: The Way the Eye "Sees" What it Saw,* in Chapter 1.) Specifically, you should control how the viewer's *unconscious eye* tracks through your image and how the viewer's *conscious eye* sees the story that you want to tell. Once you have an understanding of what the goals are for this image, you must to decide how you will attain them.

Sometimes an image is best served by using more than one Silver Efex Pro 2 layer. How I determine whether to use a single or multiple Silver Efex Pro 2 Smart Filter approach is by going to the Color Filter section and clicking on each of the individual filters.

NOTE: The power of using more than one Silver Efex Pro 2 layer is the focus of the next lesson in this chapter.

Figure 8.19 *The Color Filter section*

13. Click on the disclosure triangle for the Color Filter section, if it is not already open (**Figure 8.19**).

14. Click on each of the Red, Orange, Yellow, Green, and Blue Filter icons.

15. Click on Clear Filter, the one all the way to the left of the Color Filter set of icons.

After clicking on the Red, Orange, Yellow, Green, and Blue filter icons located in the Color Filter section, you should have seen almost no change in image structure detail in the Red through Green filters. However, a noticeable change occurred when you clicked on the Blue filter. Because of this (and the fact that, although the Blue filter achieves some of the goals in the lower zone areas of the image, it flattens too much of the contrast when applied) so a single Silver Efex Pro 2 Smart Filter layer approach appears to be the best idea (**Figures 8.20, 8.21, 8.22, 8.23,** and **8.24**).

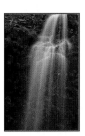

Figure 8.20 Figure 8.21 Figure 8.22
The Red filter *The Orange filter* *The Yellow filter*

Figure 8.23 Figure 8.24
The Green filter *The Blue filter*

FIGURE 8.25 *The Global adjustments*

FIGURE 8.26 *The expanded Global adjustments section*

FIGURE 8.27 *Decreasing the Brightness slider to -16%*

Step 4: Global Adjustments

Once you have defined how you want to control the viewer's eye, it is time to implement those choices. Because brightness and contrast are intertwined with each other (brightness being a range from light to dark and contrast being the ratio between light and dark), I have found that with the Silver Efex Pro 2 plug-in, it is often best to start by adjusting the overall image brightness and darkness. Keep in mind that dark is as important to an image as is light. When I approach working with light, be it in the field or in post-processing, I conceptualize it and treat it as if it were a solid object.

In this step, you will do a global adjustment to this image's brightness, contrast, and structure using the tools to be found in the Global Adjustments part of the Silver Efex Pro 2 interface (**Figures 8.25** and **8.26**).

Brightness Adjustments

The Brightness area of the Global Adjustments section is broken into five control sliders: Brightness, Highlights, Midtones, Shadows, and Dynamic Brightness. Brightness affects the image's overall light-to-dark appearance, Highlights focuses on brightening or darkening just the highlight areas, Midtones focuses on brightening or darkening just the midtone areas, Shadows focuses on brightening or darkening the shadow areas, and Dynamic Brightness affects the highlights and shadows of the more midtone areas.

16. Click on the Brightness slider. What you will do should be based on how you want the viewer's eye to move through the image. I suggest that you start by darkening the image, so move the slider to the left until you reach the desired effect. I chose -16% (**Figure 8.27**).

FIGURE 8.28 *Increasing the Midtones slider to 29%*

Now that you have set the image's global brightness, fine-tune its individual components.

17. Click on the Midtones slider and move it to the right until you obtain the desired effect. I chose 29% (**Figure 8.28**).

18. Click on the Shadows slider and move it to the left until you get the desired effect. Again, this decision is based on the observations that were made in *Step 3*. For this image, I selected -15% (**Figure 8.29**).

19. Click on the Dynamic Brightness slider and move it to the left, until you reach the desired effect. I opted for -15% (**Figure 8.30**).

FIGURE 8.29 *Decreasing the Shadows slider to -15%*

FIGURE 8.30 *Decreasing the Dynamic Brightness slider to -15%*

FIGURE 8.31 *Moving the Brightness slider to -13%*

FIGURE 8.32 *Increasing the Shadows slider in the Tonality Protection section*

20. Click back on the overall Brightness slider and move it to the right until you obtain the desired effect. I chose -13% (**Figure 8.31**).

At the bottom of the Global Adjustments part of the Edit menu is the Tonality Protection dialog box. It has two sliders that allow you to set limits for how the shadow areas and the highlight areas are affected. (They function in a similar way to the Blend If sliders in the Layer Styles dialog box.)

Next, you will protect the shadow areas, specifically the Zone 0, Zone I, and Zone II image structures and textures.

21. Click on the Shadows slider in the Tonality Protection section and move it to the right until the blocked up areas in the rocks to the left of the waterfall and foliage open up. The setting that I selected was in the middle of the slider (**Figure 8.32**).

NOTE: The Tonality Protection functionality is capable of protecting only what is in the image. Tonality Protection will not work on blown-out highlights or blocked-up shadows, because there is nothing there to protect.

Contrast Adjustments

You have set the global brightness and addressed the issues of both the light and dark aspects of the image, so it is time to globally adjust contrast. In the Contrast part of the Global Adjustments section, you will see a Global Contrast slider, an Amplify Whites slider, an Amplify Blacks slider, and a Soft Contrast slider. The Amplify Whites slider targets the upper end of contrast while the Amplify Blacks slider targets the lower end. The Soft Contrast slider works on contrast in the same fashion as Dynamic Brightness works on the elements of brightness.

FIGURE 8.33 *Increasing the Amplify Whites slider to 20%*

FIGURE 8.34 *Increasing the Soft Contrast slider to 32%*

22. Click on the Amplify Whites slider and move it to the right until you reach the desired effect. I chose 20% (**Figure 8.33**).

23. Click on the Soft Contrast slider and move it to the right until you reach the desired effect. I selected 32% (**Figure 8.34**).

Structure Adjustments

One of the many functionalities that sets Silver Efex Pro 2 apart from any other dedicated black-and-white conversion software is the Structure algorithm. Think of Structure as the Clarity tool on steroids. Though many images require global Structure adjustments, this image requires greater finesse, so you will use a granular (selective) rather than a global approach.

Step 5: Selective Adjustments

The Selective Adjustments section utilizes Nik Software's application of U Point technology in the form of *control points*. The control points in Silver Efex Pro 2 are even more refined than those in Capture NX 2 (as discussed in the Rubbing Your Nikon RAW File the Right Way PDF located on the download page for this book). The control points in SEP 2 are Nik Software's most updated version and work the same way and are as responsive as the implementation in Viveza 2. The control point approach to selection affords you unheard-of accuracy.

In these next steps, you will selectively lighten and darken the image, increase its contrast, and introduce Structure improvements to the image.

FIGURE 8.35 *The Add Control Point button*

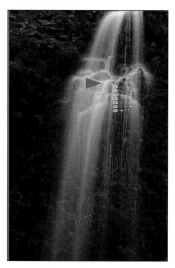

FIGURE 8.36 *Adding a control point to the waterfall*

24. In the Selective Adjustments dialog box (click on the disclosure triangle if the Selective Adjustments dialog box is not open), click on the Add Control Point icon (**Figure 8.35**).

25. Place the targeting cursor on the area that you would like the control point to influence and click or place the control point (**Figure 8.36**).

You should notice that there are a series of letters along the center bar and a series of sliders.

NOTE: The Slider / Letter Position can change sides depending on the location of the control point within an image. For example, if a control point is close to the bottom of the image, the centerline, letters, and sliders will be on the top of the main radius bar slider. If the control point is close to an edge of the image, the letters and sliders will change position. This occurs so that you can more easily and efficiently access the sliders.

You can see the area influenced by a control point by clicking on the checkbox in the Selective Adjustments dialog box to the right of the active control point in the right side of the interface.

You can also use the Zone identifier, the one you used to analyze the image at the beginning of lesson (located in the Loupe & Histogram part of the interface), to see how you are impacting the brightness and darkness of your image.

Lastly, you can control the control points with the arrow keys. The up and down arrow keys move you up or down through the different control point adjustments. The left and right arrow keys increase or decrease the effect.

26. Click on the Co (Contrast) slider and move it to the right (to increase the contrast) until you obtain the desired effect. I selected 49% (**Figure 8.37**).

FIGURE 8.37 *Increasing the Contrast slider to 49%*

FIGURE 8.38 *Increasing the Brightness slider to 25%*

FIGURE 8.39 *Increasing the Amplify Whites slider to 44%*

FIGURE 8.40 *Increasing the Structure slider to 52%*

27. Click on the Br (Brightness) slider and move it to the right until you achieve the desired effect. I chose 25% (**Figure 8.38**).

28. Click on the AW (Amplify Whites) slider and move it to the right until you get the desired effect. I elected to use 44% (**Figure 8.39**).

29. Click on the St (Structure) slider and move it to the right until you obtain the desired effect. I chose 52% (**Figure 8.40**).

30. Click on the FS (Fine Structure) slider and move it to the right until you achieve the desired effect. I selected 52% (**Figure 8.41**).

You worked on this area first because this is the primary isolate of the image and, as such, it is the area of the image that you want the viewer's eye to go to first and the area of the image to which you want their eye to return as they journey through the image.

FIGURE 8.41 *Increase the Fine Structure slider to 52%*

You edited the image in this order based on the needs of the image, not based on some preconceived rule or notion. When it comes to image editing, this is the way most workflow decisions should be made. In this image, you worked on contrast first, because there are abutting dark and light areas. By increasing the overall contrast, both of these areas tended to darken. This is why the second adjustment was to the image's brightness. Then, because you want the viewer's eye to be drawn first to the main part of the waterfall, the next fine adjustment was to Amplify Whites. You did not use the Amplify Blacks adjustment because you did not want to darken the darks anymore than they already were. Next, you applied Structure to obtain finer contrast control in the midtone image structures of the waterfall. Fine Structure was used last because it provided you with even more granular control of localized contrast so that you could introduce granularity into the waterfall's mist, reinforcing the illusion of motion. And all of this was achieved by applying just one control point. To emphasize the significance of this fact, here is the area affected by the control point that you have just adjusted (**Figure 8.42**).

FIGURE 8.42 *The area of influence*

31. Click on the Add Control Point icon. Place the targeting cursor on the area of the upper waterfall (**Figure 8.43**).

32. Click on the Co (Contrast) slider and move it to the left (to decrease the contrast) until you obtain the desired effect. I selected -29% (**Figure 8.44**).

33. Click on the Br (Brightness) slider and move it to the left (to decrease the brightness) until you achieve the desired effect. I chose -39% (**Figure 8.45**).

34. Click on the Add Control Point icon. Place the targeting cursor on the area of the lower left part of the waterfall (**Figure 8.46**).

35. Click on the Co (Contrast) slider and move it to the right (to increase the contrast) until you get the desired effect. I elected to use 29% (**Figure 8.47**).

You made adjustments to the upper and lower parts of the waterfall in order to create the illusion of depth; of three dimensionality. To achieve this, you diminished the contrast and darkened structures of the water because the upper part of the waterfall is the farthest from the foreground. The lower part of the waterfall, specifically the mist and falling water, is the most forward of all the image structures. By increasing the contrast between those image structures and the rocks and foliage behind them, you further intensified the feeling of three dimensions.

There are two more areas in this image that need to be addressed. They are the upper left-hand corner of the image and the area of the rocks to the left of the waterfall—midway down. The upper areas of the left-hand corner image are a little too bright and the rock and foliage structures to the left of the fall (in the middle of the image) are a little blocked up. The next series of adjustments will address these issues.

FIGURE 8.43 *Adding a control point to the waterfall*

FIGURE 8.44 *Decreasing the Contrast slider to -29%*

FIGURE 8.45 *Decreasing the Brightness slider to -39%*

FIGURE 8.46 *Adding a control point to the lower waterfall*

36. Click on the Zoom icon. (I set mine to 100%.) You should see this (**Figure 8.48**).

37. In the Navigator window, move the square until the upper left-hand corner of the image are in the main window. (**Figure 8.49**).

38. Click on the Add Control Point icon. Place the targeting cursor on the area of the upper waterfall (**Figure 8.50**).

FIGURE 8.47 *Increase the Contrast slider to 29%*

FIGURE 8.48 *Zooming in*

FIGURE 8.49 *Moving to the upper left-hand corner of the image*

FIGURE 8.50 *Adding a control point to the upper left area*

FIGURE 8.51 *Decrease the Brightness slider to -45%*

FIGURE 8.52 *Duplicate the control point and move it up and to the right*

FIGURE 8.53 *Adding a control point to the left of the waterfall*

FIGURE 8.54 *Increasing the Brightness slider to 15%*

39. Click on the Br (Brightness) slider and move it to the left (to decrease the brightness) until you obtain the desired effect. I chose -45% (**Figure 8.51**).

40. Duplicate the control point (Command + D / Control + D) and move it slightly upward and slightly to the right of the control point that you just duplicated (**Figure 8.52**).

41. Zoom out until the entire image is back in view (Command + - / Control + -).

42. Click on the Add Control Point icon. Place the targeting cursor on the area to the left of the main part of the waterfall (**Figure 8.53**).

43. Click on the Br (Brightness) slider and move it to the right until you achieve the desired effect. I selected 15% (**Figure 8.54**).

44. Click OK.

The Photoshop action will restart, create a Master layer, save the file that you have just created, duplicate the file, flatten the image, and save the duplicated file as a TIFF. This should be the only file that is left open on your desktop. You should see something like this (**Figures 8.55** and **8.56**). In the Info panel, notice that the main sample point (sample point 2) registers at 247 (the beginning of Zone IX, the significance of which was discussed in great length in the previous chapter).

FIGURE 8.55 *The image*

FIGURE 8.56 *The Info panel*

Image 2: The Harmonics of Chording—
The ABCs of Playing the RGBs

He who doesn't risk does not get to drink champagne.

<div align="right">—Russian Proverb</div>

The concept of *chording* with an image is something you did in both Chapter 2 and in the previous chapter. Image chording is the technique of using variations of the same type of adjustment and blending them to create a harmony that results in a visually pleasing effect in your image. That is what you did with the individual Channel Mixer adjustment layers that you balanced for green, red, and blue. In this lesson, you will apply the same concept but, instead of using four Channel Mixer adjustment layers, you will use four Silver Efex Pro 2 Smart Filter layers: one balanced for neutral, one balanced for green, one balanced for red, and one balanced for blue.

The differences between the Multiple Silver Efex Pro 2 Smart Filter layer approach and the Multiple Channel Mixer adjustment layer approach are: 1) In the Multiple Channel Mixer adjustment layer approach, the Neutral Channel Mixer adjustment layer is on top, while in the the Multiple Silver Efex Pro 2 Smart Filter layer approach the Neutral layer is on the bottom; 2) The Multiple Channel Mixer adjustment layer approach consists of using adjustment layers that do not contain any pixel data and are layers of math overlaying the pixel data (meaning that, even though you are causing a visual change to the image, you are not changing the actual pixels themselves). In the Silver Efex Pro 2 Smart Filter layer approach, because the layers do contain actual pixel data, the resulting file size is considerably larger. 3) In the Multiple Channel Mixer adjustment layer approach, you control only the channels, but in the Silver Efex Pro 2 Smart Filter layer approach, you

have control over every aspect of the image. (The considerable function of the Silver Efex Pro 2 plug-in is described in both the QuickTime tutorial and in *The Black and White on the Silver Efex Pro 2 User Interface* section at the beginning of this chapter.)

Step 1: Running the SEP 2 RGB Chording Action

The technique that you are about to use works well on both landscapes and portraits. Once again, you will use the same image as you did in the previous chapter, because the last part of this lesson will be to blend the Multiple Channel Mixer adjustment layer approach with the one that you are about to do. Be aware that you can blend the Multiple Channel Mixer adjustment layer approach with either a single Silver Efex Pro 2 or a Chorded Silver Efex Pro 2 layer. Every chromatic grayscale conversion technique that you have learned in this book can be used with every other technique in this book. Your goal is to produce the best possible image and it does not matter what journey you take to get there.

1. Open the file named LILAN_OZCH8.tif. (For convenience, a copy of this file is located in the Chapter 8 section of the download page for this book.)

2. As you did in the previous chapter, from the Actions panel, open the OZ_2_K_12 actions set by clicking on the disclosure triangle located to the left of the folder.

3. Click on the SEP2_RGB_CHORDING action to make it active.

4. Click on the Run Action button located at the bottom of the Actions panel to start the action.

5. The action will duplicate the file and open the Save As dialog box.

6. In the Save As dialog box, the file is named SEP_RGB_CORD.psb. Add LILAN_OZ_CH08 to the beginning of that name so that it becomes LILAN_OZ_CH08_ SEP_RGB_CORD.psb.

7. Locate the folder OZ_2_K_IMAGES and save the LILAN_OZ_CH08_ SEP_RGB_CORD.psb file to it.

Once you have saved the file LILAN_OZ_ CH08_ SEP_RGB_CORD.psb, the SEP2_RGB_CHORDING action will go through a series of "under the hood" events.

- The action will create a layer set,
- name the layer set SEP_RGB_CHORD,
- duplicate the base layer,
- place that layer in the layer set,
- convert the copied base layer into a Smart Filter,
- open the Silver Efex Pro 2 plug-in,
- set it to the Neutral preset (see the following note),
- duplicate that layer three times,
- and then set one of the Silver Efex Pro 2 Smart Filter layers to the Neutral preset with the Green filter, another one to the Neutral preset set to the Red filter, and the last one to the Neutral preset set to the Blue filter.

NOTE: The NEUTRAL layer is there to ensure that no color will bleed through if you do brushwork on the GREEN, RED, and BLUE layers. This does not mean that you cannot make adjustments to the NEUTRAL layer or that you cannot use it as the base layer, which you may want to do. When you are creating anything, the answer to every question should be "yes." "Yes" keeps creative motion moving forward, while "No" stops it. For example, "Can I make an adjustment on the NEUTRAL layer?" The answer is "yes." Or "Should I take a few more shots?" The answer is "yes."

What the action that you are running is doing is the same in concept as the action that you ran in the previous chapter, but with layers that have pixels in them instead of adjustment layers. You now have three layers on which you can do brushwork and with which you can address the RGB aspects of the image. You also have one layer to guarantee that you will have no color bleed from the RGB layers above it. Once again, the Green layer is the first of the "color" layers for the same reasons that I discussed in the previous chapter. The Neutral layer is on the bottom instead of the top, because the layers that you just created are solid whereas the Channel Mixer adjustment layers were transparent.

Once the action has created a Neutral, Green, Red, and Blue Silver Efex Pro 2 Smart Filter layer, a dialog box appears with the statement, "The Action will now show you the individual SEP 2 layers, starting with the NEUTRAL layer. Observe what you like and like less about each of the separate layers."

8. Once you have made your observations about the NEUTRAL layer, click on Continue (**Figure 8.57**).

9. The action will then show you the GREEN layer as it did for the NEUTRAL one. Once you have made your observations about the GREEN layer, click on Continue (**Figure 8.58**).

10. The action will then show you the RED layer as it did for the GREEN one. Once you have made your observations about the RED layer, click on Continue (**Figure 8.59**).

11. The action will then show you the BLUE layer as it did for the RED one. Once you have made your observations about the BLUE layer, click on Continue (**Figure 8.60**).

FIGURE 8.57 *The Neutral SEP2 layer*

FIGURE 8.58 *The Green layer*

FIGURE 8.59 *The Red layer*

FIGURE 8.60 *The Blue layer*

12. A dialog box will now appear, which reads, "The Action will now open the individual layers starting with NEUTRAL so you can do individual layer-specific adjustments based on what you liked and disliked about each of the individual layers. Adjust these first before any order change." Click on Continue.

Step 2: Fine-Tuning the Individual Neutral, Green, Red, and Blue Silver Efex Pro 2 Smart Filter Layers

Keep several things in mind as you work on the individual Silver Efex Pro 2 Smart Filter layers. First, you can do brushwork on only three of the four layers. Second, because you can do adjustments on all four layers (should you choose to), whatever layer you decide should be at the bottom of the layer stack (even though all four layers have layer masks) is the one on which you will not do brushwork. Third, you can select one of the presets at any time or change the layer order. If you do, you can fine-tune your adjustments because all of the layers are Smart Filters. One of the advantages of using the Silver Efex Pro 2 plug-in is that it factors in Hue when it does a chromatic grayscale conversion.

Throughout this book, you observed that the red, green, and blue channels of your image contained different representations of the image in grayscale. Not only does each of these channels have different grayscale representations of the image, a channel may also contain data not found in one or the other two channels. By approaching chromatic grayscale conversion with this understanding, you not only access the grayscale representation of the individual color channels—you can also use all of the power tools and controls of the Silver Efex Pro 2 plug-in on each channel.

Take a look at what there is to like and dislike about the NEUTRAL, GREEN, RED, and BLUE layers.

Begin with the GREEN Silver Efex Pro 2 layer. The green channel tends to hold the most of the midtone contrast and structure information. Because of this, the GREEN Silver Efex Pro 2 layer is the one best suited to be the primary one. The issues with this layer are that the model's forward shoulder is a little hot and the left side of her face (the one closest to the background) needs to be opened up a little.

FIGURE 8.61 *Placing a control point on the forehead*

FIGURE 8.62 *Duplicating the control point to under her eye*

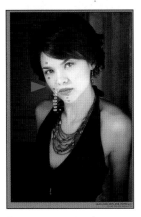

FIGURE 8.63 *Duplicating the control point to between her nose and mouth*

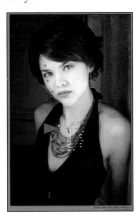

FIGURE 8.64 *Duplicating the control point to her chest*

NEUTRAL Silver Efex Pro 2 Layer

13. With the NEUTRAL Silver Efex Pro 2 dialog box open, make no adjustment and click OK. The action will close the NEUTRAL Smart Filter and open up the GREEN Silver Efex Pro 2 dialog box.

NOTE: You can make adjustments on the NEUTRAL layer. For example, you may like how the Neutral preset looks and want to use it to darken or lighten aspects of the image. This was not the case for this image. Remember that the only layer on which you can do no brushwork is the bottom-most Silver Efex Pro 2 Smart Filter layer.

GREEN Silver Efex Pro 2 Layer

14. Click on the Add Control Point icon located in the Selective Adjustments part of the Edit menu. Click on it and place the control point on the upper part of the subject's forehead (**Figure 8.61**).

15. In the Control Point set the brightness (Br) to 32%, the contrast (Co) to 9%, and the Amplify Whites (AW) to 24%.

16. Duplicate the control point (Command + D / Control + D) that you just created and adjusted, and move it to just under her back eye (**Figure 8.62**).

17. Duplicate the control point (Command + D / Control + D) that you created in Step 16, and move it to back edge of the subject's face between her nose and mouth (**Figure 8.63**).

18. Duplicate the control point (Command + D / Control + D) that you created in Step 17, and move it to the middle of her chest, just below her neck where her collarbone begins (**Figure 8.64**).

19. Placing the cursor in the upper left-hand corner of the image, just above the topmost control point, click and drag downward to the lower right

FIGURE 8.65 *Selecting all control points*

FIGURE 8.66 *All control points selected*

FIGURE 8.67 *Grouping the control points*

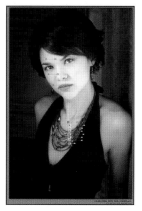

FIGURE 8.68 *All control points grouped together*

corner, just below the lowermost control point. This selects all the control points that you just placed (**Figures 8.65** and **8.66**).

20. Once you have done that, click on the Click to Group the Selected Control Points icon located in the Selective Adjustments section. This will group all of the control points that you just placed and allow you to use any one to control all the others (**Figures 8.67** and **8.68**).

21. Increase the Contrast (Co) to 37% and the Amplify Whites (AW) to 42% (**Figure 8.69**).

22. Click on the Add Control Point icon located in the Selective Adjustments section. Drag it and place the control point on the background, just to the left of the subject's earring immediately above her back shoulder (**Figure 8.70**).

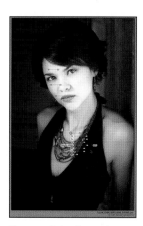

FIGURE 8.69 *Increasing Contrast and Amplify Whites*

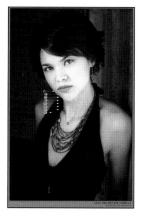

FIGURE 8.70 *Adding a control point to the background*

FIGURE 8.71 *Decreasing the Brightness to -11%*

FIGURE 8.72 *Adding a control point to the lower left*

FIGURE 8.73 *Increasing the Brightness slider to 16%*

FIGURE 8.74 *Adding a control point to the front shoulder*

23. Decrease the brightness (Br) to -11% (**Figure 8.71**).

NOTE: You have done this is in order to counteract the background's brightness that was created when you placed the control points on the subject's face, which caused some unwanted brightness on the background. As you have just seen, one of the unique properties of control points is that they have the ability to detect and interact with each other. This means that they are capable of producing mask edges not possible to create with any other technique.

24. Click on the Add Control Point icon located in the Selective Adjustments. Place the control point on the background in the lower left corner of the image (**Figure 8.72**).

25. Increase the Brightness (Br) to 16% (**Figure 8.73**).

NOTE: You do this is to open up (brighten) the background area to separate it from the dress. Prior to dropping this control point, this area of the image was blocked up.

26. Click on the Add Control Point icon located in the Selective Adjustments part of the Edit menu. Drag it and place the control point on the subject's front shoulder (**Figure 8.74**).

27. Decrease the Contrast (Co) to -25% (**Figure 8.75**).

28. Click OK. The newly adjusted GREEN Silver Efex Pro 2 layer looks like **Figure 8.76**.

FIGURE 8.75 *Decreasing the Contrast to -25%*

FIGURE 8.76 *Green Silver Efex Pro 2 layer*

FIGURE 8.77 *Adding a control point to the right corner*

FIGURE 8.78 *Decreasing the Brightness -15% and Contrast to -32%*

RED Silver Efex Pro 2 Layer

Now that you have made the fine-tuning adjustments to the GREEN Silver Efex Pro 2 layer, it is time to move on to the RED Silver Efex Pro 2 layer. Notice that the subject's skin tone appears much smoother and creamier than it did in the GREEN Silver Efex Pro 2 layer. Also, the wall directly behind the subject and the image structures in the upper right-hand corner are much smoother and have a gentler feel to them than they did in the GREEN Silver Efex Pro 2 layer. Therefore, you will want to add some of the qualities of the RED layer into her face and you will want to use the qualities of the background of the RED layer. To accomplish this, you will use control points to selectively open up the subject's face and darken the background.

29. Click on the Add Control Point icon located in the Selective Adjustments part of the Edit menu. Drag it and place the control point on the upper right corner of the image (on the background) between the image's right edge and the subject's ear (**Figure 8.77**).

30. Decrease the Brightness (Br) to -15% and the Contrast (Co) to -32% (**Figure 8.78**).

You should notice that there is a circular area of diminished brightness and contrast about the size of the Kennedy half-dollar. Because this area needs to be larger than it currently is, increase the radius of the control point.

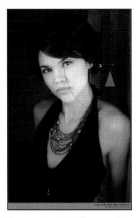

FIGURE 8.79 *Adjusting the radius of the control point*

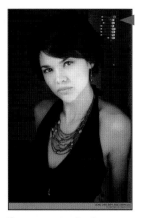

FIGURE 8.80 *Duplicating the control point to the top right*

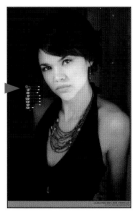

FIGURE 8.81 *Duplicating another control point to the mid-left area*

31. Click on the Radius handle (the handle located directly across from the control point). Move it outward (in this case, to the left), until the radius of the control point is almost to the upper edge of the top of the image and the lower part of the circle touches just outside of the subject's nose (**Figure 8.79**).

NOTE: How the Radius handle works is based on the control point location. Moving the handle away from the control point expands the radius of the altered area and moving the handle towards the control point decreases it.

32. Duplicate this control point (Command + D / Control + D) and move it to the upper part of the right-hand corner of the background, parallel to the control point from which you duplicated this one (**Figure 8.80**).

33. Duplicate this control point (Command + D / Control + D) and move it to the middle part of the background (left of her face) and approximately midway between the left corner of the image and the edge of her face (**Figure 8.81**).

34. As you did with the GREEN Silver Efex Pro 2 layer, place the cursor in the upper right-hand corner of the image, just above the topmost control point. Click and drag downward to the lower left corner just below the lowermost control point. This selects all the control points that you just placed. Click on the Click to Group Selected Control Points icon located in the Selective Adjustments section.

NOTE: It is sometimes a good idea to link like control points together as you build up an image. Once you have placed all of the control points, the fine-tuning aspect of the image-editing process is easier and the workflow more efficient. Also, you can always undo a group.

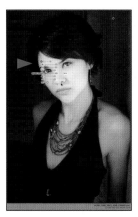

FIGURE 8.82 *Increasing the Brightness, Contrast, and Amplify Whites sliders*

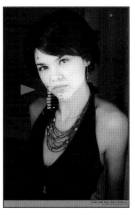

FIGURE 8.83 *Duplicating the control point*

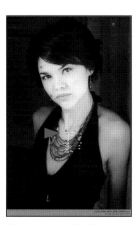

FIGURE 8.84 *Duplicating the control point to her chest*

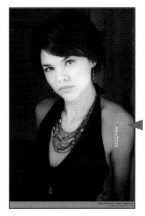

FIGURE 8.85 *Adding a control point to her shoulder*

35. Click on the Add Control Point icon located in the Selective Adjustments part of the Edit menu. Place the control point on the upper part of her forehead in approximately the same place that you did for the GREEN layer.

36. Set the Brightness to 20%, the Contrast to 18%, and the Amplify Whites to 24% (**Figure 8.82**).

37. Duplicate this control point (Command + D / Control + D) and move it to the back edge of the subject's face between her nose and mouth (**Figure 8.83**).

38. Duplicate this control point (Command + D / Control + D) and move it to the middle of her chest, just below her neck where her collarbone begins (**Figure 8.84**).

39. Place the cursor in the upper left-hand corner of the image, just above the topmost control point. Click and drag downward to the lower right corner, just below the lowermost control point. This selects all the control points that you just placed. Click on the Click to Group Selected Control Points icon located in the Selective Adjustments section. Now you have two linked control point groups.

40. Click on the Add Control Point icon located in the Selective Adjustments part of the Edit menu. Drag it and place the control point on the subject's front shoulder. Decrease the Brightness to -26% and the Contrast to -18% (**Figure 8.85**).

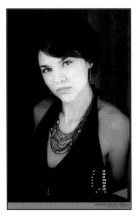

FIGURE 8.86 *Duplicating the control point*

FIGURE 8.87 *Decreasing the Brightness to -25%*

FIGURE 8.88 *Increasing the Contrast, Amplify Whites, Structure, and Brightness sliders*

FIGURE 8.89 *Adding a new control point and increasing the Structure, Fine Structure, Brightness, and Contrast sliders*

41. Duplicate this control point (Command + D / Control + D), move it to the bottom right of the image, and place it on the background between the subject's arm and body (**Figure 8.86**).

42. Click on the control point in the upper right-hand corner (this controls the background group of control points) and decrease the Brightness (Br) to -25% (**Figure 8.87**).

43. Click on the control point in the middle of the subject's chest (this controls the face and neck group of control points). Increase the Contrast (Co) to 33%, the Amplify Whites (AW) to 34%, the Structure (St) to 27%, and the Brightness (Br) to 27% (**Figure 8.88**).

44. Click on the Add Control Point icon located in the Selective Adjustments section. Drag it and place the control point on the highlighted area of her hair. Increase the Structure (St) to 54%, the Fine Structure (FS) to 42%, the Brightness (Br) to 6%, and the Contrast (Co) to 10% (**Figure 8.89**).

45. Decrease the radius of the control point to just inside her hairline (**Figure 8.90**).

46. Click OK. The newly adjusted RED Silver Efex Pro 2 layer looks like **Figure 8.91**.

FIGURE 8.90 *Decrease the radius of the control point*

FIGURE 8.91 *The image with the RED SEP2 layer*

FIGURE 8.92 *Increasing the Contrast, Brightness, and Amplify Whites sliders*

FIGURE 8.93 *Duplicating the control point to her face*

FIGURE 8.94 *Duplicating the control point to her chest*

BLUE Silver Efex Pro 2 Layer

The fine-tuning adjustments to the GREEN and RED Silver Efex Pro 2 layers are complete. Next, you will work on the BLUE Silver Efex Pro 2 layer. Here, the skin tone is rich in tonal depth, but it also shows slight mottling. Of the four layers, this one has the best separation between the background and the subject, as well as the most detail in the subject's hair. Thus, the goal here is to smooth out the mottling, reduce the darkness under her eyes, and slightly darken the wall in the upper right-hand corner.

47. Click on the Add Control Point icon located in the Selective Adjustments section. Drag it and place the control point on the upper part of her forehead, in approximately the same place in which you placed it for the GREEN and RED layers.

48. Set the Brightness (Br) to 20%, the Contrast (Co) to 14%, and the Amplify Whites (AW) to 14% (**Figure 8.92**).

49. Duplicate this control point (Command + D / Control + D) and move it to back edge of the subject's face between her nose and mouth (**Figure 8.93**).

50. Duplicate this control point (Command + D / Control + D) and move it to the middle of her chest, just below her neck where her collarbone begins (**Figure 8.94**).

51. Place the cursor in the upper left-hand corner of the image, just above the topmost control point. Click and drag downward to the lower right corner, just below the lowermost control point. This selects all the control points that you just placed. Click on the Click to Group Selected Control Points icon located in the Selective Adjustments section. Now you have two linked control point groups.

FIGURE 8.95 *Decrease the Amplify Blacks and increase the Amplify Whites*

FIGURE 8.96 *Add a control point to the background*

FIGURE 8.97 *Before the adjustment*

FIGURE 8.98 *The Sensitivity section*

52. Click on the Master control point for this group (the one located in the center of the model's chest). Decrease the Amplify Blacks (AB) to -42% and increase the Amplified Whites (AW) to 29%. The mottling in her skin tone is gone, but its richness and depth is preserved (**Figure 8.95**).

You will now correct for the similarity in tone between the background and the skin tone in the BLUE layer by placing a control point on the background to the left of the subject's face.

53. Click on the Add Control Point icon located in the Selective Adjustments section. Drag it and place the control point on the background, just above her back shoulder and parallel to her earring. Decrease the Brightness (Br) to -19% (**Figure 8.96**).

One of the remaining issues in this layer is that it lacks some of the pop and snap of the GREEN one. By addressing the issues of color, you will make the adjustments that you want by using the Sensitivity controls located in the Film Types section. This functionality is very similar in global concept to Photoshop's Black & White adjustment layer, but it allows you much finer control. In addition, it addresses the issue of colors that are made up of multiple color values better than does Photoshop's Black & White adjustment layer. This is why the Sensitivity controls located in the Film Types section are ideally suited for fine-tuning the individual colors.

54. Click on the disclosure triangle for the Film Types section. Click on the disclosure triangle for Sensitivity (**Figures 8.97** and **8.98**).

55. In the Sensitivity section, decrease the Red value to -40% and increase the Yellow value to +40% (**Figures 8.99** and **8.100**).

You did Steps 54 and 55 because the opposite of blue on the color wheel is orange. Orange is a mix of red and yellow, and yellow is a combination of the primary colors red and green. By going in the opposite direction of equal values of red and yellow (that make up the opposite of blue), you introduce contrast into the image while preserving the aspects of the skin tone that you like, as well as maintaining the integrity of your adjustments that removed the mottling of the subject's skin.

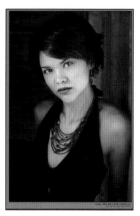

FIGURE 8.99 *After the adjustment*

FIGURE 8.100 *Decrease the Red slider and increase the Yellow slider*

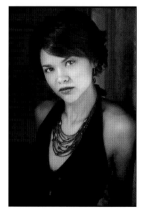

FIGURE 8.101 *The image after*

NOTE: For the sake of simplicity in what have already been very complicated lessons, I chose to use the Sensitivity controls (located in the Film Types section) on this layer only. Please note that this particular adjustment is one that I consider using on all layers every time that I launch the Silver Efex Pro 2 plug-in.

56. Click OK. The newly adjusted BLUE Silver Efex Pro 2 layer looks like **Figure 8.101**.

Once these adjustments are completed, the action will save the document and a dialog box will come up that states, "It is now time to decide layer order and what, if any, brushwork will be done OR if you want to use all layers." Remember that the bottom-most layer receives no brushwork. Restart the Action when done." The action defaults to the GREEN layer. You can move any of the four layers that you have just created into any layer order. Because they are Smart Filters, you can also readjust them later. Your big decision here is whether to fill the layer masks with white or black. The decision process for determining this is based on the 80/20 rule. (See the sidebar: *Unmasking Layer Masks and the 80/20 Rule* in Chapter 2.)

57. Click Stop.

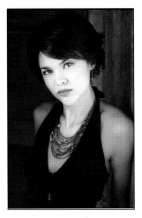

FIGURE 8.102 *The image before brushwork*

FIGURE 8.103 *The image after brushwork*

FIGURE 8.104 *The layer mask*

Step 3: Further Fine-Tuning the Blue, Red, and Green Silver Efex Pro 2 Smart Filter Layers by Using Attached Layer Masks

Blending multiple layers of different densities and different colors is not a new concept. This approach is based on a Renaissance painting technique called *sfumato*, which is the intricate mixing of thin layers of pigment, glaze, and oil to yield the appearance of lifelike shadows and light. In his work, of which *Mona Lisa* was a prime example of *sfumato*, Leonardo da Vinci used upwards of 30 layers of paint with a total thickness of less than 40 μm, or about half the width of a human hair. You are about to accomplish a similar effect using opacity. This approach works amazingly well for the creation of realistic looking atmospheric effects (e.g., misty haze) as well as for creating visual depth and dimensionality in an image.

The RED Silver Efex Pro 2 layer

58. Turn on the RED layer, make the layer mask active, and fill it with black. Set the foreground color to white and the background color to black.

59. Select the Brush tool, set the brush width to a diameter of 200 pixels, and set its opacity to 50%. Brush in the subject's face and neck.

60. Bring up the Fade Effect dialog box (Command + Shift + F / Control + Shift + F) and move the slider to the right until you reach the effect that you desire. I chose 69%. Next, set the foreground color to black and the opacity to 100% and brush back her eyes. With the brush opacity still at 100%, brush back her lips (**Figures 8.102, 8.103,** and **8.104**).

61. Select the Brush tool, set the brush width to 500 pixels, and its opacity to 50%. With the foreground color set to white and the background color set to black, brush in the right side of the image from the background down to her shoulder and then all the

FIGURE 8.105 *The image after brushwork*

FIGURE 8.106 *The layer mask*

FIGURE 8.107 *The image after brushwork*

FIGURE 8.108 *The layer mask*

way to the bottom of the image. Make sure that you do not brush into the area of her neck or face. Bring up the Fade Effect dialog box (Command + Shift + F / Control + Shift + F) and move the slider to the right until you get the effect that you desire. I chose 83% (**Figures 8.105** and **8.106**).

62. Select the Brush tool, set the brush width to 500 pixels, and its opacity to 50%. With the foreground color set to white and the background color set to black, brush in the right side of the image from the background down to her shoulder and then all the way to the bottom of the image. Make sure that you do not brush into the area of her neck or face. Bring up the Fade Effect dialog box (Command + Shift + F / Control + Shift + F) and move the slider to the right until you obtain the effect that you desire. I selected 70% (**Figures 8.107** and **8.108**).

The BLUE Silver Efex Pro 2 layer

63. Turn on the BLUE layer, make the layer mask active, and fill the layer mask with black. Set the foreground color to white and the background color to black.

64. Select the Brush tool, set the brush width to 150 pixels, and its opacity to 50%. Brush in her face and neck.

65. Bring up the Fade Effect dialog box (Command + Shift + F / Control + Shift + F) and move the slider to the right until you get the effect that you desire. I elected to use 57%.

66. Brush in her front shoulder. Bring up the Fade Effect dialog box and set the opacity to 60%.

67. Set the foreground color to black and the opacity to 100%. Brush back her eyes.

FIGURE 8.109 *The image after brushwork*

FIGURE 8.110 *The layer mask*

68. Set the foreground color to white and the background color to black. Set the brush opacity to 50%. Brush the highlight area of her hair and leave the brush opacity at 50%. Reduce the overall layer opacity to 74% (**Figures 8.109** and **8.110**).

69. Restart the action.

70. The action will save the file, then duplicate it, and save a flattened version as a TIFF.

71. The Save As dialog box will appear with _SEP_ RGB_CHORD_FINAL.tif. Add LILAN_OZ_CHO8 to the beginning of that file name so that it becomes LILAN_OZ_CHO8_SEP_RGB_CHORD_FINAL.tif.

Variations on a Theme: When Conversion Techniques Collide

Anyone who has never made a mistake has never tried anything new.

—Albert Einstein

In this next lesson, you will take the image that you just completed and combine it with the image that you created in the previous chapter. This is how I create the majority of my chromatic grayscale images. I reiterate—impossible is just an opinion. Give yourself permission to combine multiple conversion techniques. The goal is not to maintain conversion approach purity; the goal is to produce an image that reflects your voice. No one cares how many layers your file has, they care only about what the final image says to them.

 Prior to the creation of the Silver Efex Pro software, I created a chromatic grayscale image using the Multiple Channel Mixer adjustment layer approach that you used in the previous chapter. I have found that the Silver Efex Pro software can do many things that the Multiple Channel Mixer adjustment layer approach can do, but not all of them. The solution to this issue is a simple one. Create a chromatic grayscale conversion using both approaches, so that you end up with two images. Then you can use the best from each. This is what you are going to do next.

NOTE: In addition to the three actions that you have used in this and the previous chapter, there are two actions in the action set that are combined into one file; the single and multiple Silver Efex Pro approaches as well as the Multiple Channel Mixer adjustment layer approach.

1. If it is not already open, open the file LILAN_OZ_CH08_SEP_RGB_CHORD_FINAL.tif.

2. Open the file LILAN_OZCH07_OZ_2_KANSAS_BW_FINAL.tif.

3. Holding down the Shift key, click on the background layer and Shift-drag it to the LILAN_OZ_CHO8_SEP_RGB_CHORD_FINAL.tif file that you just completed in the previous lesson. Name this layer OZ2K_CM.

4. Double-click on the background layer and name it SEP2_CHORD.

You should clearly see some similarities and some differences between the two images. Both images are acceptable, but each has something that the other could use. Each also has something that you would be glad to do without. In this lesson, you will use the best of both worlds.

In the Multiple Channel Mixer adjustment layer version of the image, there is a greater depth in the subject's skin tone, but the areas under her eyes are still a bit dark. Also, some of the background is slightly brighter and has a slightly gentler contrast than it does in the Silver Efex Pro 2 image. In the Silver Efex Pro 2 image, overall, the subject's skin tone is smoother, the detail in her hair is better, and the background is deeper (**Figures 8.111** and **8.112**).

FIGURE 8.111 *Before brushwork in the SEP_RGB_CHORD version*

FIGURE 8.112 *Before brushwork in the OZ_2_KANSAS_BW version*

FIGURE 8.113 *The image map of areas to be brushed in*

FIGURE 8.114 *Before brushwork*

FIGURE 8.115 *After brushwork*

FIGURE 8.116 *Before brushwork close-up*

FIGURE 8.117 *After brushwork close-up*

Looking at both images, I thought that the Silver Efex Pro 2 version contained more elements that I liked than did the Multiple Channel Mixer adjustment layer image. Based on that, I chose the Silver Efex Pro 2 version as the base image and used the Multiple Channel Mixer adjustment layer image as the one from which I brushed in image detail. This is what I will have you do. You will brush in the subject's face, brush back her eyes (so that there will be no brushwork done to them), brush under her eyes to diminish what little darkness is there, brush in the right side of the background to bring in some of the image structures that are appealing, and then brush in the left side of the background to bring in appealing image structures from there (**Figure 8.113**).

5. Make the CM_LAYER active. Add a layer mask and fill it with black. Set the foreground color to white and the background color to black.

6. Select the Brush tool, set the brush width to 150 pixels, and set its opacity to 50%. Brush in the subject's face and neck.

7. Bring up the Fade Effect dialog box (Command + Shift + F / Control + Shift + F) and move the slider to the right until you reach the effect that you desire. I chose 62%.

8. Brush under both eyes. Bring up the Fade Effect dialog box (Command + Shift + F / Control + Shift + F) and set the opacity to 70% (**Figures 8.114, 8.115, 8.116,** and **8.117**). (See the sidebar: *Error-Free Layer Masks* in Chapter 2.)

9. Select the Brush tool, set the brush width to 150 pixels, and set its opacity to 50%. Brush in the upper right corner of the background.

10. Bring up the Fade Effect dialog box (Command + Shift + F / Control + Shift + F) and move the slider to the right until you reach the effect that you desire.

FIGURE 8.118 *After brush-work on the left background*

FIGURE 8.119 *The layer mask*

I selected 23%. Brush in the left side of the background (**Figures 8.118** and **8.119**).

11. With the CM_LAYER active (make sure it is the topmost layer), make a Master layer (Command + Option + Shift + E / Control + Alt + Shift + E).

12. Save the file.

13. Then, choose Save As and save the file (Command + Shift + S / Control + Shift + S) as LILAN_OZ_COMBINED. Examine the final image (**Figure 8.120**).

FIGURE 8.120 *The final image*

Conclusion

When you add to the truth, you take away from the truth.

—The Talmud

The technique that I have described in this chapter shows you exactly what level of granular control you can have when you convert an image from full color to chromatic grayscale. It also shows you that you can journey from one approach to another and mix them to create the image that matches your vision. The lesson that was this chapter is also the application of all of the lessons in this book.

If I told you at the beginning of this book that you were going to use color to control and create a black-and-white image and that you were going to refer to that image as a chromatic grayscale image, and that you were going to use up to nine layers, and five of which were adjustment layers and four of which were Smart Layers, and that you had to make as perfect a color image as you could before you do the conversion, you might think I had been sniffing pixels again. But if you are reading these words and have made it here, you now understand that there is very little that is black and white when it comes to the conversion process of creating a black-and-white image.

Each one of the chapters in this book represents the main stepping stones of journey that I went on in pursuit of learning how to create a chromatic grayscale or black-and-white image. It is my hope that you now have within you the echo of knowledge that is needed to look at a scene and know if the image is worthy of doing the dance of conversion and how to make your chromatic grayscale images look as good

as you imagine them to look in your mind's eye. It is also my hope that you now have the tools to create images that move the viewer the way you were moved when you were so taken that you clicked the shutter and you captured the image that captured you.

Last Words
From There to Here—Where We Are on the RGB Road

Art washes away from the soul the dust of everyday life.

—Pablo Picasso

I have spent a great deal of time discussing the techniques for taking a color image on the journey to becoming a chromatic grayscale one. The techniques in this book are the bricks of the RGB road that you walk on your path of creative expression. But technique does not define the photograph, the photographer does. The final image is a reflection of a moment in time that was so important that it compelled the photographer to capture it.

There is no such thing as the perfect photograph; the perfect photograph is an ideal that each photographer holds within and no two photographers define perfection in the same way. Once you come to that understanding, the reason for striving to perfect your technique and the reason you create images becomes clear; to move and, perhaps, please the viewer. The first viewer is really the only one who matters, because that first viewer is always you. The techniques that you use are the tools that help your artistic voice be better heard. Creative voice always trumps technique, but a creative voice without technique is a voice that may never be heard.

I believe that I know enough about Photoshop to say that I understand it, but you need not understand all its technical aspects to express yourself artistically using photography as your art form. To reiterate—technique does not define your image; you define it. Once you have determined that definition, then you decide upon which techniques best suit the requirements that you have for that image so that it expresses your voice.

Photography is the only art form in which many artists first fall in love with an image, and then spend the rest of their time pursuing its technical aspects, as if it is there that they will find the secret to successful imagery. Painters do not have *Popular Paint Brush* magazine, and sculptors do not go to *Chisel World* and sit around discussing bit depth. Too many photographers appear to believe that if they attempt to make their images technically perfect that they will have perfect images. Ansel Adams said, "I would rather have a fuzzy photograph of a sharp idea than a sharp photograph of a fuzzy idea."

What is often overlooked is the importance of imagination over technique. Cartier-Bresson said, "Give me inspiration over information." I suppose it is okay to pursue the technical aspects of any art to the point where there is no technical rock left unturned, but never at the expense of your vision, voice, and imagination.

To better understand the imagination's importance to photography, you must first understand the duality of existence that occurs when you are so taken by a series of events that that they lead you to that moment that causes you to click the shutter. The duality of existence refers to the fact that you must allow yourself to engage in a poetic way of seeing, but you must also be aware of how you might express that poetry in a photograph; something that has technical ramifications. During every moment that the photographer is engaged in allowing the image to take him/her, they must be aware of both the external circumstances (those that surround the totality of the photograph) and the inner chain of emotional moments that captures both their heart and imagination.

It is through the use of imagination that the photographer accomplishes the duality that I have described. Imagination allows the photographer to make a mental picture of what he/she emotionally perceives to be the final print. And it is that emotion that, when successfully communicated, will move the viewer.

As with every other artistic photographic impulse, imagination cannot be forced, only coaxed. When one pursues only the technical aspects of photography, one forces something that needs to be allowed to choose the moment in which it will be seen. On the other hand, a photographer must not be simply a spectator. To be taken by a photograph requires that you be an open and active participant in the moment, so that when the decisive moment shows itself, you can capture that moment decisively. Even if you do not know what you are going to do technically with the file that you create, you must be confident that you will discover what you need to know. Being taken by the gesture of the moment is the goal, so let the spirit that moves in front of the camera be the force that pushes the shutter. Choose to be open to everything that you do; to every moment that you live, because if you move through the world of photography this way, when you see the moment, its poetry will whisper its name and the pictures that you see will take you.

Afterword

I always tell my cooks to "look up." When they become too focused on details, they can miss the big picture—that what they create should give the customer both visual and gastronomic pleasure. It is easy to get wrapped up in the how and miss the why. I imagine that the same can be said about photography. The ability to capture the picture and augment it to appear perfect is only part of the skill. One must realize that the people who look at the image should be emotionally moved and experience pleasure in that experience.

One of the most important experiences that I wish for the cooks on the line at Dovetail is to see why this restaurant satisfies people and how it all comes together from the most basic to the most complex levels. All creativity comes from one place, but there are uncountable forms in which it may be manifested. Mine is cooking. Perhaps yours is photography. We both seek to communicate to others that which is within us that is uniquely us.

At Dovetail, the entire staff is enthusiastic about the creation of a wonderful meal. We strive for perfection, realizing that it is not only unachievable, it cannot be defined. My perfect might not be yours. What is important is that we are never satisfied. We want the customer to be as excited to eat our creations as we are about the creative process. I assume that photographers have similar goals; that they want their viewer to be as emotionally involved with the image as they were when they captured it.

Most very creative people, who also have technical expertise in their manner of expression, know that imperfection is just part of the process of growing in your art. It is through constant practice that you mature as an artist.

Vincent and I have sat for hours waxing poetic about chefs and restaurants, and artistic expression. Each of us will go to almost any end to express our creativity in our respective fields. One late evening, Vincent expressed a desire to spend a few days with us in our kitchen. I have heard this from friends after a few glasses of wine, but this time it was sincere.

We at Dovetail have welcomed people from many backgrounds into our kitchen so that they might better understand what kind of discipline and creativity is required to succeed in our environment. Usually we get people considering career changes, young people looking to see if the culinary arts are for them, as well as very experienced chefs who want to recharge their creative batteries. Rarely do we get an icon in another creative field who happens to be one of our best customers and a close friend. He was well aware that he had to commit to a 12-hour day, doing things that it would be difficult to define as fun. The kitchen environment is respectful; however, you are surrounded by 15 over-achieving cooks just looking for ways to make your life difficult. By the end of the night, your feet can feel like they are going to fall off. Vincent later told me that he learned a lot from those days, the least of which was about food. Rather, he told me how many parallels he found between his chosen creative endeavor and mine. (I also found it refreshing to be taught; I am so used to being the teacher.) Moreover, I think he was able to gain insight into the universality of the creative impulse and process, something this book is intended to provide for you, without the foot pain.

—John Fraser, Chef and Proprietor, Dovetail Restaurant, New York City, 2012

Index

8-bit images, 64
12-bit images, 144
14-bit images, 144
16-bit images, 64, 144
18% gray, 137
80/20 rule, 48
0521 rule, 48

A

about this book, x–xii
accuracy vs. precision, 138
achromatic colors, 112, 133
actions, 13
 explanation of, 14
 limitations of, 159–160
 loading, 14–15, 20, 157
 running, 158–160, 184, 209
 tip on recording, 14
 video tutorial on, 13, 153
 when to create, 160
 See also configurators
Actions panel, 14, 15, 157
Adams, Ansel, x, 85, 135, 139, 149, 150, 152, 157, 174,
 245
Add Control Point icon, Silver Efex Pro, 218
additive systems, 154
Adjustment Brush tool, 73, 74–77
adjustment layers, 155
 Black & White, 109–133
 Channel Mixer, 118, 153, 155–197
 Curves, 20–22, 43–47, 50
 Hue/Saturation, 13, 16–17, 36, 42–43
Adjustment panel, 13, 20, 121, 122
Adobe Camera Raw (ACR)
 basic processing set-up for, 68
 black-and-white conversions in, 71–79
 launching in Photoshop, 71
 Lightroom 4 processing and, 70
 Workflow Options dialog box, 78
Adobe Configurator, 14
Adobe Photoshop. *See* Photoshop CS6
Adobe Photoshop Lightroom. *See* Lightroom 4
Adobe RGB color space, 80
Albers, Josef, viii, 66, 67

analog photography, 150–151
Aperture 3 program, 65, 79
artifact production
 color bleed and, 125
 data clipping and, 65, 193
 minimizing, 62, 64, 193
artistic voice, 245
Auto Levels adjustment, 62, 63

B

backslash key (\\), 180
Bayer array, 154, 164
being present, 54–55
believing, 28–29
bit depth, 6
Black & White adjustment layer, 109–133
 best images to convert using, 133
 color channels and, 118, 119
 comparison tester image, 114
 conversion process comparison, 115–120
 Default vs. Auto settings, 132
 description of, 109, 111, 112–113
 extracting colors using, 129–132
 functional overview of, 110–111
 shifting colors in, 121–128
black surfaces, 107
black-and-white conversions
 camera-based, 61–63
 combining techniques used for, 239–241
 desaturation process and, 11–19
 Zone System and, 136–147
 See also specific conversion techniques
black-and-white photography
 digital vs. film, 108, 150–151
 terminology associated with, 5, 6–7
 toning process for, 183
blend modes, 22
 Color, 35, 41
 Lighten, 22, 41
 Luminosity, 129, 132
 Normal, 41
 Screen, 22, 44
Blue channel data, 164

Blue Channel Mixer adjustment layer
 landscape conversion example, 188
 portrait conversion example, 170–172
Blue Silver Efex Pro 2 layer, 233–235, 237–238
Blue slider, Channel Mixer, 166, 168, 170
brightness, 6, 107
 adjusting, 214–216
 exposure vs., 74
Brightness sliders, Silver Efex Pro, 204, 205, 214–216
Brown, Russell, 35
Brush tool, 16
brushes
 opacity settings, 175, 194
 width adjustments, 176, 191
brushwork
 channel editing with, 175–177, 191–192, 194, 196
 color extraction with, 130, 132
 contrast added with, 44–47
 exposure adjustments with, 75
 final image adjustments with, 240–241
 selective desaturation with, 16–17
 Silver Efex Pro layer mask, 236–238
Buddha, 92
Bullock, Wynn, 152
Burkholder, Dan, 152
Burn Edges controls, Silver Efex Pro, 208

C

Camera Raw. *See* Adobe Camera Raw
cameras
 B&W conversions in, 61–63
 film vs. digital, 60
 See also digital cameras
Canon 500D close-up filter, 178
Canon camera system, 62
Canon LUCIA EX inks, 108
Caponigro, John Paul, 50, 106, 147
Capture NX2 program, 65, 79, 82
Card, Orson Scott, 105
Cartier-Bresson, Henri, 245
Cates, Challen, 11, 35, 113
Cézanne, Paul, xvi
Change color wheels, 114
Channel Mixer adjustment layer, 157–197
 Blue layer creation, 170–172, 188
 channel comparison, 172, 173, 189
 chromatic grayscale images and, 153
 Constant slider adjustments, 181–182, 196
 descriptions of, 118, 153, 155–156
 fine-tuning individual layers, 174–177, 190–196

Green layer creation, 164–168, 186–187
 landscape conversion process, 184–197
 Monochrome option, 109, 153, 156, 186
 Neutral layer creation, 164, 185
 Oz 2 Kansas action and, 158–159, 184
 portrait conversion process, 158–183
 presets available in, 156
 Red layer creation, 168–169, 187
 Silver Efex Pro conversions and, 239–241
 split-channel technique vs., 89
Channel Mixer dialog box, 155, 166, 168, 186
channels. *See* color channels
chording
 contrast adjustments, 52–53
 definition of, 47, 223
 SEP 2 RGB Chording action, 223–225
chromatic colors, 133
chromatic grayscale images, 5, 6, 107, 151, 198
Cintiq pen display, 4, 22, 175
Clarity tool, 72, 74
Classic Black-and-White Conversion approaches, 92–97
Classic Film and Filter approach, 35–37
clipping data from images, 65, 193
close-up filters, 178
CMYK printing, 154
color
 achromatic, 112, 133
 elements of, 106, 107
 extracting, 130, 132, 133
 shape and, 66
Color blend mode, 41
 Black & White adjustment layer, 132
 Film and Filter conversions and, 35, 36, 38, 42
color channels
 adjustment layer comparison, 172, 173, 189
 blending/mixing, 155
 explanation of, 118, 154–155
 image editing using, 174–177, 190–196
 matching Black & White adjustment layer to, 119
 split channel conversions, 88–89
 working with individual, 155–156
 See also Channel Mixer adjustment layer
color contamination, 13, 16–17
Color Efex 4 Promo 5 software
 Contrast Only plug-in, 23–24, 50–52
 installing free version of, 4
Color Filter section, Silver Efex Pro, 206
color photography
 analog vs. digital, 150–151
 See also black-and-white photography
Color Sampler tool, 127, 162, 184

Color Selection tool, 124
color separations, 155
color spaces
 definition of, 6
 human vision and, 7, 81
 RGB vs. Lab, 80–81
color theory, 106, 107
configurators, 13
 explanation of, 14
 video tutorial on, 13, 154
 See also actions
conscious eye, 28–29, 213
Constant slider, 156, 181, 182, 196
contrast, 7
 Adjustment Brush settings for, 77
 Curves adjustment layer for, 20–22, 43–47, 50
 Nik software plug-in for, 23–24, 50–52
 Photoshop action for adding, 20
 sharpness related to, 26–27
 Silver Efex Pro adjustments, 216–217
Contrast Only plug-in, 23–24
Contrast sliders, Silver Efex Pro, 204, 205
Control bars, 114
control points
 Capture NX2 program, 82
 Silver Efex Pro, 205–206, 217, 218, 226–235
Convert to Grayscale approach, 86–87
cool-tone papers, 152
Cornsweet edge, 27
Cousteau, Jacques, 115
Cousteau, Jean-Michel, 118
creativity, xiii–xvii, 245, 247
curves, definition of, 7
Curves adjustment layer, 20–22, 43–47, 50

D

Dalai Lama, 109
Danielewski, Tad Z., 54, 121
decisive moments, 151
Deming, W. Edwards, 66
demosaicing process, 154
desaturation
 action for, 19
 problem with, 11
 selective, 13, 16–17
 when to use, 12
destructive conversion techniques, 86–102
 Classic Black-and-White approaches, 92–97
 Convert to Grayscale approach, 86–87
 Equalizing Lab technique, 98–102

Lab color space conversions, 90–97
 split channel approach, 88–89
digital cameras
 additive approach of, 154
 B&W conversions in, 61–63
 dynamic range of, 141, 142, 143, 144–145
 histogram display in, 145
 sensors in, 60
digital negatives, 152
dimensionality, 213
Disney, Walt, 153
Dmax value, 138, 142, 143
Dmin value, 138, 142
Doisneau, Robert, 158
Dovetail Restaurant, xv, 247
duality of existence, 245–246
Duplicate Image dialog box, 183, 197
Dynamic Brightness slider, Silver Efex Pro, 204–205, 215
dynamic range
 digital camera, 141, 142, 143, 144–145
 explanation of, 142–143
 exposure and, 144–145
 film photography, 141, 142, 143
 human eye and, 27–28
 image editing and, 141
 techniques for extending, 146
 Zone System and, 136, 141, 143, 146

E

editing images
 dynamic range related to, 141
 global to granular approach to, 181, 192
 non-destructive approach to, 90, 155, 159
 tablet/pen approach to, 175
Einstein, Albert, 12, 38, 82, 165
Elfont, CJ, 67
emotion, xvi, 245–246
Eno, Brian, 23, 166
Epson K3 HDR UltraChrome ink set, 108
Equalizing Lab technique, 98–102
Erase function, 73, 76, 77
error-free layer masks, 49
exposure
 brightness vs., 74
 dynamic range and, 144–145
Extending the Dynamic Range (ExDR), 146
extracting hard-to-remove colors, 130, 132, 133
eye and vision. *See* human eye
Eyedropper tool, 127

F

f/stops, 27–28, 143, 144
Fade command, 50
Fade Effect dialog box, 17, 45, 176, 191, 236
Feininger, Andreas, 112
Feynman, Richard P., 88, 109
Film and Filter action, 36
Film and Filter conversions, 35–53
 Classic Film and Filter approach, 35–37
 Neo-classic Film and Filter approach, 38–40
 Neo-neo-classic Film and Filter approach, 41–53
Film Types section, Silver Efex Pro, 206–207
film-based photography
 digital photography vs., 60, 150–151
 dynamic range of, 141, 142, 143
 papers for printing, 152
filters
 close-up, 178
 Silver Efex Pro, 213
 Smart, 23, 210, 213
Finishing Adjustments, Silver Efex Pro, 207
Fraser, John, xv, 247

G

Gallagher, Robert C., 41
gamma, grayscale and RGB, 89
Gilchrist, Alan, 7
Global Adjustments, Silver Efex Pro, 204, 205, 214–217
global learning approach, 55
global-to-granular workflow, 181, 192
Grain sliders, Silver Efex Pro, 206
granular learning approach, 55
grayscale channels, 198
grayscale images
 chromatic, 5, 6, 107, 151, 198
 definition of, 7
 Photoshop conversion to, 86–87
 pure vs. chromatic, 107
 RGB gamma and, 89
Green channel data, 164, 167
Green Channel Mixer adjustment layer
 landscape conversion example, 186–187
 portrait conversion example, 164–168
Green Silver Efex Pro 2 layer, 226–228
Green slider, Channel Mixer, 166, 168, 171

H

Haas, Ernst, xv, 152
Hamilton-Baillie, Ben, 90

hard-to-remove colors, 130, 132, 133
highlights
 exposing for, 144–145, 146
 protecting, 25
 sampling, 162–163, 184–185
histograms
 Auto Levels adjustment, 63
 camera display of, 145
 exposure examples, 145
 Silver Efex Pro, 211–213
History Browser, Silver Efex Pro, 204
Hoffer, Eric, viii, ix
Holbert, Mac, 74, 160
hue, 107
Hue slider, 36, 37
Hue/Saturation adjustment layer
 action for creating, 161
 channel adjustments and, 161, 168–169, 178–180, 184
 color analysis using, 121–122, 161
 Film and Filter conversions with, 36, 42–43
 selective desaturation with, 13, 16–17
human eye
 color spaces and, 7, 81
 conscious, 28–29, 213
 guiding within images, 67
 structure and function of, 27–28
 unconscious, 26–28, 213

I

illuminance, 146
Image Borders section, Silver Efex Pro, 208
image harvesting, 146, 147
image maps, 44, 66, 174–175
imagination, 245–246
in-camera B&W conversion, 61–63
Info panel, 9–10, 31, 158, 163, 184
ink sets for printing, 108–109
Isolate theory, 67

J

JPEG vs. RAW files, 154

K

Karr, Alphonse, 13, 60
Kearin, Stephen, 94
Knoll, Thomas, 74
Kokemohr, Nils, 201, 202

L

Lab color space
 Classic Black-and-White Conversions, 92–97
 color/luminance info stored in, 9–10
 correlation to human vision, 81, 91
 Equalizing Lab technique, 98–102
 explanation of, 91
 RGB color spaces vs., 80–81, 101
landscapes
 Channel Mixer conversion of, 184–197
 portrait photography related to, xiv
Large File Format (.psb) documents, 41
layer masks
 chorded contrasts and, 52–53
 color channel editing using, 175–177, 191–192, 194, 196
 contrast added using, 44–47
 error-free technique for, 49
 extracting colors using, 130, 132
 opacity settings for, 50
 overview on working with, 48
 Silver Efex Pro use of, 236–238
 viewing images and, 48
layers
 converting into Smart Filters, 23
 filling with color, 42
 opacity of, 174, 190
Leonardo da Vinci, x, 82, 94, 236
light
 dark related to, 29
 qualities of, 143
 range of visible, 9
Lighten blend mode, 22, 41
lightness, 7, 106, 107
Lightness slider, 13
Lightroom 4
 Adobe Camera Raw and, 70
 basic processing set-up for, 69
 black-and-white conversions in, 71–78
 Develop module interface, 71
 printing photos from, 109
linear color spaces, 80
loading actions, 14–15, 20, 157
logarithm, 80
Lombardi, Vince, 13
Lopez, Lizzet, 41
Loupe & Histogram section, Silver Efex Pro, 211
luminance, 7, 9, 107
Luminosity blend mode, 129, 131, 132

M

Magnusson, Eric, 108
Making Digital Negatives for Contact Printing (Burkholder), 152
Master Opacity dialog box, 196
Matisse, 19, 54, 107, 168
McNally, Joe, xiii
middle gray, 137
Midtone Contouring technique, 109, 160–161, 184
Midtone Contrast technique, 74, 160
midtones
 adjusting, 215
 exposing for, 145
Moholy-Nagy, Laszlo, 33
Monet, Claude, 3
Monochrome option, 109, 153, 156
Mozart, Wolfgang Amadeus, 165
Multiple Channel Mixer conversion approach
 landscape example of, 184–197
 portrait example of, 158–183
 Silver Efex Pro images and, 239–241

N

Negative, The (Adams), 139
negatives, creating, 152
Neo-classic Film and Filter approach, 38–40
Neutral Channel Mixer adjustment layer
 landscape conversion example, 185
 portrait conversion example, 164
Neutral Preset, Silver Efex Pro, 210, 224
Neutral Silver Efex Pro 2 layer, 226
Newman, Arnold, 28
Newton, Sir Isaac, 13
Nik Software
 Color Efex 4 Promo 5 plug-in, 4
 Contrast Only plug-in, 23–24, 50–52
 Silver Efex Pro 2 plug-in, 202–241
Nikon cameras, 62, 79, 143
Noguchi, Isamu, 54
noise
 color bleed and, 125
 exposure settings and, 144–145
non-destructive image editing, 90, 155, 159
non-linear color spaces, 80
Normal blend mode
 explanation of, 41
 Film and Filter technique and, 38

O

opacity
 brush, 175, 194
 layer, 174, 190
 layer mask, 50
Opponent Color Theory, 91
Overlay view mode, 73, 75, 77
Oz2Kansas.com website, 4
Oz 2 Kansas action
 Channel Mixer adjustment layer, 158–159, 184
 Silver Efex Pro 2 plug-in, 209
Oz Power tools action set, 4

P

panchromatic film, 5, 9
papers, photographic, 152
Patton, George S., xvi
pen-based image editing, 175
perfect practice, 198
Peter, Irene, 96
photographic papers, 152
photography
 definition of, 143
 digital vs. film, 108
 imagination and, 245–246
 See also black-and-white photography
Photoshop CS6
 configurators for, 13, 14, 154
 Large File Format documents, 41
 Lightroom 4 integration with, 70
 perspective on using, xvi
 printing photos from, 109
 running Channel Mixer actions in, 166
Photoshop Lightroom. *See* Lightroom 4
Picasso, Pablo, 86, 245
pins for editing, 75
Plaisted, Parker, 101
poetic approach, 55
Polygonal Lasso tool, 49
portraits
 Channel Mixer conversion of, 158–183
 landscape photography related to, xiv
 technique for retouching, 56
posterization, 162, 185
Pratchett, Sir Terry, 29
precision vs. accuracy, 138
Preset Browser, Silver Efex Pro, 203

presets
 Channel Mixer adjustment layer, 156
 Curves adjustment layer, 20, 21, 44, 46
 Silver Efex Pro 2 plug-in, 203
pre-visualization, 147
primary colors, 154
primary layer, 174, 190
printing
 creating negatives for, 152
 preparing images for, 109
 special ink sets for, 108–109
 subtractive approach used in, 154
 zone system for, 139
ProPhoto RGB color space, 50, 64, 80
Protect Highlights slider, 25
Protect Shadows slider, 25
.psb file format, 41
Publilius Syrus, 141
pure grayscale images, 107

Q

QuickTime videos
 on actions, 13, 153
 on configurators, 13, 154
 on image maps, 44, 175
 on Silver Efex Pro 2 plug-in, 202

R

Radius handle, Silver Efex Pro, 230
RAW files
 color channels in, 154–155
 JPEG or TIFF files vs., 154
RAW processors, 60, 65–82
 basic processing setup for, 68–69
 black-and-white conversions in, 70–79
 color space consideration, 80–81
 limitation in using, 82
Ray, Man, 26
recording actions, 14
Red channel data, 164
Red Channel Mixer adjustment layer
 landscape conversion example, 187
 portrait conversion example, 168–169
Red Silver Efex Pro 2 layer, 229–232, 236–237
Red slider, Channel Mixer, 166, 168, 171
reflectance, 107, 143
retouching portraits, 55–56

RGB color formula, 9–10, 108
RGB color spaces
 channels in, 108
 human vision and, 81
 Lab color space vs., 80–81, 101
RGB values, Zone System, 163
Ruby-Lith mode, 180
Ruth, Babe, xvii

S

Salieri, Antonio, 165
sampling
 colors, 127
 highlights, 162–163, 184–185
saturation, 107, 161
Saturation slider
 analyzing color using, 121–122, 161
 Film and Filter approaches and, 36, 37, 42
Save As dialog box, 19
Screen blend mode
 Equalize Lab technique vs., 98, 99, 100
 explanation of, 22, 44
Scrubbing slider, 37, 124, 127, 129–130
secondary colors, 154
seeing, process of, 26–28
Seeing Black and White (Gilchrist), 7
Selective Adjustments, Silver Efex Pro, 205, 217–222
selective desaturation, 13, 16–17
selenium-toned papers, 152
Sensitivity controls, Silver Efex Pro, 234–235
sensors, camera, 60
SEP 2 RGB Chording action, 223–225
sfumato technique, 236
shadows
 adjusting, 215, 216
 exposing for, 144–145, 146
 protecting, 25
shape vs. color, 66
Sharpen For option, 78
sharpening process, 26–27
Shibumi state, xv
Silver Efex Pro 2 plug-in, 202–241
 analyzing images using, 211–213
 Blue layer adjustments, 233–235, 237–238
 brightness adjustments, 204, 205, 214–216
 combining images created with, 239–241
 contrast adjustments, 204, 205, 216–217
 download information, 203

fine-tuning Smart Filter layers, 225–238
full-screen mode for, 210
global adjustments in, 204, 205, 214–217
Green layer adjustments, 226–228
layer masks used in, 236–238
Multiple Smart Filter layer approach, 223–238
Neutral layer adjustments, 226
Red layer adjustments, 229–232, 236–237
running actions in, 209, 223–225
selective adjustments in, 205, 217–222
Single Smart Filter layer approach, 209–222
structure adjustments, 217
user interface overview, 203–208
video tutorial on, 202
silver-based papers, 152
skin retouching, 55
Smart Filter layers (Silver Efex Pro 2)
 fine-tuning individual, 225–238
 multiple layer approach, 223–238
 single layer approach, 209–222
Smart Filters
 converting layers into, 23
 Silver Efex Pro, 209–238
Smith, W. Eugene, xiii, 29
split channel conversions, 88–89
Split Screen mode, 23
sRGB color space, 64, 80
Stalin, Joseph, 102
Stieglitz, Alfred, 26, 198
Strong contrast preset, 20, 21, 44, 46
Structure sliders, Silver Efex Pro, 205, 217
subtractive approach, 154
surface reflectance, 107

T

tablet-based image editing, 4, 175
Target adjustment tool, 72
test bars/strips, 114
TIFF vs. RAW files, 154
Tiffen filters, 178
tonal reproduction curves, 8
Tonality Protection dialog box, 216
tone reproduction, 7–8
toning B&W images, 183
Toning controls, Silver Efex Pro, 207
transmittance, 143
tutorials. *See* video tutorials

U

U Point technology, 217
unconscious eye, 26–28, 213
underscore (_) character, 78
Unsharp Mask technique, 27

V

van Gogh, Vincent, xiii
video tutorials
 on actions, 13, 153
 on configurators, 154
 on image maps, 44, 175
 on Silver Efex Pro 2 plug-in, 202
Vignette controls, Silver Efex Pro, 207
visible light, 9
vision
 color spaces and, 7, 81
 human eye and, 26–28
visual framework, 90
visualization, 147

W

Wacom tablets, 4, 22, 175
warm-tone papers, 152
Welcome to Oz (Versace), 56, 151
Welcome to Oz 2.0 (Versace), 26, 43, 44, 62, 67, 146, 160,
 174, 193
Weston, Edward, xiv, 152
White, Mark, 35
White, Minor, 152
white surfaces, 107
White's Illusion, 30, 31, 168
Why To of My How PDF, 22, 109, 160
Wilde, Oscar, 26
William of Ockham, 5
Wilson, Robert Anton, 59
workflow
 artifact-minimizing, 62, 193
 global-to-granular, 181, 192
 Silver Efex Pro, 204
Workflow Options dialog box, 68, 78

Z

Zakia, Richard D., ix, 133
Zone System, 136–147
 basics of, 136
 dynamic range and, 141, 143, 146
 exposure zones in, 137
 print zones in, 139
 reproducibility and, 138
 RGB values corresponding to, 163
 shadows/highlights in, 146
 Silver Efex Pro 2 and, 211–213
 visualization and, 147